Tualatin Pul.

Tualatin Pul.

REALISTS
AT WORK

REALISTS AT WORK

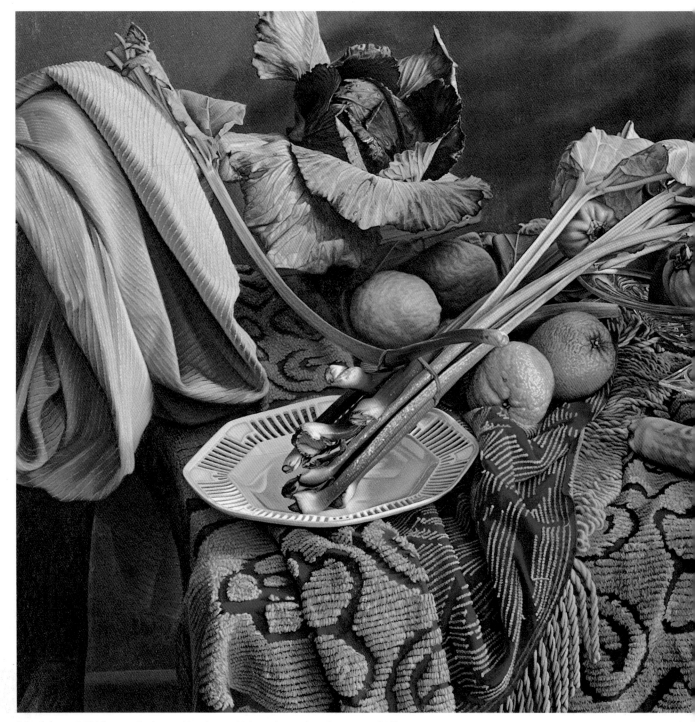

Detail from *Still Life on a Bedspread* by James Valerio (reproduced on page 143).

BY JOHN ARTHUR

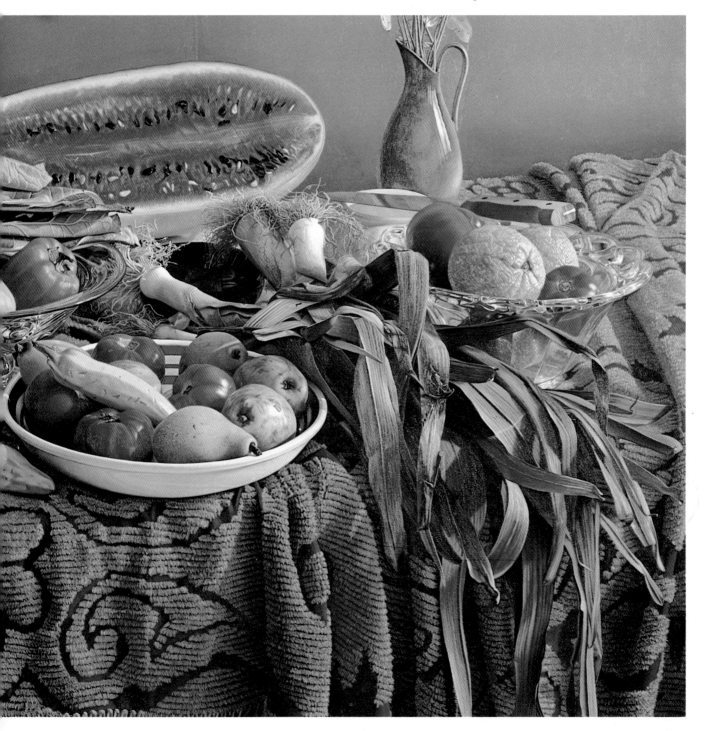

WATSON-GUPTILL PUBLICATIONS / NEW YORK

For Mother and Dad

First published 1983 in New York by Watson-Guptill Publications, a division of Billboard Publications, Inc.
1515 Broadway, New York, N.Y. 10036

Library of Congress Cataloging in Publication Data
Arthur, John, 1939-
 Realists at work.
 Includes index.
 1. Photo-realism–United States. 2. Realism in art–United States. 3. Painting, Modern–20th Century–United States. 4. Painters–United States–Interviews.
I. Title.
ND212.5.P45A7 1983 759.13 [B] 83-14545
ISBN 0-8230-4510-2

Distributed in the United Kingdom by Phaidon Press Ltd., Littlegate House, St. Ebbe's St., Oxford

Manufactured in Japan

2 3 4 5 6 7 8 9/88 87 86 85 84

Photo Credits:
Tom Arndt and Glenn Halvorsen, 51 (top); Scott Bowron, 45; Fred Boyle, 99; D. James Dee, back of jacket, 83, 90 (top and bottom right), 95; eeva-inkeri, 73 (top), 75 (top and bottom), 136, 138, 140, 142 (bottom); Lee Fatheree, 121; Bruce C. Jones, 88; Nancy Lloyd, sequence photos 14-15; Colin C. McRae, 118 (bottom); Eric Pollitzer, front of jacket, 21 (lower left), 87, 92, 93, 149 (bottom), 156 (bottom); Nathan Rabin, 19; Zindman/Fremont, 49. Photographs of the artists, their worktables, and still life setups were taken by the author.

Edited by Virginia Croft
Design by Jay Anning
Graphic production by Kathy Rosenbloom

ACKNOWLEDGMENTS

One of the few points upon which I find myself in complete agreement with Mies van der Rohe is his statement "God is in the details." This book, with its myriad of details, has obviously taxed the patience and fortitude of many people.

First, I would like to thank the painters for their hospitality and openness, which gives the interviews their value, and for their sustained cooperation, which was essential in assembling the book.

Second, I would like to thank the following galleries and their staff for their assistance and advice:

Allan Frumkin and George Adams, Allan Frumkin Gallery, New York; Warren Adelson, Coe Kerr Gallery, New York; Ivan C. Karp and Carlo Lamagna, O.K. Harris Works of Art, New York; John Cheim and Robert Miller, Robert Miller Gallery, New York; Allan Stone and Joan Wolff, Allan Stone Gallery, New York; John Berggruen and Gretchen Weiss, John Berggruen Gallery, San Francisco; Kathan Brown and Karen McCready, Crown Point Press, Oakland and New York; Jack and Ethel Lemon, Landfall Press, Chicago; Carolyn and Brooke Alexander, Brooke Alexander, Inc., New York; Jack Mognaz and Pierre Levai, Marlborough Gallery, New York; Nancy Hoffman and her staff, Nancy Hoffman Gallery, New York; Margi Conrads, The Pace Gallery, New York; and the numerous private collectors.

Once again, *The Allan Frumkin Gallery Newsletter,* Irving Sandler's *The New York School: The Painters and Sculptors of the Fifties* (New York: Harper & Row, 1978), and various essays by Linda Nochlin have provided me with invaluable background material.

At Watson-Guptill, David Lewis has been a constant source of encouragement, Virginia Croft has judiciously edited the lengthy and complicated text, and Jay Anning has given a sense of order to an overabundance of visual material.

And last, my wife, Karen, has given considerable assistance and kept me on the track—which is not a small job.

CONTENTS

Detail from *Orchid and Shining Spring* by Joseph Raffael (reproduced on page 110).

PREFACE

There is a sense of authenticity and immediacy which is best conveyed in an interview. Certainly it is the format which most clearly reveals the ambience of an encounter with an individual.

From my high school days, I remember the Mike Wallace television interviews with Frank Lloyd Wright, which convinced me of Wright's genius and instilled a lifelong interest in architecture. In college I began reading the superb interviews with literary figures in the *Paris Review,* and my interest in that particular format has intensified over the years.

I hold in the highest regard *Francis Bacon,* edited by David Sylvester (Pantheon Books, N.Y., 1975), and Sylvester's preface has served as an instructional guide for the interviews I have conducted. W. H. Auden's preface to *Van Gogh: A Self-Portrait* (E. P. Dutton and Co., N.Y., 1961) explaining his focus in the selection of letters has also been helpful.

Also, I most fondly remember the series of articles appearing in *Art News* in the later fifties which described the procedures of various painters, particularly "Porter Paints a Picture" (1955) by Frank O'Hara and "Diebenkorn Paints a Picture" (1957) by Herschel B. Chipp. The information in these articles is essential to understanding the sensibilities of Fairfield Porter and Richard Diebenkorn and for coming to grips with the polar positions toward figuration on the East and West Coasts, which were far more than a geographic separation. This distinction is essential to an understanding of today's figurative and abstract painting.

None of the painters in this book were strangers. I have followed some of them through their careers since the sixties and have known most of them personally since the early seventies. In the past decade, there have been correspondence, numerous casual encounters, and long visits. I think of them as close friends.

While each of these painters has played an important role in contemporary Realism, and while they share the common link of high verisimilitude, there is also a great deal of diversity in their images, attitudes, and studio procedures. But, at times, surprising similarities have emerged.

I have attempted to maintain the casual, conversational flow of the actual interviews, but, in fact, they have been reconstructed. For this reason, my method behind the interviews should be clarified.

Individual questions for each painter were prepared in advance, with the exception of certain specifics regarding studio procedure, which were intentionally constant. An enormous amount of information and insights into an artist's working arrangements can be gleaned from the studio, and

for that reason each painter was interviewed in that environment. While all of these painters are represented by New York galleries and all of them have lived in New York for extended periods of time, only two of the interviews took place in Manhattan. My travels took me from northern Maine to the San Francisco Bay.

Once the interviews had been recorded on tapes, which ran from ninety minutes to more than two hours, transcripts were made. These verbatim transcripts totaled almost a hundred thousand words, which were edited down to less than half that length. Then each interview was color coded by topic, cut apart, and rearranged for cohesion and continuity.

The edited transcripts were then sent to the painters for corrections, clarification, and at times amplification. Occasionally additional written questions were necessary, and those answers were woven into the interviews. At times, some of the material was considered to be too personal, a few of the questions and responses were perhaps a bit indiscreet, and they were deleted at the artist's request.

Considering the procedure, these interviews could best be described as collaborations.

Aside from the fact that all of these painters are considered to be major Realists, other common traits and patterns emerge which are extremely important. Obviously, they distinguish and separate all of the serious artists I have met from the legions of amateurs and dilettantes.

First, and most central, is that these painters are intelligent, strong-willed, committed, and believe deeply in their work. Second, all of them have very regular work habits and put in long hours each week. That is necessary to accomplish what they have done. Innate ability and intelligence are certainly key ingredients, but little or nothing can be accomplished without personal industry, endurance, and ambition.

In closing, I would emphasize that this book is not intended as a survey of contemporary Realism, nor is it an instructional guide for making representational images. Instead, it will at best serve as an indication of the diversity of thought, breadth of expressive means, and wide range of methodology employed to obtain those ends within the context of Realism.

It is my good hope that the answers to the questions I have raised will be useful and enlightening to all who share my interest in this vital aspect of contemporary art.

John Arthur

Newton Highlands, Massachusetts

JACK BEAL

From the early, romantic nudes of his wife, the painter Sondra Freckelton, through the extravagant, abstractly constructed still lifes and elaborate portrait compositions, to the more recent narrative and allegorical paintings, Jack Beal has remained one of the most complex and psychologically penetrating Realists of our time. He is one of the finest contemporary draftsmen and printmakers and is noted for his beautiful and extremely personal use of pastel in his landscapes.

Coinciding with their move to the Catskills and rebuilding of an old mill located on a valley stream, Sondra Freckelton has made an evolution from abstract sculpture to watercolor still lifes, which have brought her to national prominence as a painter. In addition to her studio activity, she manages, with the aid of apprentices often in residence, to maintain a large vegetable garden, tends her flowers and landscaping, looks after geese, ducks, and dogs, and together with her husband, prepares elaborate gourmet meals for the constant stream of household guests and other visitors. It is clearly an ebullient household.

In addition to the many houseguests at the New York loft, there is also a seemingly endless cascade of area farmers, carpenters, artists, printers, students, curators, and writers through the mill, all at the invitation of the gregarious Beal. Usually at the center of disparate conversations, somehow Jack Beal continues to work.

His erratic schedule and flux of diversions belie the fact that Beal is a highly organized painter. A glance around the studio, recently constructed on the knob of a hill overlooking the valley, reveals his organizational abilities and propensity for detail.

"There comes a point where the picture begins to assert its own needs, and you must pay attention to those needs. If you are blindly copying what's in front of you, you will end up with a good copy but perhaps not a good painting."

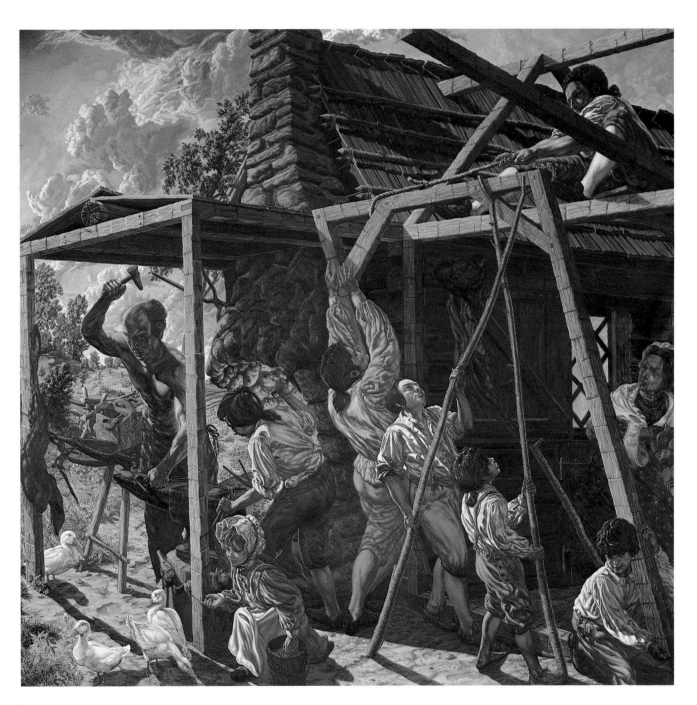

The History of Labor Murals: 18th Century, "Settlement" (1975-76), 144" × 144" (366 × 366 cm), oil on canvas. U.S. Dept. of Labor, Washington, D.C. Courtesy Allan Frumkin Gallery, New York.

There are so many times I've told young painters that they ought to make copies or translations of drawings and paintings by masters whom they admire. Most often they look at me incredulously, because they can't believe that it's possible to learn anything in that way. Besides, we're in a time when such a premium is placed on individuality that people are afraid of putting themselves in someone else's place for fear that they will submerge their own individuality.

Well, I've learned more of what I know about color, for example, by making little studies from Braque and Bonnard than in any other way. I learned how to draw the human head, finally, after thinking that I knew how, by making a number of copies and translations of drawings by Renaissance masters. It was one of the best learning procedures I ever participated in, because I was able to have my hand guided by a master. If your own personality is strong enough, you're going to be able to absorb what the master teaches and integrate it with your own personality.

In this painting, Still Life with Self-Portrait, *you said you were referring to the Fantin-Latour still lifes.*

Yes. I've started off on a dark-toned canvas to build the luminosity from the very beginning. I especially wanted the bright yellow spring flowers to establish themselves in space and jump off the canvas. I can build from there, making some things lighter than the ground color and others darker than the ground color, but allowing those flowers to emerge immediately with their own light trapped inside them. I painted all the flowers with white acrylic before I began painting in oil. I laid in the pattern of light on the canvas with the white acrylic, then went back after several days, when the acrylic had dried, and started working over them with oil. If I had tried to paint with oil directly on the dark canvas, they would not have developed that luminosity, and it would have taken several coats of paint to even approach what I was after.

What are you sizing the canvas with?

It's a mixture of DuPont Lucite and acrylic. I add acrylics to get the coloration that I want to start with.

The gray brown is a beautiful ground, quite a bit darker than medium value.

Oh, yes. As a matter of fact, it's very much akin to the color of pastel paper that I often use, a dark gray Canson Mi-Teintes. I've grown so used to that color that I decided to try to make some paintings on it, which is a totally different procedure than starting on a white canvas. It almost looks like I have a half-finished painting when the work has barely begun.

Your ground is completely opaque. It's not a stain.

Yes. It's necessary, when you are painting oil on canvas, to have a good, solid, thick ground. The primary purpose of the ground is to protect the canvas from the destructive qualities of the oil paint.

> **"Composing pictures is one of the greatest pleasures I get out of making art. I want to make the whole picture some kind of machine, or gestalt, an organism which has a life of its own."**

You leave a lot of the toned paper exposed in your pastels, but by the time you're finished with the painting, most of the tone will be covered.

Not in all cases. I've done about seven or eight small pictures on ground like this, and in a couple of them I left the ground in certain areas, or modified it just slightly. But when this painting is finished, there probably will be tiny areas that will not be covered.

Even this small still life, which is very typical of your work, is composed like a piece of sculpture. And it shows an aspect of your work that confuses a lot of people—that is, the chair that the objects are sitting on appears to be tilted—but that's because you are six feet four inches tall. You are actually looking down on it.

Yes. I always look at things, I guess, from a different height than most other people. I also like to get close, and when you are close and looking down like that, there is a different perspective. Also, it opens up the space, which is one of the most important things to me. For a long time, like almost all contemporary painters trained in modernism, I was an abject servant of the doctrine of the sanctity of the picture

plane—that is, the picture plane was a pristine surface in front of which no action could occur and behind which limited action could occur. Finally, the modernist doctrine of the sanctity of the picture plane drove paintings to being totally flat. I realized that it was ridiculous for artists, who were supposed to have more freedom than just about anybody, to submit themselves to this kind of absolute law. I decided that I wanted to get as much space as possible inside the picture. One day I was talking to my dealer about another artist. In criticizing him, I said, "Good Lord, Allan. He breaks through the picture plane all the time!" As soon as I said that, I realized it was a marvelous thing to do. So now I visualize the picture plane as something to use with total freedom, like the open stage in contemporary theater. In this painting, for instance, the closest daffodils are in front of the picture plane, leaning out over the most forward object at the edge of the canvas, which is a chair leg. It opens the space up miraculously. I try to establish those aspects right away.

Another thing that's typical of your composition, in addition to the highly structured space, is that you're fanatic in your use of the edge of the canvas.

Right.

And composing with those edges.

I *love* composing. Composing pictures is one of the greatest pleasures I get out of making art. I want to make the whole picture some kind of machine, or gestalt, an organism which has a life of its own. In order to do that, you have to build a structured composition, like a piece of music, with a beginning and an end. Inside that structure, it's a matter of working with the details. First of all is building the still life, which is like building a piece of sculpture, and then looking at that still life from different positions until I find the angle which is going to allow me to get the complete machine on the canvas. Drawing that on the canvas is one of the most exciting parts of making a painting. I like to work into the painting everything that I've learned from my own past successes and failures and what I've learned from looking at nature and great art.

You had the canvas stretched to a certain size, then you composed your still life.

Yes.

But in almost every painting you make the objects very close to a one-to-one scale—the daffodils look slightly larger—and you seem to arrive at the composition very quickly.

I know. The best part is sometimes over with all too soon, but it's not as quick as it seems. You can see there are a lot of erasures and alterations.

Having followed the development of quite a few of your paintings at this point, I know that, although there is a lot of shuffling around, the overall structure of the composition is there almost from the start.

Well, a lot of that comes in the process of setting up the still life or the models. If I'm using a model, for example, the composition is developed in constructing what I call the "sculpture." In the late fifties, when Sondra was doing abstract sculpture, most of our friends were sculptors, such as Tom Doyle, David Weinrib, Mark di Suvero, and Cliff Westermann. I admired their work above almost everyone else's at the time because they were using objects in very dynamic and exciting ways. I knew I didn't want to make sculpture—I have a feeling for making paintings—but I would see how they arranged things,

how they built things and caused something dynamic to happen. Except in the paintings of Jim McGarrell, Paul Georges, and a few others, that sort of thing wasn't happening in anyone's work at the time. Almost all painting was trapped in the second dimension. So when I first began, in the paintings that were in my first one-man show in 1965, for example, the setups were all built like sculptures. I would take objects in our house and a person (usually it was Sondra but sometimes myself) and I would make a sculpture of them. Then I would look at it from different attitudes and heights until I found something I could translate three-dimensionally onto a two-dimensional canvas. So, many of the compositional decisions are made before I ever make a mark on the canvas.

You do your drawing with vine charcoal, and there is some fine tuning.

Yes. Moving the actual objects or the drawing of the objects. In this setup I finally had to add that top yellow daffodil because I was trying to make a low crescent, but that upper section just cried out for something, so I had to add that daffodil. It made the difference.

You painted the daffodils first because they were perishable?

I went through three different bunches to get that one on the canvas.

And that part is complete?

Yes. What you see there represents a week's work.

One of the major differences between this painting and the earlier ones is that when you were working on white canvas you blocked in the entire image with very soupy color and then worked it up in parts. In this painting you have the dark gray ground and no other color except the flowers. Is there a big difference in the way you have to approach it?

Yes, there is, as a matter of fact. With the little painting that I'm working on now, I find myself making color changes that I would not have foreseen when working the other way. By this point I would have already made all those decisions. When working on white canvas, as I said, many of the most exciting decisions were made at the beginning, and from then on, the course of the painting was just finishing it, which I don't enjoy as much as composing and making those initial color decisions.

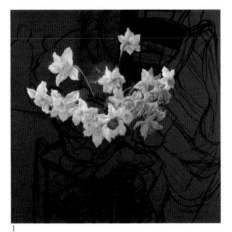

1

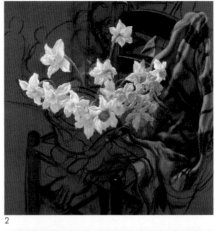

2

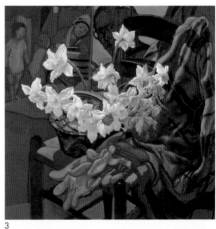

3

1. Beal begins by making a charcoal drawing on toned canvas, and completes the daffodils first. The still life setup is shown on page 23.

2. The portrait reflected in the mirror is drawn in with charcoal. The coat and parts of the chair are being developed in oil.

3. Next the gloves, vase, and tapestry are blocked in with oil.

4. The gloves, vase, and chair are developed further.

5. Details of the tapestry and the wood-grain of the floor are refined, and the still life and chair are completed. At this point, only the self-portrait remains as a drawing.

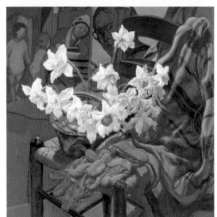

4

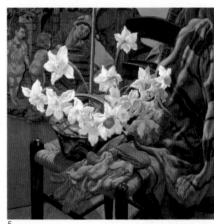

5

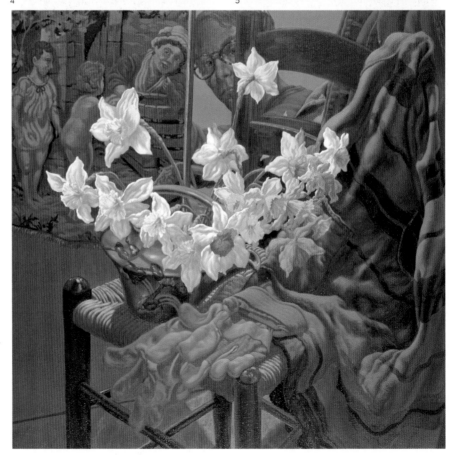

Still Life with Self-Portrait (1982), 36″ × 36″ (91 × 91 cm), oil on canvas. Courtesy Allan Frumkin Gallery, New York.

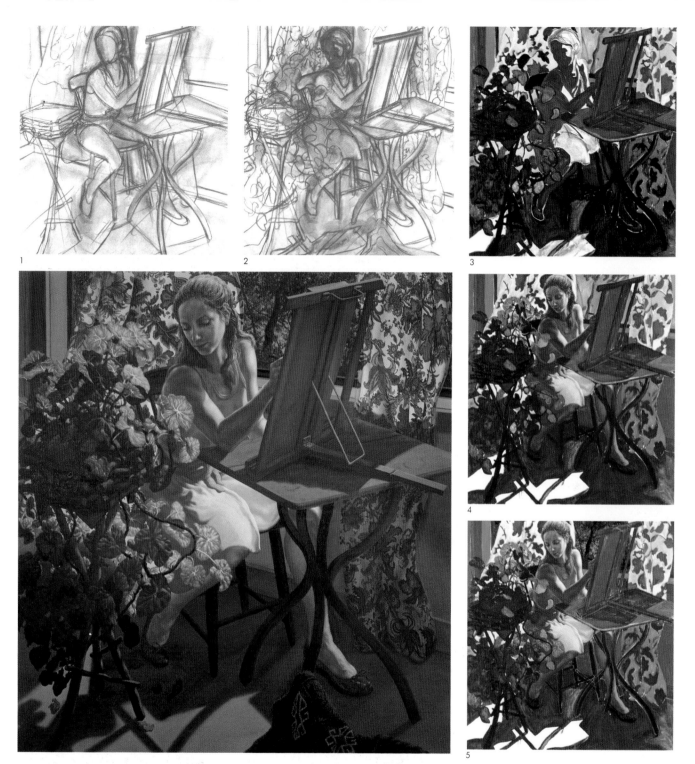

Anne Wilfer Drawing (1983), 50" × 54" (127 × 137 cm), oil on canvas. Courtesy Allan Frumkin Gallery, New York.

1. Vine charcoal is used to make the drawing on white primed canvas. Although the drawing is not completely developed, the composition is firmly established.

2. The finished drawing contains some indications of lights and darks. Anne's shorts have been replaced with a skirt, and the begonia, fabric patterns, and other details have been indicated.

3. Color and tone are blocked in with a wash of oil diluted with turpentine. At this point, the patterns of light and dark are established, with everything keyed to the color and value of the figure.

4. The head, figure, and clothing are developed first in the overpainting.

5. The landscape beyond the window is completed, parts of the begonia have been painted, and refinements of the furniture are being made with white pencil.

The invention of the image.

Yes. This way, I am taking more of a risk, but I'm enjoying the process of painting more because I'm making changes as I go. In the others I made changes but they were minor adjustments. Here, I'm going further out on a limb, but I'm allowing the painting to grow like a garden.

One of the problems of drawing with vine charcoal is that it picks up in the paint.

Yes, but that's very easy to deal with. You just lay in a very light line of paint and then brush off the charcoal with a dry brush. It comes off the canvas so readily that you can blow it away.

What's your medium?

Mostly I use just straight, pure, gum spirits of turpentine. When I do use a medium, I use a mixture of one-third each of turpentine, damar varnish, and stand oil.

But in the early stages, only turpentine.

Yes. I like to use a medium with the dark colors because on acrylic ground—any ground actually—they tend to absorb and go flat.

You're working wet-into-wet when you model the forms?

Yes.

Actually, for the local color of the flowers, it looks like you've broken them down into about three colors and three tones.

I never break it down. I have colors smeared all over the canvas, and I start out trying to be systematic like that, but the next thing I know I'm not getting to it at all. I was trying, especially in the white petals of the daffodils, to achieve the kinds of subtleties that, say, Frederick Edwin Church got when he painted snow scenes or skies. I find that you have to make infinite changes in order to arrive at that.

And you use paper palettes.

Right.

Your palette is very, very well organized. Your yellows are together, your oranges, blues, greens, and earth colors, and you use the center portion for mixing.

Yes. I start out closest to me with a big blob of white, and next to that some black, which I use very sparingly. I almost never use black—only to darken

another color, such as a green or a blue. If I want a black on the canvas, I'll generally make it by mixing a dark green or a dark blue and raw umber, which gives a much richer black. Then I'll run my earth colors up the palette, my reds, yellows, and greens across, and my greens and blues down. It's set up almost like a spectrum.

You seem to have your brushes organized too.

For paintings like this, I generally stick with bristle brights. When I am laying in large areas, I use a big, fat one. But in a painting this size, I won't have a chance to use any of those fans, because there won't be that kind of blending to do, but I like fans also.

> "I have tried not to learn what warm and cool means or what the primaries are. I know some of these things because you can't help but learn, but I try to let my color be as responsive as possible to the subject that I'm painting."

You have some sable brushes also.

A few, but I try not to use them anymore. They give a totally different look to the paint. I've been trying to stick with the bristles, because I like the way they put the paint on the canvas. There was a time when I was addicted to sable brushes, but my painting got too hard and crisp. So now I'm trying to get only as hard as a bristle brush will allow me to get.

What kind of paints are you using?

Winsor & Newton.

Just Winsor & Newton?

Yes. Well, there are two Shiva colors I like for which Winsor & Newton has no equivalent, a maximum red IV and a maximum violet V. I don't like alizarin crimson. There's something about it that's repellent. So I use Shiva maximum red IV, and maximum violet V is one of my favorite colors in the world. I can't get it by mixing other colors. But other than those two, I use Winsor & Newton.

With the exception of the white daffodils, this painting is going to be very dark. The mirror with your face reflected will be a light strip. It's going to be a very low-key painting with a fairly elaborate chiaroscuro construction.

I was concentrating on the daffodils, trying to show the glory they had when the sun hit them on our hill across the way. There was a period when they were standing at a height above the ground so that when the sun peeked over the hill, they would be in light and the ground beneath them would be dark. They were glowing across there, lit from within. I'm trying to get the same kind of representation as they had then.

Also, it looks like the painting is going to be richly colored. Do you get into using opposites? The white daffodils have orange centers, they are in a blue vase, you have pale blue gloves, there's violet in the coat, yellow flowers. How much of that is worked out?

This may sound naïve, John, but I have purposefully tried to keep myself relatively ignorant on the subject of color. I have tried to learn as much as I could about every aspect of art, but I have tried to keep my color on an intuitive level. I have tried not to learn what warm and cool means or what the primaries are. I know some of these things because you can't help but learn, but I try to let my color be as responsive as possible to the subject that I'm painting.

It's always connected with local color?

Yes. Yes, I have always felt that if I kept color on that level it would always bring me back to earth, even though quite often in my paintings the color is heightened. I am letting the color decisions make themselves as the painting goes along. I believe that if you structure a painting in a certain way, so that your sensitivity is keyed to the growth and development of the painting, at a certain point the painting itself begins to dictate its needs. For example, in this painting I painted the daffodils first (if this were a figure painting, I would do the figure first) and let them dictate what the other colors would be, regardless of what was in front of me. One mistake that some figurative painters make is to try to reproduce exactly what is in front of them. There comes a point where the picture begins to assert

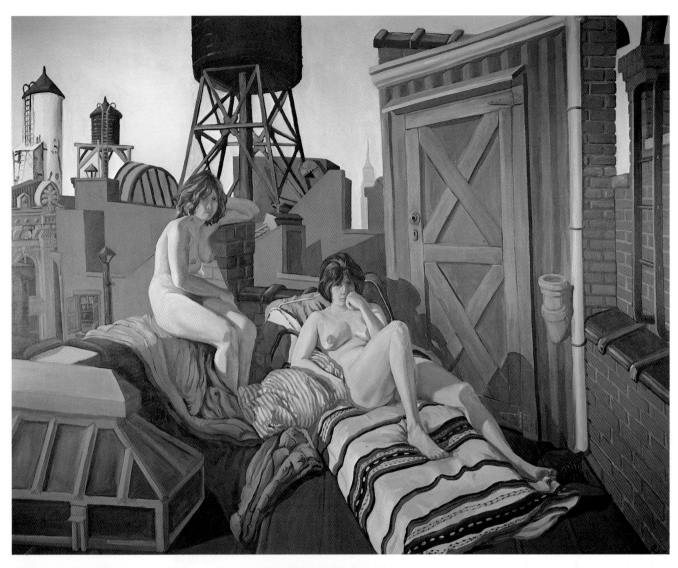

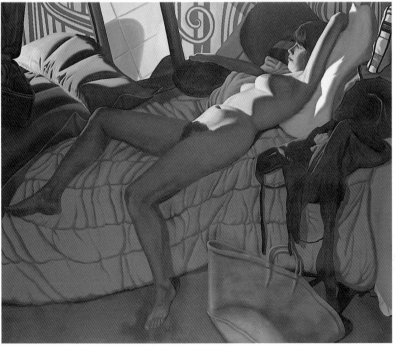

The Roof (1965), 120″ × 96″ (305 × 244 cm), oil on canvas. Extended loan to the Rose Art Museum, Brandeis University, from Mrs. Robert B. Mayer and the estate of the late Robert B. Mayer, Chicago.

Nude with Suitcase (1966), 76″ × 66¼″ (193 × 168 cm), oil on canvas. Courtesy Allan Frumkin Gallery, New York.

its own needs, and you must pay attention to those needs. If you are blindly copying what's in front of you, you will end up with a good copy but perhaps not a good painting.

The yellow in those daffodils is not a totally naturalistic color but it's the color I felt would best explain what those daffodils looked like on that hill in the morning, and the green in the chair and the other colors are dictated by the yellow in the daffodils, and so on. I finally care less about what an object looks like over there; it's got to look right in the picture. That's some of what art is about, making those adjustments.

How long does it take to do a large painting such as The Painting Lesson *or the two farm paintings?*

The two farm paintings took me two years. *The Painting Lesson* took me about six months. I did other paintings while I was doing the two farm paintings, but they really took forever. The lawn in the first farm painting (with the pigs in it) took eighteen days to paint.

You have been fairly adamant about the one-to-one scale.

Right. When I make paintings of people, I like them to be the size they are because I want to believe in those people. Anything that I can do to strengthen that belief, I will do. That means painting people the size, the shape, the color they are. That early portrait of Ivan made me change the way I put paint on a canvas.

You're talking about an early painting, from 1963. It was very expressionistic, Soutine-like.

Yes. At the time, I applied paint often by squeezing colors directly on the brush and slapping it onto the canvas. Those paintings have a kind of energy and enthusiasm that still exists in the early stages of my current paintings, but is not so obvious when the form and surface have been developed. But after having that painting around my studio for a few months, I began to realize that the flesh on his face looked flayed, as though I had gone at him with a knife. I realized that I had done a disservice to my subject by allowing my ego or individuality as a painter to distort the image. Each person's image is important to him, and if we have the empathy we're supposed to have, we should

respect that. From that realization on, I have tried to paint people with the same kind of scrutiny that people give to themselves when they're shaving or applying makeup or that they give to others in conversation. My whole style of paint application changed as a result of that understanding. So when I make a painting of people, I make them the size and shape that they are, with the gestures they use, and in the environment they choose for themselves.

Sondra says that making a painting, for her, is like writing a letter to someone, with the same kind of personal attention: I'm sending this to you, the viewer. That's such a loving, simple statement about what contemporary Realism is all about.

> **"I have tried to paint people with the same kind of scrutiny that people give to themselves when they're shaving or applying makeup or that they give to others in conversation."**

Unlike Philip Pearlstein and Alfred Leslie, who hire models, often using someone they don't know very well, you have never been able to work that way. You always use friends.

A couple of times I have hired models, but I like to paint people whom I know and feel good about and am interested in, because all of that is going to add to the life of the picture. I am always looking for ways that I can add to the vitality of the picture.

Going over your work from the sixties to the present is like repertory theater; the objects in the still lifes and the individuals in your paintings—Sondra, Dana, yourself, and others—we have watched age and change.

Right. I'm also not adamant that my models sit absolutely still or quiet. I try to make my models as comfortable as possible, often setting up a TV in front of them, because I worked as a model in art school and I know that it is the most boring job that I ever had. I figure I have to be good enough to catch the action because it will add to the life of the picture.

You often use other people for the bodies, or make mannequins, and you've stuffed the clothing with rags or newspapers. Have you ever made plaster casts of the figures, as Alfred Leslie does sometimes?

No. I'd rather have models for all that time, but I feel guilty absorbing someone else's time for such a great period.

What about using photographs?

I use photographs sometimes as reference points. I know there are Realist painters who think that the use of photographs is absolutely anathema to the whole Realist persuasion.

Well, it didn't bother Eakins or Degas.

No. I use anything that I can. But I rarely paint directly from photographs because, finally, the camera is one-eyed and people are two-eyed. You need the ability to see around corners, and cameras can't do that. I have used photographs to make drawings for compositional sketches and I find that helpful. For example, if I had a number of hands to paint in a picture, I might lay in the initial drawing from the model, paint a rough undercoat from a photograph, and then get the model back for the final posing. It's mainly a labor-saving device for the model.

Sondra was a classmate at the Art Institute of Chicago in the fifties, wasn't she?

I entered art school in 1953 and she entered in '54. We never graduated. Neither of us has a degree in the world.

Sondra has played a very important role as a model, painting assistant, compatriot, and as a critic.

Yes. The best critic that I have, and I am her best critic.

Do you have any idea how many paintings you've done of Sondra?

I've no idea in the world.

Who were some of the other students at the Art Institute at the time you were there? I know Red Grooms was there.

Yes. Red came in for a short time. Richard Estes was there. John Chamberlain. Claes Oldenburg was a night student, I think, and was working full time as a journalist. Richard Hunt was there, Irving Petlin, Robert Barnes, Peter Gourfain. I know I'm omitting a dozen more. It was a very exciting time, very energetic.

Were you doing Abstract Expressionism at the time?

Oh, yes. Absolutely. But I went off to art school in 1953 under the thrall of the famous illustrators. My first real love was the illustrations of Ben Stahl, who did all the frowsy nudes that were used for John Steinbeck paperback covers. They were sort of impressionistic, a bit like Manet. I was living in Norfolk, Virginia, and was totally unexposed to art until I took an evening art class with Regina Bartley. I got to Chicago and had three terrific teachers, who immediately hurled us into the maelstrom of art history and made us study everything in sight. I had a drawing teacher, Briggs Dyer, who taught from Kimon Nicolaides' theories, an art history professor, Kathleen Blackshear, a student of Helen Gardner's, who had us do analytical drawings of a great work of art each week: an analysis each of line, second dimension, third dimension, value, color, and texture. Then I had a general drawing teacher named Isobel Steele MacKinnon, who had been a pupil of Hans Hofmann and taught Hofmann's space. The amalgam of these three was incredible. Dyer taught, "Try everything," Blackshear said, "Look at everything," and MacKinnon taught a very definite structural thing. Having the three outlooks as foils for one another was very healthy, instead of being pushed totally in one direction.

It's ironic that Richard Estes had the same teacher and learned Hofmann's conceptual space, which he uses on a much more intuitive level. His paintings are very complicated spatial constructions, as are yours, and both of you are coming from Isobel MacKinnon.

By the way, we are doing a homage to Isobel MacKinnon. I've written a "seed" essay, and a number of other essays will be written.

In the sixties and seventies, while Sondra was a sculptor, she was also the model that you used for the many nudes that you did during that period. Recently you have been very harsh in your assessment of some of those paintings, which I would argue are extremely noteworthy, and I feel are some of the finest paintings in contemporary Realism. One of the aspects that interests me—ultimately you found it disturbing—is that there is a very humanistic eroticism as opposed to

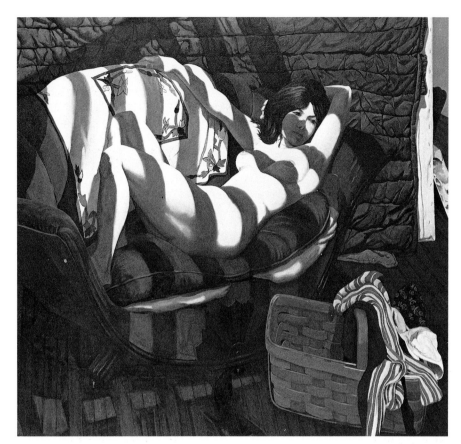

Striped Nude (1965), 72″ × 66″ (183 × 168 cm), oil on canvas. Courtesy Allan Frumkin Gallery, New York.

the prurient Photorealist works that Goodyear singled out as being erotic. What is your feeling about that body of work?

I wasn't trying to make erotic paintings, John. It's obvious that I love Sondra very much, and I was trying to celebrate her in all her glory. Especially in the two Danae paintings. I see the whole Danae myth as a symbolic statement of the position in which women are placed, and I used the subject initially for a number of reasons, but mostly for that. In both paintings Sondra is both the Danae and the maidservant. I was trying to make a statement about Sondra—how much I love her and how beautiful I think she is—but also it's about women as prisoners, as victims. In the first painting, Danae looks sort of submissive and perhaps even eager about what is going to happen to her, but in the second, Danae looks a bit angry; as a matter of fact, she has her fist balled up.

How many years apart were the Danae paintings?

Seven. The first was done in 1965 and

the second, which you saw me working on at Black Lake, was finished in 1972.

Were there drawings for the paintings?

Yes. Quite often I make small sketches. I often make compositional sketches on yellow legal pads with ballpoint pen so that I have no emotional investment in them—just sit down and start drawing and try to arrive at some kind of composition. Mainly, I try to get some kind of exciting pose and then build the "sculpture" around that.

Drawing is very important to you and you've produced an enormous body of drawings: portrait drawings, still lifes, some landscapes. The pastels are often as large as paintings, such as the six that you did for America 1976 *[a Bicentennial exhibit sponsored by the Department of the Interior and curated by John Arthur], but you've always kept the way of using pastel separate from painting. They aren't heavily worked.*

Right. Did you see the most recent landscape that I did up here, the large one? It is far and away the most

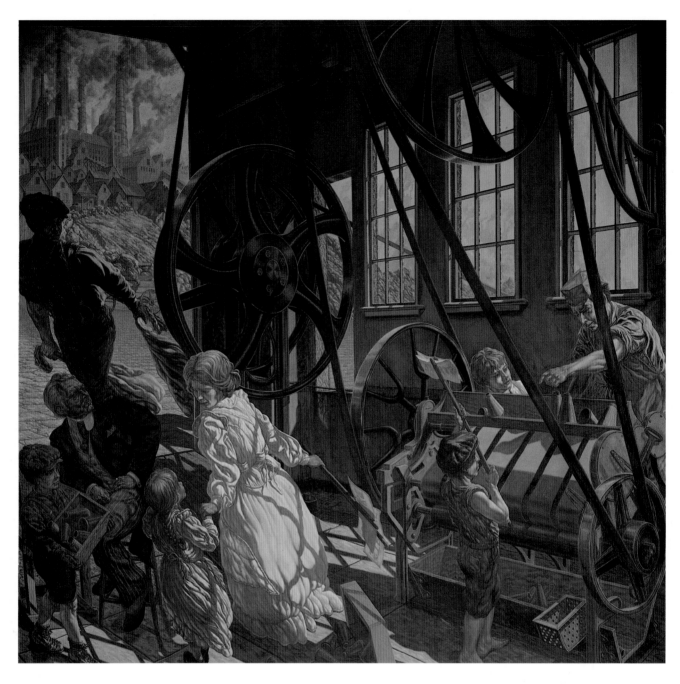

(Above) *The History of Labor Murals: 19th Century, "Industry"* (1975-76), 144″ × 144″ (366 × 366 cm), oil on canvas. U.S. Dept. of Labor, Washington, D.C. Courtesy Allan Frumkin Gallery, New York.

(Page 21, top) *Sydney and Frances Lewis* (1974-75), 78″ × 72″ (198 × 183 cm), oil on canvas. Courtesy Allan Frumkin Gallery, New York.

(Page 21, bottom left) *Lobster* (1975), 25″ × 19³/₄″ (63.5 × 50 cm), color lithograph. Courtesy Brooke Alexander, Inc.

(Page 21, bottom right) *Buds* (1980), 41″ × 31″ (104 × 79 cm), color lithograph. Courtesy Brooke Alexander, Inc.

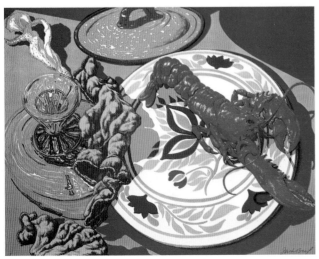

worked-up pastel drawing I've ever done. My pastel style is changing now. I have a self-portrait in New York that I'm just finishing. I think that the pastels and paintings are getting closer together, maybe partially because I am using the dark gray ground on the canvas.

The dark gray ground comes from the toned paper you used in the pastels, but with them you let the ground of the paper do a lot of the work. Also, you didn't blend the colors.

Right, but I'm starting to blend now.

But even in the big landscape of the valley, the color wasn't blended.

Oh, no. It's all single marks, almost pointillism in certain places.

You're the only painter I know who allows assistants to actually work on your paintings.

Right. I wish I could have apprenticed to an older painter when I was younger. To me it's the best way to learn painting. The greatest art the world has yet produced came from artists whose training was as apprentices, journeymen, and then masters. This system was in effect for hundreds of years, and no better method has appeared—nor is it likely to. I am determined to help revive this honorable and effective tradition. My first assistant was Walter Hatke.

He is emerging as a very fine painter.

Yes. I was doing the series of table paintings in which all the lines were drawn out. I would mix the colors, and he would apply the paint; then, when he left for the evening, I would go over the paint that he had applied with my own brush to make the paint move in the way that I wanted. Later, in a painting of Sondra on a flowered sofa with a carpet underneath, I drew out every nubbin in the carpet and made him a little map. I mixed up seven or eight individual colors for each nubbin, and he'd fill them in. Again, when he left in the evening, I would go back over the area and "Beal-ify" it, if you will.

I remember Sondra painting part of the flowered fabric in that painting.

Yes, she did, in the same procedure that I used with Walt. My next involvement with apprentices was with the Labor murals [four large paintings commissioned for the new Department of La-

bor building in Washington, D.C.], which I would never have undertaken without apprentices. There was more than apprenticeship on those paintings, it was full involvement by all five of us. I did the charcoal drawings on the four canvases and then I mixed up pots of color and put a dab in the area in which that color was to be laid on, and the assistants [Sondra, Bill Eckert, Bob Treloar, and Dana Van Horn] would paint it in. When we got to the finished areas, Bob, who was good at hard-edge painting, got to do all the precise work. Dana was very good with landscapes, so he did the trees and skies. Sondra did many of the still life objects, that being her area of mastery.

> ## "I wish I could have apprenticed to an older painter when I was younger. To me it's the best way to learn painting."

Dana and Sondra built little models with painted clay figures, which was something I think Thomas Hart Benton did for some of his paintings.

Right, for the nineteenth- and twentieth-century paintings, the activity depicted was very much like the activity in the studio, so we didn't really need models for them. But for the seventeenth- and eighteenth-century paintings, which were exteriors, we needed something to establish the quality of light and color, so we built rather detailed models.

Those interior spaces of the mill and the twentieth-century laboratory are made up.

To me, those paintings are like theater, and I was a playwright. I was trying to make a human environment. All of us began to believe in the environment to such an extent that, for example, when Bob was up on the scaffold, working on the nineteenth-century painting, he lost his balance. He reached out to try to grab the large wheel in the painting. And once I tried to climb a charcoal ladder in the twentieth-century painting. To make a believable Realist picture, you have to believe in the activity on the canvas as strongly as the activity of real life.

Anyway, during the last two months

on the paintings, I took over and made many alterations. It's a long and honored practice, using apprentices. Raphael learned that way with Perugino, Titian with Giorgione, and Tintoretto, the Bellinis, Rubens, and Rembrandt all studied as apprentices and had apprentices themselves. But I also like it because it adds to the vitality of making art. I am a gregarious person, and having people around and involved with making the art allows life and energy to flow into the art and back.

Your subjects have moved much more to allegory and narrative in the past five years.

I realized that the best things I have learned about life and how to live came from the arts, and I began to want to make paintings that were directly related to the life I live, with the hope that I can transmit that directly to someone else so they can understand it in the ways that I have been able to understand it from other artists.

You have chosen to paint things connected with the farm, but you cannot sever yourself from New York, which leads to a very complicated life style.

Yes, but I love being around people. I like to be in unexpected situations, to learn how I'll deal with them, like going to the opera and discovering a marvelous singer I have never heard before, then coming home to find that my van has been stolen.

You have done some of the great pieces of Realist printmaking, but printmaking, for you, has become so elaborate and involved that there is a point of diminishing returns.

It has become too time-consuming and wearying. I had some instances of bad luck in which things that I had spent a long time on got wiped out. I can do several small paintings in the same time.

That last litho, Buds, *is certainly a successful print.*

Well, Bud Shark, in Boulder, was terrific to work with. But every plate bore the inscription JBLL, "Jack Beal's Last Lithograph."

You usually paint one painting through until it's finished.

Most often, but at times I have had several paintings going simultaneously,

like the two farm paintings. But I painted those all the way through.

I can't think of any paintings that you have scrapped.

I have abandoned the "Gluttony and Temperance" painting because the couple who were modeling broke up. I haven't made a failed painting in a number of years, which probably means I'm not trying hard enough.

In the paintings you use a Caravaggio-like light. Part of that is because you usually paint at night and you arrange the light.

Yes. Ever since I discovered Caravaggio, maybe even before, I was trying to use light to define form. I think that becomes most apparent in the figure paintings, such as the painting of Sondra with the alternating stripes of light and dark falling on her. I was trying to learn how light can define volume. One of the big excitements about painting representationally is trying to represent the illusion of the third dimension on a two-dimensional surface. As I said in my diatribe against the sanctity of the picture plane, I think that illusion is magical and artists should use any tools necessary to achieve that sense of magic.

As you say, I paint mostly at night, so I use mostly artificial light. I like to have control of my light because I'm using the light to define the form so clearly that the introduction of natural light would really be disruptive. That is why I set up the still life way over in that corner, because any sunlight that comes in comes through these windows only in the morning and shines only about halfway across the floor.

Yes. You've laid out the studio almost backwards to the typical use. The north wall is a solid wall with no windows. Your large window faces east. But it's primarily for the view, right?

Yes. It's also because of the fact that I'm not an early morning painter, so the sunlight is gone by the time I get to work.

You have never done watercolor.

No. The world's best watercolorist (Sondra) is married to the world's worst watercolorist (me). I have tried to do watercolors, but they require a kind of preplanning of which I am incapable. That is to say, I am not very good at visualizing things in advance. I am more

a person who responds to something in front of me. I've always been a reactive person, responding to situations. Maybe it's because I had gone to eighteen different schools and lived in thirty-three different houses by the time I left college. I was constantly thrown into new environments, and I learned very early that to develop preconceived notions about situations was very likely to lead to great disappointment. I tried to have an open mind and deal with things as they came at me. In an interview recently I was asked to choose a symbol for myself, and I chose chameleon. Watercolor, I think, requires the ability to be able to visualize very clearly, with some kind of confidence beforehand. I like to work with oil because I can make changes all the way through, I can make mistake after mistake, and rectify the mistakes as I go along.

And you did gouaches, but with them you could make that kind of change.

You mentioned the time when you were doing the table paintings with Hatke. They were very, very abstract and very schematic. That was the only time in your career, I think, when you really went off on a tangent.

Yes. I was trying to explore a subject as fully as it was possible to explore. I think there was a last gasp of modernism exhausting itself in me. But I wanted to carry something to an extreme, so I did.

Bringing up Walt reminded me that one thing I want to say is that I am proud of the relationships that I have had and the part I have played in the development of younger painters. I like to think that the younger painters who come along and look at my work might go at making art with hopes and ambitions that are as large as mine, but with talent and training that are larger. One of the disappointments, to me, about what is happening in Realism right now is that many younger painters seem to be developing their talent and style but don't seem to be engaging or generating big pictorial ambitions. Those younger painters who have worked with me, by God, they have pictorial ambitions, and they know the joy of composing pictures. They know how exciting it can be to make a big, grand, glorious composition that is like a Verdi opera or a Haydn symphony. I pin my hopes on them.

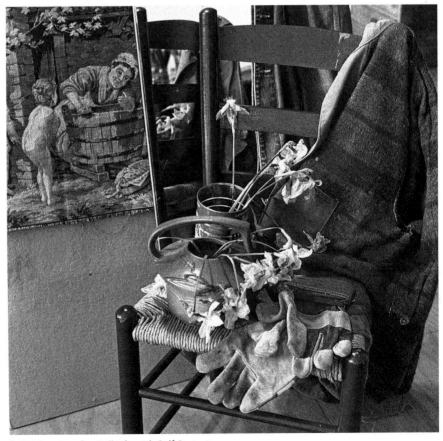

Still life setup for *Still Life with Self-Portrait.*

WILLIAM BECKMAN

Through his stark, frontal portraits and nudes of his wife, Diana, his self-portraits and agrarian landscapes, William Beckman has pushed the employment of direct observation to obsessive extremes. These protean, unsentimental portraits and figures, widely noted for their remarkable clarity and lucidity, are the result of Beckman's technical facility and draftsmanship, coupled with his ability to sustain the intensity of his vision for the prolonged durations required to develop each painting.

Since his move to Dutchess County in New York state, William Beckman has also increased his involvement with the subject of the rural landscape. This work, which has consisted almost entirely of large pastels, depicts the quietude of the landscape contrasted against brooding, often turbulent skies.

His large, light-filled studio has been connected to an earlier studio, which adjoins the back side of their two-story farmhouse. It is immediately clear that all activity evolves around the studio.

"I wanted to be near working farms, farms where the machinery was still operative and where cattle grazed, like the farms in Minnesota. I like farmers. I speak their language."

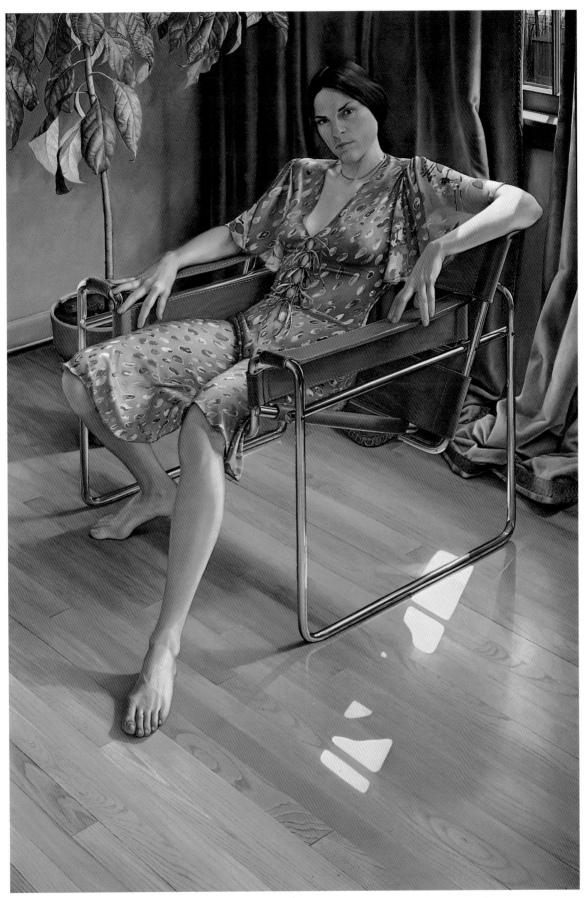

Diana III (1976), 51" × 74" (130 × 188 cm), oil on panel. Courtesy Allan Stone Gallery, New York.

You grew up on a farm in Minnesota and had no exposure to art, Bill. Isn't that correct?

I went to a country school where there were only thirteen kids in my class. There were about 250 people in my home town. Almost every kid in the class was from a farm, and to my knowledge no one in the town had gone to college until my older brother. He got a scholarship and went to South Dakota State University in Brookings.

What does he do now?

He is an engineer in Minneapolis and doing very well.

My parents hoped I would take over the farm, but I didn't like farming. Since my parents were helping my brother, when I got out of high school it just wasn't possible for me to go to college.

You didn't do any drawings or anything at that time?

None. The school library was very small and there was no material on art. I had never seen a painting, nor did I know that art museums existed.

I did little clay figures, copied comic book covers, and I did drawings when I was in church. My parents would give me paper to keep me quiet and I would do drawings on tiny pieces of paper. It was just to amuse myself and I never thought anything about it.

Then your first real encounter with drawing was when you did blueprints in Minneapolis?

I was seventeen when I graduated, and I hitchhiked through the West, taking odd jobs. I worked as a wrangler on a ranch right outside Yellowstone Park. We raised horses, so I knew how to ride. After that summer I moved to Minneapolis. I went to Control Data and took an aptitude test. They would give you a weird shape and you would have four choices of what it would look like put together or taken apart and laid out flat. I had a very high score on the test, so they sent me to a trade school for six weeks and I learned to be a draftsman. I worked at Control Data for a year and a half.

Did it interest you?

I needed a job and I was good at it. We could work any number of hours, but we usually worked ten hours a day. There was no time clock. I was making a lot of

money, but I hated it. I did make enough in that year and a half to put myself through a year of college taking night classes at the University of Minnesota.

And you studied philosophy?

I studied philosophy and anthropology.

I was living across the street from the Minneapolis Art Institute at the time. There was a park between my apartment and the institute. One day a girlfriend and I were sitting on a park bench in front of the museum and she said, "Why don't we go in?" I said, "Fine, let's go!" and we went in and it turned me upside down. I loved it. I just couldn't believe there were paintings like that around.

I immediately began taking art courses, but I couldn't afford the University of Minnesota, so I went up to St. Cloud.

"My first two shows in New York were boxes, but they gave me trouble because people were responding to the construction of the box and not the painting in the box."

How old were you then?
Nineteen.

When you went to St. Cloud, were you interested in doing figurative art?

No. I was just interested in art. But the institute didn't have a lot of abstract paintings. Most of them were representational, so I hadn't seen much abstract painting.

If you're talking about the early sixties, which was when I was in school, it wasn't a particularly good time to be in art school with an interest in figurative art.

No, but when I started I still had a strong interest in philosophy, so I was studying for a double major. But you are right, most of the instructors were abstractionists, and so that's what I was doing.

Those early paintings that I saw had a West Coast look.

Yes. The Walker Art Institute had a large Bay Area exhibit, and that show

directed me toward figurative painting. I painted that way for four or five years. At the time I was still toying with the idea of writing or doing something in philosophy, but that show really convinced me to go into art. That is also when I met David McGovern. He had a very strong influence on me, as a fellow art student and someone who was interested not in teaching but in being an artist.

Did you major in printmaking?

They didn't differentiate. It was a comprehensive degree, but most of what I did was printmaking because the printmaking instructor was better than anyone else.

Then you went to Iowa, which is best known for printmaking, and you did a lot of printmaking in college, but you have done no prints since then.

No. I don't like prints. I think that making prints hurts a painter. It takes too much time away from painting. I think most painters who make prints are just mass producing their work rather than exploring the medium of printmaking. Why not use the time to do a painting? I'm not sure I'll always feel that way, but I have until now. If I ever do prints, they will probably be drypoints.

Have you seen William Bailey's drypoints?

Yes. That's about what I would do—something on that order.

Printmaking is a great discipline. It requires a lot of control to do prints with any kind of finesse. Those aspects are strong factors in your work.

Right.

Finesse and technical control are very characteristic of your paintings, pastels, and drawings. When did that begin to develop in your work?

When I started painting, no one appreciated that kind of control. The University of Iowa was the first place where anyone responded to that aspect of my work. I suppose once people started reacting positively to it, I felt more confident about doing it. Before then, everyone was encouraging me to remain loose. Also, as I said before, I was very impressed by Park, Diebenkorn, and the Bay Area painters. I still like thick paintings. Something in me goes

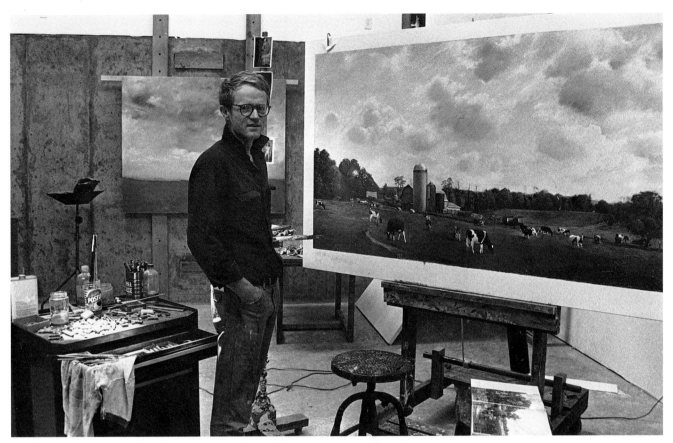

out to that kind of work. I suppose it's the expressive quality. I tend to control my work so much, but I have another side of me that wants to paint loose. I worked that way as an undergraduate, and someday I might even go back to that kind of painting. But the Germanic quality, the very precise side of me, wants to control everything. I'm extremely competitive and I always have the feeling that I could be painting better. That has hurt me because it slows me down. Each painting takes longer and longer because I want to make it better than the painting before. In a sense I'm competing with my own work.

That precision started in the drawings, somewhere around 1965 or '66. I wanted to control my work more and more but I wasn't good enough to do it with paint. It took a very long time to achieve it in my painting. About 1969 I did that little self-portrait with the hat. That's when I was first able to achieve some control in painting.

Did you study with Burford?

Byron Burford, Hans Brader, and Miguel Condi were my main instructors at Iowa. Condi isn't that well known, but he had a couple of shows in New York a few years back. He is a good draftsman, very Spanish. He has a real flair for line.

Two important factors are that you met Diana at Iowa and you began to do the boxes there.

Yes, the trompe l'oeil boxes. I found the boxes at the dump.

Did you immediately have the idea of building illusionistic constructions in them or were they just nice boxes?

I have an obsession with dragging stuff home. My whole garage is full of stuff, like that thing over there in the corner, which I also found in a dump. I just took the boxes home and they laid around for about six months, until I got the idea to put drawings in them.

The first ones had drawings inside, and then paintings with mirrors. The boxes became very complicated—very ambiguous little interior spaces.

Right.

You weren't familiar with the Dutch boxes at the time?

No, I had never seen them. In fact, I saw the first one three years ago in Detroit.

Did the boxes just evolve into paintings?

I think the first one was in 1967 and the last one in '71. My first two shows in New York were boxes, but they gave me trouble because people were responding to the construction of the box and not the painting in the box. I wanted people to react to the figures I was painting, but the only comments I ever received were about how interesting the perspectives and the illusionistic aspects were. I felt I was losing touch with my reasons for being a painter. I simply stopped doing the boxes and started doing triptychs and diptychs. I was still using the same format, only they were flat. There are three paintings like that, and they were done in 1970 and 1971. In 1971–72 I did my first large figure. I had been doing the little portraits all along, and a few small landscapes in Minnesota.

Did you and Diana start running in Iowa?

No, we bicycled in Iowa. Now we run about seventy miles a week.

You run in the Boston and New York marathons.

Yes.

Running is a matter of testing one against one's self, pushing, extending—a matter of stamina and endurance.

And will.

An act of will.

And putting in the hours.

Yes. Those are the same traits that are behind your pastels and paintings.

And time. When I start a picture, I'm going to stay with it for a year, and if I give it up (which is rare), I may have wasted six or eight months. It's an incredible commitment and it requires almost the same amount of will as running in a marathon. You are competing with yourself, as I said before, and that is what one does in running. Of course, in a race you are competing with other people, but basically you are competing with yourself against time. You want to do better than your last time out, and your time in each race determines whether you achieve that goal.

You didn't want to go into teaching when you finished graduate school?

Never. I had seen too many instructors in schools in the Midwest who had grown bitter because they had never done what they thought they should have done. They all wished they had gone to New York and at least made a stab at it. They all felt that they had been cheated. The older they got, the more angry they became with themselves and they became less effective as teachers.

I know that I would have gotten bitter if I hadn't gone to New York and made an attempt. I was in a show at the Richard Feigen Gallery in Chicago. It was called *Seven Students from Iowa.* On the night of the opening, Diana found out that she was pregnant. It was a real downer, because I only had about six months left of school and we wanted to go to New York. I started thinking, "Can we go to New York with a little baby and pull it off?" Everyone kept telling me that I couldn't—that I shouldn't do it— that it was stupid and the kid would suffer as a result. But I had my heart set on it and then three of those boxes sold out of the show. That made me feel that I had to go to New York for a while.

So in 1969 you answered an ad for a loft.

Yes. We got to New York February sixth of 1969 in a snowstorm and took a

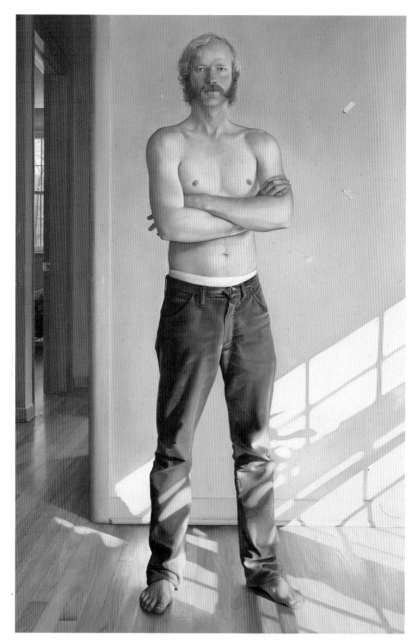

(Page 28, top) *Self-Portrait* (1974), 48″ × 72″ (122 × 183 cm), oil and tempera on wood panel. Courtesy Edmund Pillsbury Family Collection, Fort Worth.

(Page 28, bottom left) *Self Portrait* (1969), 8″ × 10″ (20 × 25 cm), oil on panel. Courtesy Allan Stone Gallery, New York.

(Page 28, bottom right) *Lower East Side* (1971), 10½″ × 12″ × 16″ (27 × 30 × 41 cm), egg-oil on panel. Courtesy Allan Stone Gallery, New York.

(Page 29, top) *The Baldwin Farm* (1982), 74½″ × 40⅜″ (189 × 103 cm), pastel on paper. Courtesy Allan Frumkin Gallery, New York.

(Page 29, bottom) *Maynard Minnesota, Hartney's Farm* (1982), 56″ × 29½″ (142 × 75 cm), pastel on paper. Collection Art Institute of Chicago.

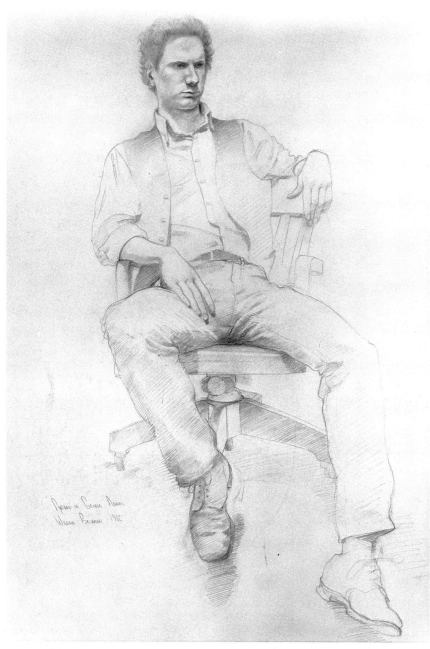

Portrait of George Adams (1982), 23″ × 29″ (58 × 74 cm), pencil on paper. Courtesy Allan Frumkin Gallery, New York.

They invited me in and we talked, and then we agreed on the terms and I took the loft. Also, that is where the Figurative Alliance used to meet. Which was one of the reasons I came to New York, to find painters who painted the figure and got involved in things like the alliance.

You became acquainted with the alliance through Alfred. Even though your paintings are quite different, there is a strong similarity in the compositions, as in the self-portrait that you are working on and the nude of Diana, at least in the frontality. Was Alfred an early influence?

It's hard to put it in those terms, but I think some of the things I'm trying to do in this painting are similar to what he's doing. I think we both want to express the strength of the individual, the closeness of the family and its importance. That's why I've painted only Diana, Deidra, or myself. I think Alfred shares the same sort of feelings. That side of him has been an influence. It's in his paintings and I responded to it, even in his early black-and-white portraits.

But there is very much more. I think the Birthday for Ethel Moore *is one of the great paintings of our time, but it is about the importance of a minor moment. Some have criticized Alfred for the drama that he puts into his paintings, but . . .*

He uses unusual lighting.

It is a very old way of emphasizing the subject.

Where we differ is in the way we paint—our approach is about as different as night and day—but in a sense he has influenced me.

Do you remember any of the paintings you saw on that first museum visit when you were nineteen?

A Rembrandt, a Courbet, and a neat little Corot. Actually, the names of painters didn't mean much to me at that time. I had no art history background, so I didn't know how important they were. A Titian didn't mean any more to me than a Bouguereau. I made no evaluations.

Looking at the individual portraits, I felt as if I were communicating directly with the painters, and the subjects communicated with me directly. I'm still sort of hesitant in my response to mythological, historical, and genre paintings, because there's too much interacting

place on First Street on the Lower East Side. It was a walk-down with nothing in it. No heat, no glass in the windows, just a sink with cold water. It took a week to get it so that we could live there and provide for our week-old baby. A popcorn popper was the only source of heat for cooking that we had. The first month we ate all our food out of that popcorn popper. We had no bathtub, so we took sponge baths. I grew up without indoor plumbing as a young child, and we used to take sponge baths on Saturday nights. We stood in a pan and washed ourselves with a rag.

But it was a bit of a shock for Diana. She wasn't used to that sort of thing. And it was a dangerous neighborhood. But then I answered that ad in the *Village Voice,* and who should open the door but Constance West.

You knew immediately who she was.

I had seen her in paintings, and I just stood there with my mouth open in disbelief. Then I said something like "Are you really Constance West?" and she said yes and then I saw Alfred Leslie. He was working on that big painting of Constance in the satin dress.

within the picture. I feel like an outsider looking through the keyhole. I don't like that aspect of painting, and that's one reason why I responded to Leslie so much, and Nathan Oliveira, because Oliveira almost always did single figures. And Richard Diebenkorn. He did single figures too, and, maybe it's my personality, but I don't like groups. I like individuals and I feel I can communicate better one to one.

What about the landscapes?

I'd always thought of myself as a figure painter; that's where I spent most of my time until now. My landscapes were done only in the summers, which we spent in Minnesota during the time we lived in Manhattan. I would do three or four small landscapes right on the farm, trying to get what was directly in front of me, just painting what I saw as honestly as I could. Personally, I have nothing against painters in Manhattan who do landscapes, but I think it's stupid. How can you do a landscape in the middle of the city? I know a painter who has a place in the country and does a lot of little studies up there, but he paints in Manhattan. I don't understand how you can be responding to the landscape when you are living in New York.

What precipitated the move from Manhattan to the country?

Well, the main reason was because we couldn't afford the loft on East Broadway. The rent went up too high. We had to move to Brooklyn in 1972. We had a five-room apartment there. That was about when I stopped doing the boxes and started doing the triptychs. Then I painted the big nude of Diana, which took about a year. That painting sold for enough money to give us an option of either buying a loft in Manhattan or moving out to the country. Deidra was five years old and starting school the next year. Plus, I had enjoyed doing those landscapes in Minnesota and I really wanted to do more. I didn't want to go more than a hundred miles outside Manhattan, so we started on the Jersey shore, just driving around and looking for a place where I would feel comfortable working from the landscape. We didn't really find anything until we got to the east side of Dutchess County, near the Connecticut border. The area was all working farms. I wanted to be near working farms, farms where the ma-

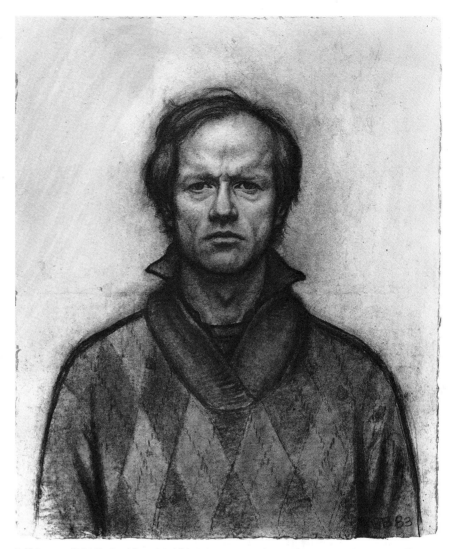

Self-Portrait (1983), 24½″ × 29½″ (62 × 75 cm), charcoal on paper. Courtesy Allan Frumkin Gallery, New York.

chinery was still operative and where cattle grazed, like the farms in Minnesota. I like farmers. I speak their language. They always come out to see what I am doing.

When I start painting a farm, it's like the first time they've really looked at it. They have probably been there for decades but have never actually looked at it. They often will say, "You're not going to put that old car in there? I dragged that out here twenty years ago." It's really funny. When I did the Van Lea place, he tore the siding off the barn—the side I was working on—and put new siding up and repainted it, but I'd already finished.

The first house we bought was a tenant house right next to a farm. You could throw a rock into their cow yard from our place. We moved out because I was doing rather large landscapes and,

with the narrow stairs, it was hard to get the paintings out of the house. So we sold the place and got this one. It was in bad shape, so it had been on the market for two years. We fixed it up and added the studios.

The last large painting was the standing nude, Diana IV.

Originally it had all kinds of stuff in it— the heater on the floor, a window in the background, and a wooden stool. Eventually all of them were taken out. They were all just extras that detracted from the figure. The figure was too strong; I just kept pulling the other things out, one at a time.

There are drawings from standard sheet size all the way to life-size drawings for that painting.

There are four drawings, twenty-three

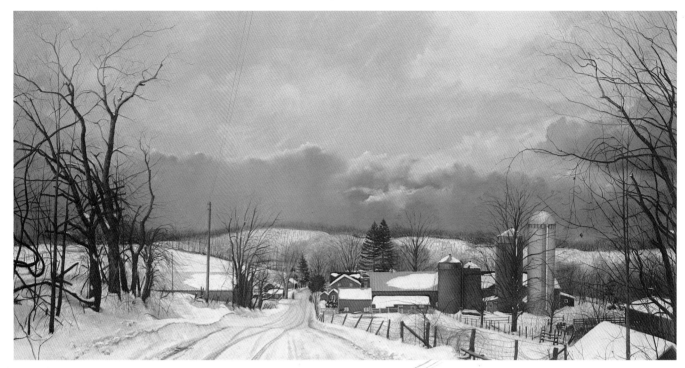

Hillaire Farm (1982), 54½″ × 28″ (138 × 71 cm), pastel on paper. Courtesy Allan Frumkin Gallery, New York.

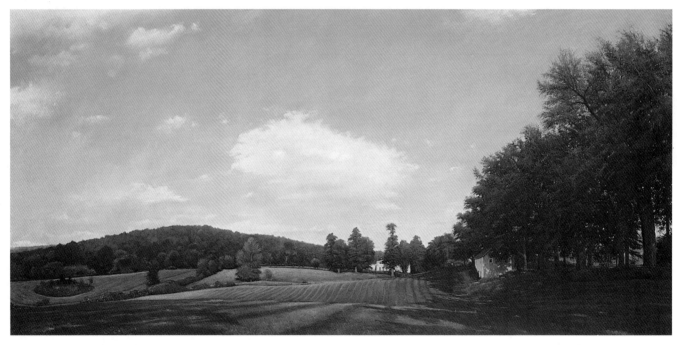

Kaye's Farm, Late Summer (1982), 54″ × 25½″ (137 × 65 cm), pastel on paper. Courtesy Allan Frumkin Gallery, New York.

Study for Hillaire Farm (1982), 29″ × 23″ (74 × 58 cm), pencil on paper. Courtesy Allan Frumkin Gallery, New York.

Study for Kaye's Farm, Late Summer (1982), 29″ × 21½″ (74 × 55 cm), pencil on paper. Courtesy Allan Frumkin Gallery, New York.

by twenty-nine inches, and the big one.

In all of them, there are very slight changes, such as moving the leg. In one of them, Diana is wearing glasses.

Also, the perspective kept changing. I kept lowering the focal point, from her head, to her breasts, to her navel.

Are there always that many drawings for a painting?

Yes.

What about the self-portraits?

That is one of them, there. It's the drawing that is closest to the painting. I generally do from four to ten drawings.

And the last drawing is usually gridded?

A lot of them are gridded. The grid is a visual reference point for me. I have never transferred the drawing to the canvas by using a grid. I grid the canvas so that I can take a quick glance at the gridded drawing and know exactly where an arm should be in a square. I redraw directly from the model, so in a sense it's like having two models at the same time, the old drawing and the real subject. Whenever I am working on a painting, I always work straight from the model. The drawing I use only as a reminder. I do the whole series of drawings in succession, mostly as a memory device. The longer I work from the same pose, or a similar pose, the more my memory will keep all the variations and reference points. By the time I get to the painting, I've already done the figure four or five times, so I've already established a strong idea about how to carry through. It's not that I don't use the model after that. As I said before, she's there all the time I'm painting.

If I did a painting of you right now, the third or fourth drawing would probably be stronger than the first because I would get to know your face better each time I did it.

You paint on wood panels.

Yes. Most of my paintings are on Brunzeel panels, which are made in Holland specifically for saltwater boats. The problem with American plywood is what they do with the core; it usually is pulpwood and full of gaps and holes. The Brunzeel panels are continuous sheets of hardwood alternating in direction.

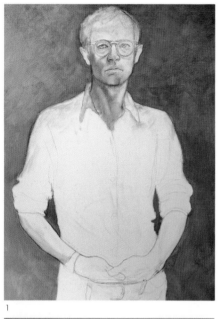

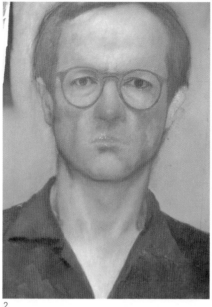

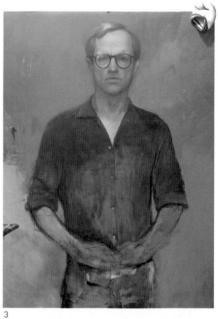

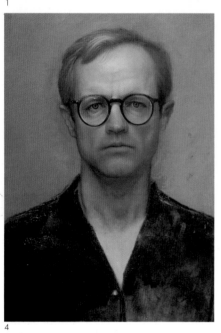

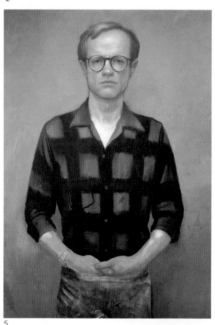

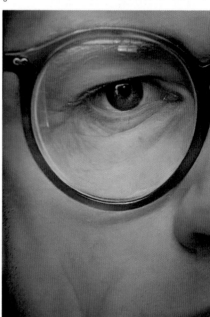

1. Pencil and charcoal drawing with turpentine wash on part of the shirt and arm. The background is an earth-toned wash.

2. The self-portrait is built up with thin layers of paint. Each layer is sanded down with a fine sandpaper.

3. At this point, the area within the eyeglasses is brought up close to completion. The position of the hands is still unresolved.

4. The eyes and other features are finished further, and a layer of gray-green has been brought into the background.

5. The drawing of the hands is firmed up, the pattern of the shirt blocked in, and the face is finished further.

6. Detail of the eye shows the amount of information and finish in Beckman's paintings.

7. Detail shows the hands, shirt, and belt in the finished painting. Rendering the hands is a particularly difficult aspect of working from direct observation.

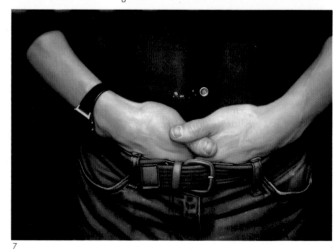

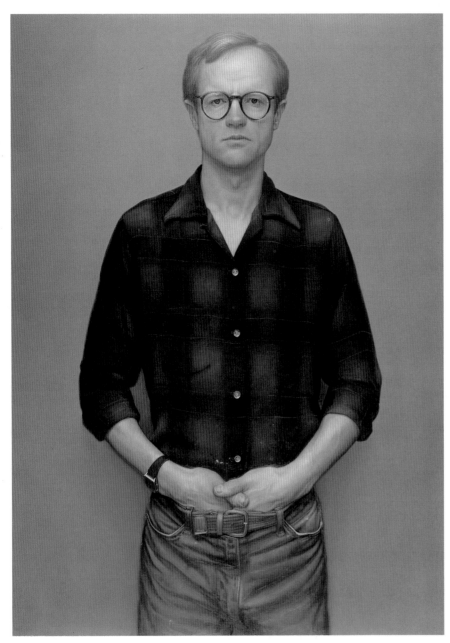

Self-Portrait (1982), 36½″ × 50″ (93 × 127 cm), oil on panel. Courtesy Allan Frumkin Gallery, New York.

How do you cradle the panels?

The oak cradling goes all around the edge, and the panel is dadoed into it. Oak straps are glued directly to the back of the panel, and then the cradle is screwed to that. There are no screws into the painted panel. It floats inside the dado and is held in by pressure so it can contract and expand.

And what are you sizing the panel with?

I've tried just about everything, from rabbitskin glue with lead to hand-mixed gessos. Since I work on wood, I have found that Liquitex gesso is the easiest

to paint on because it's not as absorbent and it doesn't seem to have any adverse effects on the oil. On canvas Liquitex gesso is notorious for cracking.

Yes, it's very brittle.

I put about fifteen coats of gesso on. Five would be sufficient as a ground, but I have to apply between ten and fifteen coats to get the texture this smooth. And if you don't gesso the back, it warps. For every coat on the front, there has to be a coat on the back to equalize the tension. The hand-mixed gessos absorb incredibly, so I use a thin

coat of retouch varnish to seal the surface so the oil doesn't soak in.

Do you begin the drawing by putting the grid on?

Yes, on the panel.

But then you go back to the model to do the drawing?

In the past, I have placed the model behind a stringed grid.

I was in your studio once, when you had a string grid for a self-portrait.

The main purpose of the string grid is to keep the models in the same position. That way I can take one quick look and know if they're still in line with the string. If not, I can move them back—just like that.

You use primarily natural light?

Both. I have skylights and spots. I prefer to work in daylight, but I use spots because few museums or private collections make use of natural light today. Ultimately it is the warm artificial light of a spot that your painting will have to work in.

With what do you draw the figure on the canvas?

Pencil or charcoal usually.

Do you separate the drawing?

Once the drawing is laid in, and some of them are quite elaborate, very detailed, I wash them with turpentine. The turpentine blends with the charcoal or pencil and actually creates a tone. A lot of the drawing gets washed away. It comes off on the brushes. Pencil, charcoal, and turp are worked together. Then I start adding a few earth tones, like the burnt umbers, and end up with a warm tone. It's sort of like a wash drawing. From that point on, instead of line, I'm working with modeling and shadows.

But you are working very broadly at that point.

Very. The drawing is very coarse. This wash takes about a month.

And it is transparent.

Yes. I use a rag as much as I use a brush. I lay the tone on and pull it back off with a rag. I'm really scrubbing in the tones.

We were talking earlier about how much

moving around you've done on this self-portrait—lengthening and shortening the torso, repositioning the hands, and so forth. But once you have all that established, what procedure do you use for the finish, such as the eye in this painting? How do you work toward the detail?

It's funny. After about two months of working on a painting, I feel that I have to get some part brought up almost to full realization. I do it, more than anything else, to maintain my excitement. I have to see something that's near the end because I know it's probably going to be another ten months before I'm finished. I just want to be able to see what one area looks like—really controlled and developed. I did that in this pastel, the top of that silo. Then the rest of the painting sort of evolves around that part. Nine times out of ten that part will have to be reworked once I get another area that's more developed, but I always have areas I'm comparing to another part of the picture. It'll keep coming up until the whole picture is realized.

Can you describe the alternating layers of transparent and opaque paint?

Practically every morning I get up and start over again. I take a very fine sandpaper and sand the area I've just worked on, unless I'm totally satisfied with it. There are two reasons. I started doing it because I knew that by using thin layers of paint, layer after layer, I was going to have an oil deposit on the top. The pigment in oil paint settles and the oil comes to the surface. Some colors dry quicker than others, so putting on layer after layer invites cracking. To avoid this, I get rid of the oil film on top. By sanding lightly, I take off the oil film and get down to the hard pigment underneath. I put each layer of paint on top of the other.

Is your vehicle primarily linseed oil?

The only linseed oil I use is what's in the tube of paint. The only medium I use is turpentine, and I use very little. The only time I use additional oils is very near completion. After around thirty coats, the painting is often so dry that new paint won't adhere too well. So I put a little oil into the paint to keep its film strength. Also, I deliberately sand with the form of the figure; fine lines are left by the sandpaper, and when I paint over them, some of those lines stay.

They end up being almost like the very fine cracks in skin. As I develop the painting month after month, I have these very delicate lines that follow the nose, mouth, et cetera.

What is the difference between the transparent and the opaque layers? Are you glazing?

No, not really. All of the whites and most of the yellows are very opaque, and most of the greens and blues are transparent. That's really in the color more than anything. If I lay in a shadow, it's basically a transparent color that's going down. If I'm laying in a yellow highlight, it's going to be opaque. And if you're laying these layers the way I do,

obviously each layer has a slight amount of opaque color and a certain amount of transparent color. If I want to show veins or something that actually is below the surface of the skin, I don't want to paint a blue line across the top, so I have to lay the blue lines underneath, then come over them with the very thin oranges and flesh colors. That way I get the opaque and transparent quality of the skin and the veins. They end up looking—and physically being—below the surface of the paint, just like skin.

You use a very restricted palette, don't you?

Yes, I do. Ultramarine blue is probably ninety percent of all the blue in my painting. I find that pigment works best for the flesh tones I use, and for the skies. The two greens I use are a permanent green deep and viridian. Then I use about four different oranges, all different brands—Grumbacher orange, Utrecht orange, Blockx orange, and a Winsor & Newton orange. One of them is very cool, one's warm, and the Blockx and Winsor & Newton tend to work better for flesh tones. They're very important for getting subtle changes in the flesh tones. I use a lot of

Naples yellow mixed with a lot of white—flake white and titanium almost exclusively. I use mostly raw umber, very little burnt umber, and some burnt sienna. There are two violets I use a good deal of, too—Blockx light red and Winsor & Newton's cadmium red purple—and Mars black for black. That takes care of my palette.

What kind of work schedule are you keeping? For a large painting we're talking about a year's work, but are you working every day?

I try to get in fifty hours a week, and I always think in terms of a week because I often miss a whole day. Weekends and weekdays really mean very little to me. I often work on Saturday or Sunday unless we have company or go somewhere on the weekend. I prefer to work in the morning. Those are my best hours, and the earlier the better. As soon as it's light, I go to work, and I try to work until noon, when I take an hour break for lunch. Then I work until four. It varies with the season. In the winter I work until about four, or until the sun goes down. In the summer I'll often go to seven or seven-thirty. That's when we go out for a run, to release some of the tension that's built up.

How many self-portraits have you done?
Nine.

Because of the way the paintings are pushed—the amount of information and the precision of the images—it's easy to assume that they are extremely accurate physical descriptions. In fact, every self-portrait looks like a different person. How do you account for that?

I really don't know. Each time I attempt to paint exactly what I see. Obviously, one changes over the years. The nine self-portraits were done over ten years. Of course, I am getting older, and I find that very intriguing. In fact, part of my thesis is to record myself and my wife as we age. But the reason they look different, I really don't have an answer. It certainly isn't intentional. I believe it's more of a by-product of how the painting grows. They each develop differently.

Other artists have spent a great deal of their lives doing portraits and self-portraits. Rembrandt and van Gogh did whole series of self-portraits, and both seemed to have had the same problem.

I doubt if they worried about it, and I certainly have never considered it a problem.

Also, the artist sees himself in reverse, which accounts for a great deal of distortion, because all of our faces are asymmetrical. I find that aspect quite intriguing.

Most of your landscapes are pastel. You're changing from a wet to a dry medium, but you're pushing pastel to the same extremes as your oil paintings.

I'm trying to, at least.

There are several major differences. First, the figures are always motionless, like sculpture. Except for the little marathon painting, which is the only one that depicts movement, the figures are frontal and static. But the landscapes depict a transitory movement in terms of the passing light and weather. Also, the large pastels aren't done directly from the subject. They are worked up from drawings and from memory.

Yes and no. I end up on the site so much that I am practically on site. I go there four or five times a day if I really run into trouble. If not, I'll get there once a day. All the landscapes I've ever done, I run by. Since I run every day, I'm running by the site twice a day. Secondly, nature is transitional. I am intrigued with how much variation there is in the sky. Also, the farmer's life is dependent on the weather. It either makes or breaks him, every year.

Since we saw the big Ruisdael exhibit at the Fogg Art Museum last year, there has been a noticeable shift in your pastel landscapes. There's much more drama and emotion in them.

I agree. I had never seen that many Ruisdaels in one place and probably never will again, since it was the first large exhibit in a couple of hundred years. It's hard to describe, but his ability to understand the drama of the weather and the importance of its effect on the land had an incredible impact on me. Ruisdael was able to orchestrate his skies in a way—and sometimes this is very abstract—that gives a sense of looking at the sky all the way down to the land, and you can feel the emotion rising from it. The landscape is usually very tranquil, very still. The sun seems to be gently caressing the earth, but if you slide up to the sky, there's all that

turmoil, all that activity up at the top. Yes, I find the drama very provoking.

The large pastel that you're doing is on two sheets of museum board glued to a panel. You're working it up in layers, the same way you do the oils.

More so than I have in the past.

But with this one you're mixing oil with the pastel.

Right. This is the first time I've tried it. I've used wash in the past, but this is my first attempt to put oil with the pastel. In some ways it is an experiment, but I find that I can mix the two media quite well and get an effect which is sort of new. The effect is of light skimming over the surface in the rough areas.

I think of your figure paintings in terms of the Ingres and Holbein, and the landscapes seem to loop back to the Dutch and to Constable.

And Constable loops back to the Dutch also. He is one of the few exceptions who really seemed to paint what he

saw. Even Ruisdael took those little mole hills and made mountains out of them—took the castles and put them up on cliffs when, in fact, they were on small, rolling hills. I don't believe that's true of Constable. I have gone to some of the spots he painted and they're not that much different from what he actually saw.

Like the Dutch, farmers are preoccupied with the weather. You mentioned earlier that your landscapes are never pure landscapes, they are farms.

There is always a sign of humanity in them. People or traces of people. That's critical, because I feel the unity between man and the land is one of the most meaningful things to portray in a landscape. I can't imagine myself going out and doing a virgin landscape. What has changed man's destiny the most? I think it's his ability to master the land and live off it, his agricultural capabilities. If he had not become an agrarian, I do not believe he would have survived. That comes all the way down to our farmers today.

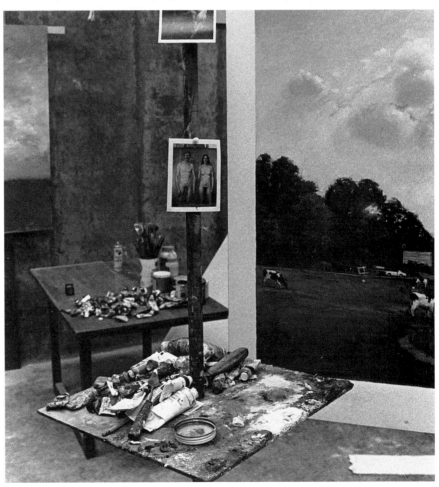

CHUCK CLOSE

The gigantic cerebral reconstructions of deadpan portrait photographs have simultaneously placed Chuck Close in the forefront of Photorealism and given him high consideration as a "process" or "conceptual" artist.

His earliest photo-derived works evolved from an attempt to shake the traces of gestural painting and the subjective use of color. Close has never strayed from that most familiar visual encounter, the human countenance, as a subject and has done endless variations on many of the photographs.

In addition to the paintings, watercolors, and pastels, Close has explored etching, lithography, and paper prints, always with surprising procedural twists.

His work with toned paper pulp has led to the incorporation of collage in a new series of grisaille portraits, which were in progress when this interview took place. Two long work tables extended from both sides of the large canvas and were lined with chips of warm- and cool-toned paper, sorted by value into numerous trays.

"I wanted to rip the images loose from the context in which we normally view an image of a person. There is a tradition of emphasizing those key areas of the face which control likeness, while the skin, neck, hair, and background are not normally considered to be of primary importance in the reading of a portrait."

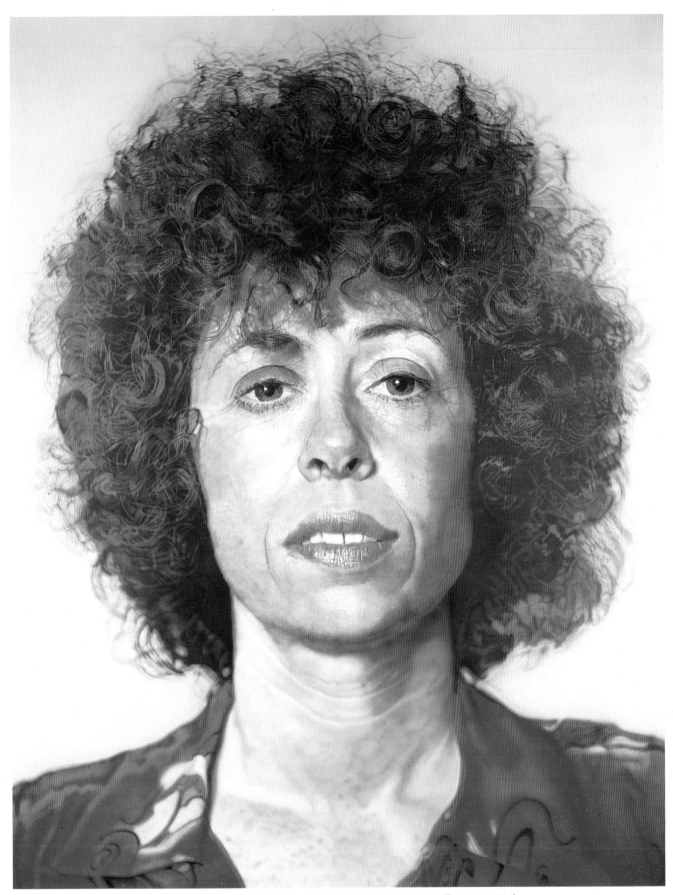

Linda (1975-76), 84" × 108" (213 × 274 cm), acrylic on canvas. Courtesy The Pace Gallery, New York.

Chuck, you grew up in Everett, Washington, which is certainly not a metropolitan area. How did you get involved in the visual arts?

Well, you are looking at the product of single-mindedness. I have known since I was four that I wanted to be an artist, and there is a tremendous advantage to being single-minded. In my case, it appears I had some learning difficulties, so it wasn't possible for me to do other things, which helped cement my resolve that art was the way to go. Art got me through school. I demonstrated to my history teacher that I was not a goof-off by making a forty-foot-long mural of the Lewis and Clark Trail, for example, which indicated my interest in the course, even though I wasn't always able to do the course work. I've always used art. It was the area in which I felt unique, and it gave me a sense of being special. I starting taking private art lessons when I was seven or eight.

I would assume that the backbone of your education as an artist was at Yale.

Actually not. That's where something very special and wonderful happened, but I got through grade school, junior high, and high school depending on art. That was the area in which I really felt good about myself. I had been told that I would never be able to get into college, so I didn't take any college preparatory classes in high school. I thought I would be a commercial artist or something. I thought of art as going into a trade. So I couldn't go to University of Washington, but any taxpayer's child could go to Everett Junior College (it's now called Everett Community College), which happened to be a wonderful school with an incredible art department.

I went there for two years and did very well, graduating with honors. I did it by finding different ways to skin a cat. I graduated from the University of Washington summa cum laude and got all the scholarships, and I had learned that there are other ways of getting information besides reading. I still have a great deal of difficulty getting input from the printed word. There was an incredibly dedicated and interesting faculty at the University of Washington, as well as at Everett Junior College. It was very fortuitous for me, but I have always been in the right place at the right time. Luck is a very big aspect in anyone's career.

At the end of my junior year, I was a candidate to go to Yale Norfolk, the Yale summer school for music and art. I met interesting students from around the country, like Brice Marden and David Novros. Then I went back and completed my senior year at Washington in 1963. I didn't intend to go to graduate school, and I thought I couldn't be drafted because of my eyes, but it turned out that I could. So I quickly applied at Yale, a little late, but due to the fact that I knew some of the faculty from Norfolk, I got into graduate school, which was an incredible experience. But again I was in the right place at the right time.

> **"I decided to get some tools that I didn't have a history of using and try to do something in which I wouldn't bring the baggage of all my previous work."**

That was probably the most dense population of exceptional students that has even been in a university art department, as we all know today.

Well, we sure didn't know it then, and I don't think the faculty knew it either, to tell you the truth.

Which had the most impact, the kinship with the other students or the faculty, or was it a combination?

I would say that it was primarily the students, but the students wouldn't have gotten there if the faculty hadn't chosen them. I think Yale has a tremendous advantage over other art schools in that it doesn't have an undergraduate program feeding students directly into the graduate program. They recruit from around the country, so the Yale summer school is really out-of-town try-outs for the Yale graduate school. The students have a chance to work for a summer with the cream of the crop from thirty-five different schools, which ends up being part of the feeder system into Yale's graduate school. Coming from such diverse backgrounds, influences, and attitudes, in years when it works well, that mix is the most dynamic and exciting situation imaginable. But it wasn't that the faculty was of no influence. Yale just didn't have a particular look or style, like the Rhode Island School of Design or Pratt. I think we demanded more of each other than the faculty demanded of us. It was intensely competitive but also incredibly supportive. Also, there were a lot of visiting artists from New York.

Yes. Yale's proximity to New York was very important. As a graduate student, you were doing abstract painting, weren't you?

Yes. Only a few people at Yale weren't though. Janet Fish wasn't.

Janet evidently got turned around at Skowhegan.

Rackstraw Downes was painting like Al Held. Richard Serra was making paintings roughly related to Hans Hofmann. Steven Posen had studied at Washington University in St. Louis, so there was the influence of Max Beckmann, but his paintings were basically nonobjective. Brice Marden is the only artist who is still working in a way that's related to what he was doing then. I was working out of de Kooning's pink angels and Hofmann, Gorky, and all that. By and large, we were rather reactionary and suspicious of what was going on in New York, which was healthy. We weren't suspicious of the system. We didn't think it was corrupt or anything like that, but we weren't trying to make a mean average of the last five *Artforum* covers, which is what you often find in graduate schools, people drawing almost directly on what's current in New York.

When did you begin using images?

A bunch of us from Yale got Fulbrights at the same time, and Richard Serra also got a traveling grant. So we were in Europe together and returned to the United States about the same time. Some of the group went straight to New York, but I panicked. I felt the need for a job, so I taught at the University of Massachusetts for two years. That's when I started working from photographs. That was around 1965.

I think the earliest painting I've seen is that large monochromatic nude. Did you take the photograph from which it was done?

Yes.

Was it painted or done with an airbrush?

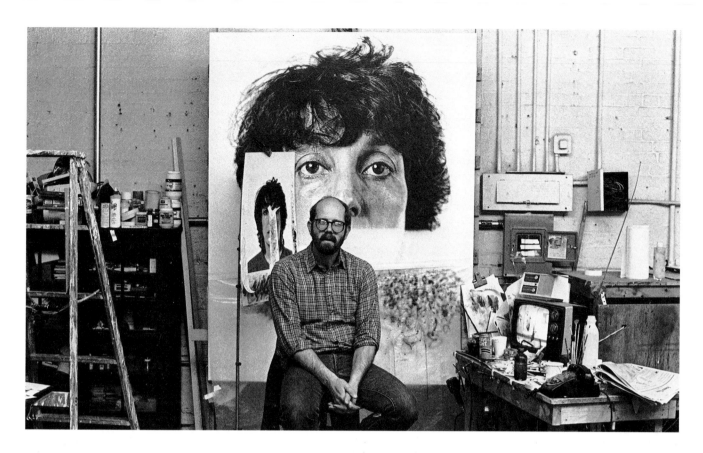

The second version was done with an airbrush. The first version, which I destroyed, was painted with regular brushes, but I couldn't get rid of all the old habits—the way I had always pushed the paint around—so I decided to get some tools that I didn't have a history of using and try to do something in which I wouldn't bring the baggage of all my previous work.

You've talked about getting rid of the "art mark," eliminating all gesture and personalization—what we would describe as signature painting. The airbrush, a mechanical tool, seems to have supplied a perfect means toward that end.

It's perfect, except that there's a look to airbrush, too, and I didn't want my work to look like airbrush paintings. Nothing gets made without the hand, so in a way it's not possible to make a gesture-free painting. The airbrush was more a way of getting rid of *my* "art marks" rather than getting rid of "art marks." No painting has ever been made without a process, a technique. I just made a choice about which ones I was going to use and which ones I couldn't afford to use anymore.

You mention the process. In Realist Drawings and Watercolors, *I described you as being like a topographer, a mapmaker, in that you're much more involved with the system and codification of information than in the actual image. But that issue is confusing, because all your images are of people you know very well. Only the look and the process are impersonal.*

Yes. I contributed to the misunderstanding of that aspect of my work in other interviews by focusing so much on how the images are made. There is a very basic reason why I did that. Given work of this nature, the only thing that is transmitted by the photographic reproduction is the iconography, and what is represented is self-evident. There doesn't seem to be much I need to say about that. So I talk about the choices, the limitations, all of those things, but I think I have contributed to the basic misunderstanding that my work is really about the process. That's not accurate, because the way you choose to make something influences the way it looks and therefore what it means. If you gave the same photograph to five different painters, they would build five totally different visual experiences. Yet, in reproduction, the paintings would prob-

ably all look identical, because of the same iconography.

One of the problems with criticism of work like mine and the painters with whom I'm often linked is that very few writers have discussed what it is like to stand in front of the paintings. I think the actual experience of an Estes street scene and of a painting by Cottingham is very different. Yet, reproduced on the same page, their work might look quite similar. So I have not focused much on the iconography, but these *are* images that matter a great deal to me. I would never spend a year to make one of them unless it was an image that was very important to me and, hopefully, to the viewer.

The reason I chose the human head was that it is something that everybody knows a lot about and cares about. If I painted a rock and made the texture too rough or the color too green, nobody but a geologist would know or care, but we all know faces, so if the texture of the skin is too rough or the color too green, the viewer instantly recognizes that something strange is going on.

I care a great deal about these images and the people who were kind enough to lend me their images. In contrast to the history of portrait painting, which is a

(Above) *Leslie/Unfinished* (1973), 22½″ × 30″ (57 × 76 cm), watercolor on paper. Collection Robert Feldman. Courtesy The Pace Gallery, New York.

Susan/Pastel (1977), 22″ × 30″ (56 × 76 cm), pastel on paper. Courtesy The Pace Gallery, New York.

(Right) *Small Kent* (1970), 21½″ × 24½″ (55 × 62 cm), colored pencil on paper. Collection Louis Meisel. Courtesy The Pace Gallery, New York.

tradition by and large of commissioned portraits, these people were really unselfish, not knowing what I was going to do or how many years I might keep dealing with their images. I mean, poor Phil Glass or Keith Hollingworth. They lent me their images in 1968 or 1969, and I'm still doing pieces based on them. So it's a long-term commitment. I really want to make it clear how important these images are to me. I would never work with someone else's photograph. I would never do a commissioned portrait. I would never alter an image to please a sitter. These are very personal experiences.

Another reason I have commented more on technique, process, and limitations is that just because I want something in the image doesn't mean I'm going to get it. The only way you can get it is by divorcing yourself somewhat from the image. You've got to sit down and figure out how to do it.

But they can best be described as portraits.

Sure.

In terms of expression they are very deadpan. In the earliest ones, such as your self-portrait with the cigarette or the one of Nancy Graves, the personality was much more disguised. The images were reminiscent of passport photographs or mug shots.

Well, I wanted that neutrality. It's curious that I personally consider myself a humanist. I care about people and I try to lead a moral life. I'm as concerned as the next person with man's inhumanity to man and hate what's going on in the world, but it seems to me that those pieces that are often described as humanist with a capital *H* deal only with extremes of emotion—Francis Bacon's screaming head of a cardinal or a pope, Leonard Baskin's blind, bloated, dead bodies. I don't think that this is the only way to comment on a human being.

People without extremes of expression still have tremendous indications embodied in their faces which tell us a lot about them, neutrally presented with no particular editorializing on my part. I'm not trying to get people to think anything in particular about the subject. I just want to present it flat-footedly, in a deadpan kind of way. Yet people who laugh all the time have laugh lines. If they frown a lot, they have

Stanley (1980), 42″ × 55″ (107 × 104 cm), acrylic on canvas. Courtesy The Pace Gallery, New York.

furrows in their brows, so I don't have to paint them laughing or frowning in order to get that. I want to present them without cranked-up or exaggerated emotion. And I don't want the viewer to walk away from the painting with only one experience. I think a variety of people looking at an image will often leave with totally different experiences because of that neutrality.

The first time I saw one of your large paintings I was reminded of Gulliver's Travels, *specifically Gulliver's descriptions of the huge hands and gigantic heads of the Brobdingnagians. Physical information magnified and closely observed can become repulsive.*

I think there's an aspect of that in my work.

In terms of the scale?

Yes. I wanted to rip the images loose from the context in which we normally view an image of a person. There is a tradition of emphasizing those key areas of the face which control likeness, while the skin, neck, hair, and background are not considered of primary importance in the reading of a portrait. I wanted to make those areas almost as interesting and important as the more symbolic areas of the face.

The focus in the paintings indicates that

Self-Portrait (1977), 41" × 54" (104 × 137 cm), hard ground etching and aquatint.
Photo courtesy Pace Editions, Inc., New York.

you used a studio camera. The focal plane is fairly shallow, so the noses go a bit out of focus, as do the ears.

Yes. I usually use a flat-plane lens that will make a sandwich of sharp information in the middle of the face around the cheeks, eyes, and mouth. Those areas which come out in front of the focal plane and blur, and the areas behind tend to go . . . actually, blur is not the right term. Blur depicts movement. There's another term for relative focus.

If I remember Gulliver in Brobdingnag, there was an instance of his not quite knowing where he was when he was crawling around on this thing, of having tremendous information about the pieces but not putting it together. He knew that he was crawling through

hairs on some part of the body, but didn't know if it was the arm or the leg. I think it's possible to almost get lost in my earlier paintings, get more information than you ever knew or needed to know about part of the face. And yet, because of the scale and the way we tend to scan one of those images rather than see it as a whole, we could receive all this information and still get lost in it.

In ways your paintings are the extreme opposite of Alex Katz's portraits, in that Alex is stripping the image to the essentials.

I remember making a note when I started these portraits that I wanted to do the opposite of what someone like Tom Wesselmann did. Wesselmann

would paint a whole area of the body absolutely flat pink and then, just by the placement of two nipples and a patch of pubic hair, warp that flat plane into mounds and depressions. It all happened from the placement of key symbolic areas. I don't want to make nipples or pubic hair more important and so have getting there be half the fun. If you read the critical reviews of Pop Art and don't see the pictures, you'd almost think they are about nonobjective paintings. There is almost no reference to the fact that they are representational paintings. They are very minimal and happened at the same time as minimal art.

I've always talked about limitations and about using the least amount of pigment necessary to fill the painting, and at times my work has been compared to Sol LeWitt's, as if I considered myself a minimal artist. It's true that I was very interested in the art of that time, and my notions of how to build a painting were influenced by the same things, but I wanted to make the opposite, the most maximal kind of painting. You can see in Wesselmann and maybe in Katz's work a figurative equivalent of some of the more reductive notions. I always wanted to give more and more information, not less and less.

A long time ago you said that the size of your paintings was dictated by the maximum size canvas that you could get into your studio and on the elevator.

Yes. I always composed in an eight-by-ten or four-by-five camera format. I wanted to work on a relative proportion, so I usually worked on seven-by-nine-foot paintings. I had ten-and-a-half-foot ceilings, so nine feet was the maximum height I could use and still get the painting up enough so that I could lie on the floor and finish the bottom of the painting. I've also said, somewhat facetiously, that I wanted to make the biggest painting I could because it takes longer to walk by and therefore is harder to ignore, but I did want to make big, aggressive, confrontational images that were hard to ignore, that you just couldn't have *no* feeling about. You could love them or hate them, but at least you had to see them.

When I was in school, there was a notion that you couldn't make a human head larger than life-size, that somehow we couldn't identify with it. Well, that

was craziness, especially in a post-cine-matic society in which we're used to looking at Katharine Hepburn's kisser smeared across a ninety-foot-wide Cinemascope screen. But when a little thirty-five millimeter movie frame is blown up to a ninety-foot image, it doesn't have a correspondingly greater amount of information. It's jiggly and blurry.

I wanted the painting to remain inti-mate, so that each viewer standing in front of it would have the same kind of involvement with the minutiae, even though it was large scale. That is very different, I think, from the large-scale paintings of the fifties and sixties, when the paintings got big and the brush-strokes got bigger too. When the Ab-stract Expressionists went from easel paintings to large canvases, they got bigger brushes. The part-to-whole rela-tionships stayed virtually the same. I wanted to make an almost mural-size experience while keeping the intimacy of the small mark and the increment of a small-scale painting.

You mentioned that your loft ceiling was ten feet six inches. So you gave yourself some room to work at the bottom. I remember when you cut a notch in the ceiling and built a box on the roof so that you could crank the painting past the ceiling and work at eye level. Then, when you moved into this studio, you got a forklift chair so that you could move up and down the painting. You're still using that, I assume.

Yes, on the large paintings.

What kind of canvas do you use and what sizing?

Linen, with fifteen or twenty coats of wet-sanded gesso, so it's practically like a piece of Formica. It's very, very smooth, but absorbent.

You've never projected slides?

No.

The transfer of the photograph to the canvas was done by using a grid.

Right. I would snap a chalk line on the canvas with charcoal dust so that it could be removed with a rag. The pencil drawing was shorthand for the painting. It didn't look like a "drawing"—a dotted line, sometimes a dash line, then a dot and dash line, or a wiggly line that meant something else. I used the grid in

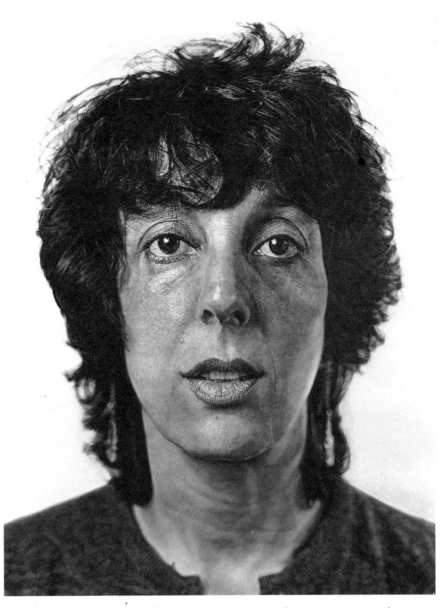

Gwynne (1982), 74¼" × 58¼" (189 × 148 cm), watercolor on paper mounted on canvas. Courtesy The Pace Gallery, New York.

the early paintings as a way to quickly find which area I was in. Then I erased the chalk line but left little crosshairs at all the intersections, and only used the grid to put in the pencil drawing.

How long did the drawing take?

Three or four weeks, usually.

Were you using a hard pencil?

Yes, like 9H or something. Then the pencil drawing would be erased as the painting was made. In some areas, the paint would be dense enough to cover the drawing.

Then you started putting the tone in with an airbrush. I've read that you could do a

big painting with a tablespoon of paint.

Well, I don't limit myself. If I got six inches from the bottom of the painting and ran out of paint, I wouldn't quit. But, yes, I would paint a whole year, and my accountant couldn't believe that I took off only sixty cents for paint—one sixty-cent studio-size tube of black acrylic, but mixed with water until it's very dilute, like watercolor. All of the acrylic paintings are essentially water-color in that respect. Actually, I did use watercolor for the ones on paper.

So do you paint them one grid at a time?

No. I work in areas. I pretty much ignore the grid while I'm painting. There is no white paint, only black.

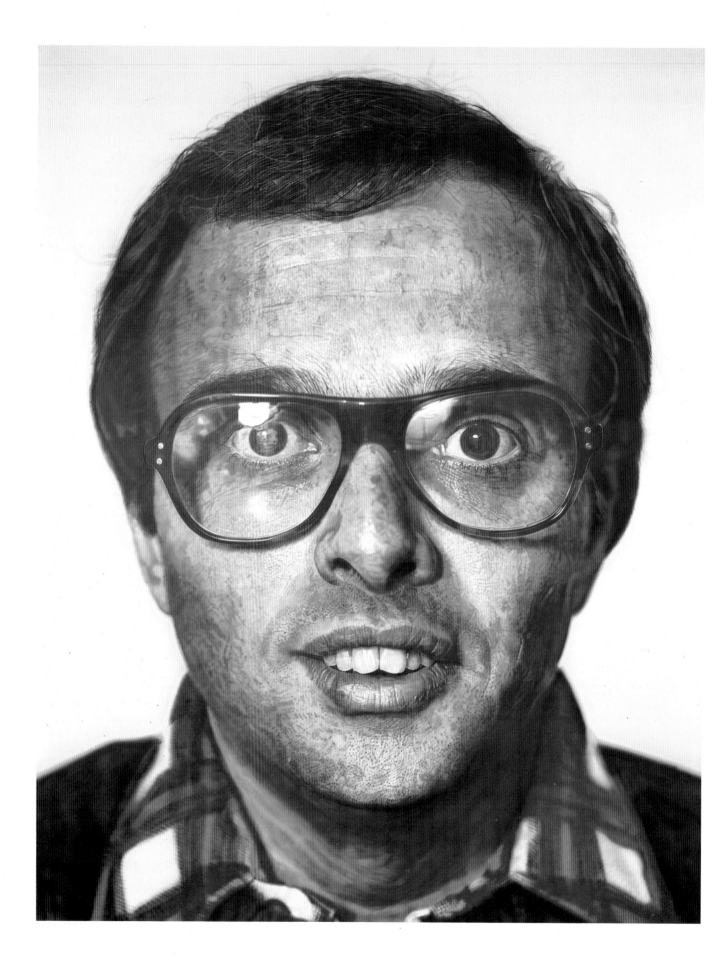

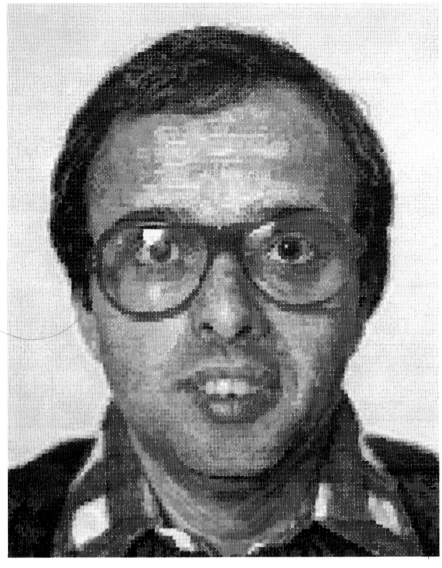

(Page 46) *Mark, 1978-79* (1978-79), 72" × 108" (183 × 213 cm), acrylic on canvas. Courtesy The Pace Gallery, New York.

(Above) *Mark/Pastel* (1978), 44" × 56" (112 × 142 cm), pastel on watercolor. Courtesy The Pace Gallery, New York.

(Left) *Mark Watercolor/Unfinished* (1978), 40" × 53½" (102 × 136 cm), watercolor on paper.

You use the white of the canvas for the lights?

Right. It's like making a pencil drawing on white paper. This paint is so dilute that I can spray and erase back or whatever, find the area, and start to define the things, and then slowly build the density by going over and over, gradually bring it up to the right value. I have lots of time to resolve the shapes and manipulate the edges, do all those things, because I work so thinly. But there is no way to overpaint, so I don't work in a precise square. You can't get the next square to butt up without a seam. I find a natural edge, like a shadow along the nose or where the cheek meets the hair, and use that as a dividing line.

So it's almost like fresco painting.

Yes. Very much like that. Bite off what you can chew and do that. Each area is more or less finished before I move on to the next.

How long did the large monochromatic paintings take?

They took about four months.

What kind of hours were you putting in?

I guess six to nine hours a day. Sometimes it didn't help to do more than about six hours, because I started making too many mistakes. I worked usually in three-hour chunks, three hours in the morning and then a break. Then three hours in the afternoon. Sometimes I came back and worked another three in the evening. It got counterproductive to put in more than three hours at a time because fatigue would set in and it was very nerve-wracking work. The way I have chosen to work can be tedious, but liberating also. There is something liberating about knowing exactly what I have to do. When I used to fly by the seat of my pants and paint with all my nerve endings exposed, the painting would be good one day and in the toilet the next. That was more nerve-wracking than working this way. Ultimately, the entire experience is positive. There aren't good days or bad days. The painting won't fall to pieces because of any particular thing I did the previous day.

From the early monochromatic paintings you went to color. One of the unusual features is that you had the color photographs separated into three colors, like

an offset reproduction without the black.

Well, so many things I do are not for major "art" reasons but for quirky little personal reasons. I always had tremendous trouble with indecision prior to the black-and-white paintings. I would paint in, paint out, and scrape off. I never knew when to quit and would beat an area to death, or have a good start and be afraid to work on top of it. Many of those problems seemed to be connected with the problem of making decisions about the palette—removed from the painting—trying to mix paint and make a decision.

I found making these decisions out of context incredibly frustrating and not suited to my temperament. I'd want a particular green in the painting, then would mix a green on the palette but never be quite sure it was the right green. Then I'd put it into the painting and have a tendency to say, "Oh, it's not the right green, but I like it anyway," or "It's close enough." Those things were incredibly difficult for me, and I discovered the joy of working without a palette when I made the black-and-white paintings. The paint literally mixed on the canvas, and all the decisions were made in context. I put the paint on until I had enough.

Then, when I moved on to color paintings, I did not want to return to traditional paint-mixing methods. I wanted to continue to mix on the canvas. In order to do that, I had to equip myself with whatever was necessary to make those judgments. Also, I liked the fact that the black paintings were full of so much stuff but were also incredibly economical. I used the least amount of paint necessary to make a black-and-white image, just black paint on a white canvas. I wanted that thin, ethereal lack of physicality in the color paintings.

The fewest number of colors necessary to make full-color image is three: a red, a yellow, and a blue. So I took color transparencies and went to the lab and worked with the technicians on dye transfers. From the color image we would print out the various color separations. Then I would work from the separations, and I made, in essence, three one-color paintings—a red, a yellow, and a blue painting—layered on top of one another to create the full-color painting. I had to know exactly how much magenta to put in, how much cyan blue to put in, and how much yellow. All

of that occurred on the canvas. There were no judgments outside.

Except for referring to the red separation, you had no way of knowing what the finished painting would look like until you got all three different layers.

In fact, everyone said it wasn't going to work, because a difference of one percent in any one of the separations would make a significant color difference. A machine could maintain that kind of control, but how could I? If I had tried to make three separate paintings on sheets of plastic and put them together, I could never have done it, but I put on the first color and got it as accurate as possible. Since I couldn't see how much of the second color I was putting on, I had a composite separation made,

"My invention is an invention of means, rather than an invention of shape or other things."

which was a combination of the first two colors, and simply brought the painting along to the two-color state. I used the separation, which was the combination of red and blue, to see whether I had put enough blue on, and when it approached what the two-color separation looked like, I began to put the third color on. There was always a lot of adjustment at the end. I would spray more red, blue, or yellow to correct the color, which was all done by eye.

Well, Chuck, in spite of the built-in checks, it's like top-notch color printing. I've worked with printers on some of my books, and even with laser scanners and all of the technology, when it gets down to making accurate reproductions, it's a matter of some person making the right decisions.

That's right. Give me a good separator over any laser scanner. Nothing equals good instincts and years of experience. But, you see, work like mine can really be misunderstood because it seems so coldly mechanical. The system seems so artificial and contrived. Many people don't understand how intuitive the whole process is. No system ever guarantees any degree of quality.

When I had every choice open to me, every color in the world, I used the

same five or six color combinations over and over. Working nonobjectively, I could make any shape that I wanted, but I repeated the same stupid shapes over and over. Having imposed a system on the construction of an image, I found myself making shapes and colors I had never made before. There was tremendous room for invention and intuition; all of the joy, the pleasure, and the excitement was in the nuance, and nuance is everything. You can give the same recipe to ten cooks, and some make it come alive, and some make a flat soufflé. A system doesn't guarantee anything.

In the end, the strength is always in the subtleties, in the things we can't describe. Nothing is more hackneyed than Shakespeare's plots, and nothing adheres more to the conventions of the time than a Vermeer painting.

I was thinking of Vermeer. Those are probably the greatest paintings ever made. His invention is incredible, even though it's probably very close to what he saw. You don't get a painting unless you push the paint around, and it's how you push things around that matters.

I know exactly what the painting is going to look like, on one level, because it's going to look very much like the photograph. My invention is an invention of means, rather than an invention of shape or other things.

We've been trained, in the modernist tradition, to think of invention as "So-and-so invented a particular signature shape, or surface, paint handling, or color combination." We've come to think of that as invention. But if you look at all the painters who had to work within the strict conventions of Madonna and Child, with the donor on the right side, some of them had real vision and managed to work within those limitations and make wonderful paintings. Others made dogs.

I think the key to understanding this kind of work is to look for the invention in different places. We have to look for the fine-tuning and nuance in a world in which everything has been reduced to the lowest common denominator. The reproduction is the barest indication of what a painting is about, and judgments are being made on a very crude level regarding the artist's intentions.

After the color paintings, I saw a large

painting that had a very small but visible grid. It appeared that you were assigning a value to each gridded-off square, based on the values in the gridded photograph, and then spraying with dots of various values.

The dots were of a relatively equal size, but the difference in value was what produced the image. In a halftone reproduction the dots get bigger and smaller, but they're all black. My dots stayed essentially the same size but were of varying values, and they would cluster together or remain separate, depending upon the values.

From a distance they looked almost the same as the earlier paintings, but up close you could see the series of dots of different values.

Those pieces were the product of the following thinking: I wanted to change what was going on in the studio. Mainly I've tried to keep myself engaged in what I'm doing by changing what's actually going on in the studio, rather than changing the image. I don't want to paint camper trailers one year and pickup trucks the next. The experience would stay the same, even though the subject changed. I wanted to alter all the other variables—scale, material, technique, or whatever—in order to change my experience. If I could keep myself engaged and involved, then I would be able to do the same thing for the viewer.

The other factor was that I had always been interested in a nonhierarchical approach to the portrait, in which each piece was as important as every other piece. It was very hard with those continuous-tone black-and-white paintings, and the color paintings, to feel the same way about an area in which I had worked for a long time as I felt about an area in which I perhaps had done nothing or was a lot less involved. In order to keep the whole painting of equal importance, I would spray the same kind of mark in every square inch of the painting. It's sort of analogous to an architect taking a pile of bricks and stacking them up one way to build a cathedral and then stacking them up another way to build a slaughterhouse. There is nothing about the brick, the increment alone, which will tell you what the experience ultimately is going to be. The incremental unit is the same. The dot pieces were an outgrowth of

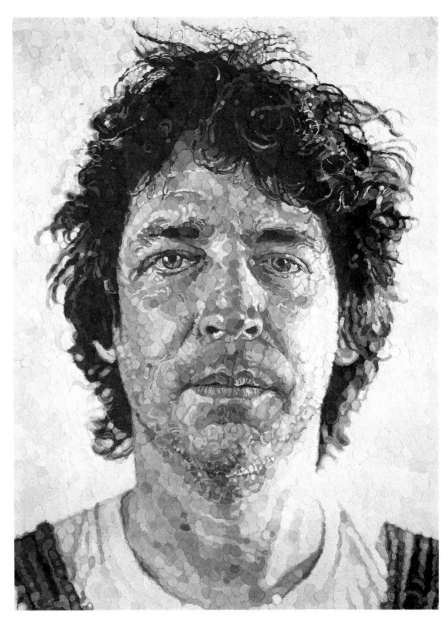

Jud (1982), 72″ × 96″ (183 × 244 cm), paper collage on canvas. Courtesy The Pace Gallery, New York.

that thinking.

I was on my way to the opening of my first dot-drawing show, and I saw a cover of *Scientific American* on the newsstand with a computer-generated, square-by-square image of Abraham Lincoln. I was really shocked to find out that someone else was trying to make the kinds of judgments about information needed to read an image. Some people have commented on the relationship between those dot pieces and what can be done with a computer scanner, but I've tried to stay ignorant of what the computer does. I think that, finally, those computer images are kind of dumb. The machine can make only

one judgment and maintain it throughout. A lot of what I do is capricious and arbitrary. I get tired of doing it one way and I do it another way. I think there's a tremendous amount of invention in the selection, but I suppose there is surface similarity. I'm averaging together information and figuring out a way to make a mark that stands for it.

I believe the first piece you did that was all line in a grid, similar to the changing values in the dots, was the little rubber-stamp print.

Yes. Actually, the self-portrait etching, which was made with diagonal lines, was an interesting process, too. I was

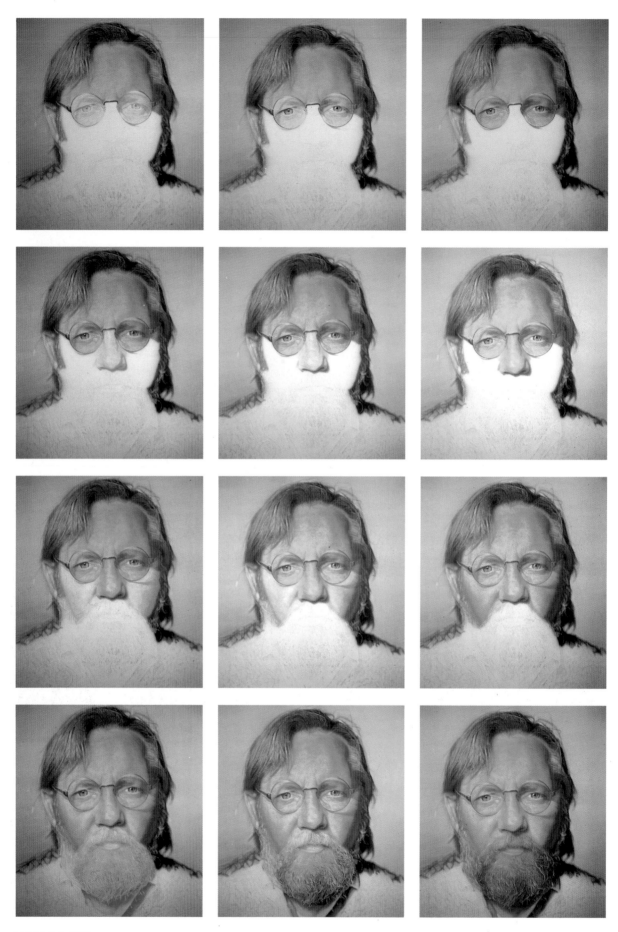

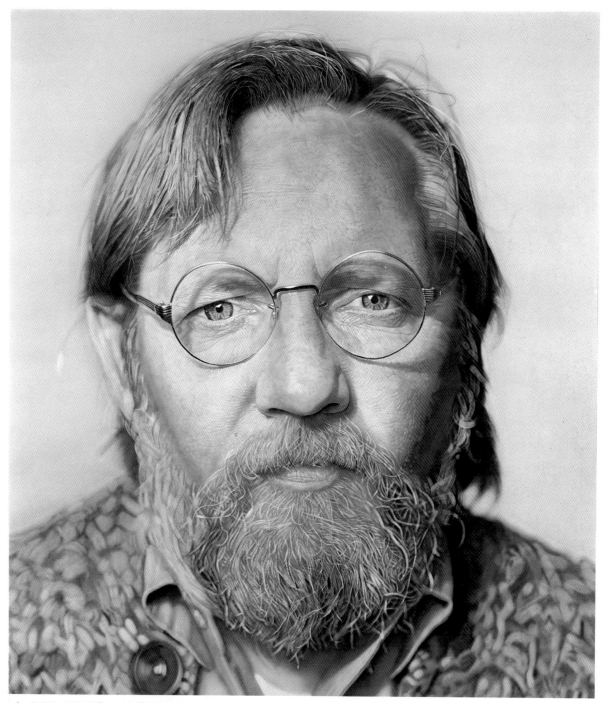

John (1971-72), 90" × 100" (229 × 254 cm), acrylic on canvas. Collection Mrs. Robert B. Mayer.

Using a natural edge, such as the hairline or the frame of eyeglasses, Close airbrushes the painting in segments using separate layers of magenta, cyan, and yellow.

The first row on page 50 shows the steps in painting the eyes. In the first photograph, the eyes are completed with magenta only. The hair and forehead have been painted with a combination of all three colors, and the pencil drawing can be seen on the lower half of the canvas. In the second photograph, cyan has been airbrushed over the magenta. This layering is similar to the progressive layering of ink in the four-color printing process. With the addition of yellow, shown in the third photograph, the painting of the eyes is complete.

Close continues this progressive layering of magenta, cyan, and yellow to complete the nose (second row), the cheeks (third row), and the beard and mouth (fourth row).

The interior view of the studio (left) shows the color separations and various combinations of the three colors, which Close uses for reference.

working on a bright copper plate, and the etching ground was a dark purple, almost black, so I had to think the opposite, make light lines where there were going to be black lines. Curiously, about two-thirds of the way through, I said, "This plate looks really familiar." I realized that it looked like a photograhic negative. So I took photographs of the plate, processed them, and made a contact negative. Then I made a negative print of the plate, which was the way the etching would ultimately print. I was able to make all the corrections by thinking of the plate as a photographic negative. When it went into the acid, the first proof that we took off the plate was perfect. It was a self-correcting process.

There are the large pastel drawings in which you actually used different colors.

Right, I had spent all that time making color images with three stupid colors, none of which were visible in the finished painting. You never saw just red or blue or yellow. You only saw the way they combined to make a resultant color. In the three-color paintings, two things control what you see: one is the relative percentage of one color over another. More red than yellow or more yellow than blue makes a specific color. Then, the relative density determines whether it's a lighter or darker color. All of the decisions had to do with sorting out how much of the three component colors would be used.

Did you varnish the paintings? There is a protective coat on the acrylic paintings and the watercolors.

A restorer sprays it on. It is a plastic. Anyway, I went to pastels because that is the medium that comes in the greatest number of stock colors, especially if you buy all the different brands. I had a lot of pastels custom made, too, so I had literally thousands of colors. Instead of trying to build an image with three colors, I spent all my time sorting the pastels into trays of yellows, browns, or whatever, and trying to find the closest approximate color. So, as a thought process, making the pastels was diametrically opposed to making the color paintings.

The large pastels are done on paper. Is the paper mounted?

Sometimes, or stretched, like canvas. I mixed marble dust into the medium to make a tooth for the pastel.

You worked on those upright? Did you work from top to bottom? And what about the problem of the pigment that falls off?

I tilted the drawing forward slightly, and most of the pigment just fell into my lap. I got terrible pigment poisoning from the powder working through my pants into my legs. I've had a lot of trouble with materials. I also got poisoning from the stamp-pad ink, which is why I went to lithography ink. I was getting minor nerve damage. Stamp-pad ink is lethal, it turns out. I called the hazardous art materials expert in New York and told him what I was using, and he found out what was in it. It was terrible.

> "I went to pastels because that is the medium that comes in the greatest number of stock colors.... I had a lot of pastels custom made, too, so I had literally thousands of colors."

It gets to be very dangerous.

You never know, art could kill you!

I find those fingerprint pieces ironic in that they become the ultimate "signature" painting.

It's a portrait of me at the same time that it's a portrait of someone else. Also, I thought it was great to make art that could not be forged.

Right. Signature painting free of gesture—which is a first.

That's the way I feel about these new collages, too, in the sense that they are very physical, very textural, all the things that we associate with sort of a signature-expressionist content.

The collages seem to be an outgrowth of the fingerprint pieces and the paper pulp prints that you did with Joe Wilfer.

Yes. We made twenty-four tubs of pulp, tinted with pigment and arranged in twenty-four values from white to black.

The prints have always been influenced by my other work, but they have also influenced the paintings and drawings in return. The mezzotint was the first piece that I did in which the grid was allowed to remain. It was engraved straight into the plate. The mezzotint was conceived as something to be done incrementally, and the increments would show. Later the dot drawings evolved out of that thinking. The first paper prints were just in the grid. Then I started manipulating the images while they were wet—which was closer to the fingerprint pieces that preceded them—and that led to making these collages. I hadn't made a collage since I was in graduate school, and the idea was very bizarre and foreign to me. But when you have piles of any raw material, it's always tempting to see how you can put the things together in a different way. I wouldn't have had the raw material had I not been making the prints.

On these pieces, there's a very distinct cool gray and warm gray, and these chips of paper are randomly placed. The collages are very, very tactile, almost like reliefs. Another feature that is fascinating, and I think you mentioned it earlier, is that in ways they're very much like the old contour maps with exposed layers.

As a kid, I used to go to the state parks in Washington, where I grew up. They had wonderful relief maps in the parks that showed the mountain ranges. I always loved them just as objects. They were wonderful. Also, I had a summer job with the U.S. Army Corps of Engineers while I was in college, and worked on drawings that were later translated into relief maps, so they have always interested me. Now that same kind of build-up is beginning to recur in these collages.

The collages are on gessoed canvas, too.

Yes.

You can't put down a grid, as you do on the other works, because you would cover it up. So with these you are trying to work with a slide projection.

Yes. It is a cumbersome and unsatisfactory solution, so I'm going to abandon it. I've never wanted to work from a projection. The idea of making art in the dark always seemed bizarre, so I've used it just to get an indication of where things were. But the projector moves around and jiggles. Also the slides fade. I'm going to return to another grid system. I prefer having to find everything.

In this portrait of Jud Nelson, the drawing looks like it was done with a felt pen. It is completed in the lower half, and there's an indication of values, but the hair isn't completed.

No. I'll do the top portion on the forklift.

This is a bit smaller than some of the paintings.

It's a little smaller because the chips would pop off if I tried to fold it. It is six by eight feet. I've never used this particular scale before, but it's the biggest size I can get out of the elevator without folding.

What kind of glue are you using?

It's similar to Elmer's glue, but it's supposed to be superior.

The glue is only on the back side of the paper, and I assume that there will be no fading or deterioration.

It's one-hundred-percent rag and pigment, not dye. So they should last forever.

These pieces are really surprising in the way the information comes across. In a funny way they're like a low relief, and they're very painterly. From a distance, Jud reads as being a fairly articulate but painterly image. Up close, the layering of the chips of paper doesn't really correspond to the planes of the face.

Right. The nose doesn't stick out in front of everything else.

In fact, it seems to recede a bit.

been very interested in the fact that artificiality and reality are poles apart. All paintings are somewhat involved with the difference between the physical reality you're looking at and what is conjured up. I've always tried to take advantage of that aspect and orchestrate a variety of experiences for the viewer.

You mentioned that you were trying to avoid tearing the pieces in these, trying to use the full shapes.

Accepting the limitations of the unit.

How long have you been working on Jud?

Since this fall. I started the collages at the beginning of the summer and did the medium-sized one and two small ones, one of which isn't finished. When I got back to the city, I started *Jud*.

You mentioned once before that the dealer Ivan Karp saw your work quite early.

He came down to the studio, but he felt that the paintings were too sentimental. That was about 1968, when Richard Estes first showed in New York. I didn't know Richard's work; in fact, I didn't know anybody was working from photographs when I started making portraits, with the exception of Richard Artschwager, who worked from newspaper photographs of train wrecks and various things. But I think Ivan had seen Estes' work, and he tried to get me to paint machines. I think the Charles Sheeler show was at the Whitney Museum and the "machine show" was at the Modern, so I guess he thought it was a good time for painting machines. He said it would launch me. It was very intimidating, since he was working with Leo Castelli at the time. But I refused, so we parted ways.

That's a very uncomfortable position for a young painter to be in.

Well, you often hear about dealers manipulating their artists, trying to get them to paint certain things or keeping them from painting others. I think that's all overblown. It makes for good art bar stories. There are dealers who are frustrated artists, and given half a chance, they will vicariously paint an artist's paintings. But I question the artist's intelligence if he lets his dealer alter what he wants to do. It just doesn't make sense.

We're talking about esthetic integrity. I think that, ultimately, each artist should be trying to find his or her center. Bending to such advice is a political decision and quickly takes one off the path.

Look at all the people who listened to Clement Greenberg, for instance. Anybody else who thinks he has a better game plan or thinks he knows where your work should be going ought to be the artist. In my experience, everything has been a logical outgrowth of my own involvement and happened without putting my finger to the wind to find out in which direction the art world in general was going to lurch. I just can't imagine chasing the art world and trying to figure out how to succeed. There are times when absolutely nobody is interested in what you're doing, and there isn't a hell of a lot you can do about it. Some people are ahead of their times. For instance, there was just no interest in figurative painting in the fifties, and those painters were in big trouble. But I don't know anyone who has benefitted greatly from trying to set a strategy for a career. It's just not a logical business.

ROBERT COTTINGHAM

In the late sixties, Robert Cottingham moved from a highly successful career in advertising to the field of fine art and, almost from the beginning, produced surprisingly mature and technically polished paintings of urban images.

Unlike the highly detailed replications in mainstream Photorealism, his paintings are keenly composed and edited transcriptions of his photographic source material. Cottingham has also differed from most of the Photorealists (as have Close and Estes) in his traditional and craftsmanly approach to printmaking. Instead of using photomechanically produced plates, which give anemic results, he has relied on careful and painstaking handwork, and the results of his achievements are some of the finest examples of contemporary etching and lithography.

No painter could choose a living and working environment more remote and removed from his subjects. Far from the cacophony and visual clamor of urban outdoor advertising so typical of the decaying sections of our cities, Robert Cottingham lives on an old dairy farm in Connecticut, where he concentrates on these abstract folk icons of retail promotion.

His home, which dates back to the eighteenth century, is filled with antiques, English signs, and pub mirrors. Cottingham has recently moved his studio from the cramped quarters in an old icehouse on the property to the spacious dairy barn. It is efficiently laid out, and is highly conducive to his industrious operation.

"I'm not primarily interested in documentation, although I think there is a certain documentary aspect to my work. It's unavoidable because of the degree of realistic depiction involved and by the nature of the subject matter. It's a vision exclusive to the century and is fading fast."

Tiptop (1981) 60" × 96" (152 × 244 cm), oil on canvas. Collection Graham Gund.

Bob, you spent years in advertising. I assume that you were painting at night, isn't that right?

Painting at night and on weekends and vacations. But I was in advertising for years before I began to paint. I had never done a painting before I was twenty-eight.

You didn't major in art?

No. I studied advertising and graphic design and worked as an art director. I wasn't an illustrator or anything like that. When I was twenty-eight, I decided to start painting, and I used whatever spare time I had. If I wasn't in the office, I was painting.

But you had a successful career in advertising.

I was creating print and TV campaigns for the New York advertising agency Young and Rubicam. I'd been doing that for years, but once I started painting, I was hooked.

So you are self-taught as a painter?

More or less. I studied graphic design at Pratt Institute, but I never took a painting course there. In Los Angeles I attended several night courses, where I studied briefly with Robert Irwin and Emerson Woelffer.

Were you going to museums?

From a very early age. The first time I got turned on to art, I was twelve years old. I saw Hopper's *Early Sunday Morning* at the Whitney Museum. I'm sure that was the beginning of my painting career, although I didn't know it until sixteen years later. It obviously set my course, even to the choice of subject matter. Mondrian and Demuth also had a significant influence on my work. Demuth's painting *I Saw the Number Five in Gold* had a tremendous impact on me—the centrality of the image, its emphasis on a number—and Mondrian's taut compositions creating unbelievable tension. I'm convinced that all those early influences come together even now in my choice of imagery.

Hopper is very important to everyone with an interest in Realism. Your earliest work, which I have seen only in photographs, was of suburban houses.

One of the first paintings I did was of a building across the street from where I was living, on East Fifty-fifth Street in New York. I sketched it from my window and painted it. That was in 1963 and was the beginning of my interest in the urban scene as subject matter. Shortly after that I transferred to the Los Angeles office of the ad agency. They wanted someone with New York experience out there and I was a bachelor at the time, so I was easier to move than someone with a family. It took me a year to relate to the Southern California environment. I wasn't at all comfortable with pink and white stucco buildings. Pseudo-Spanish haciendas are a long way from New York brownstones. But after about a year, I started painting again and did *Southland Hotel,* the building outside my window there. I then began scouting other locations in search of subject matter, using the camera as a kind of sketchbook. Working from the photographs in the studio was a lot more convenient than trying to set up an easel on Santa Monica Boulevard.

> **"I'm interested in painting a specific American iconography, and so the signs I choose naturally have to be American."**

Were you showing in L.A.?

Yes. I had three shows there, the first in 1968, which was the one that convinced me finally to end my advertising career.

That's interesting. Estes' first exhibit in New York was in 1968, at the Allan Stone Gallery. But a lot of dealers had turned him down. There wasn't much interest in that kind of subject matter in New York. When did you start showing at O.K. Harris in New York?

The first show was in 1971.

That wasn't very long after you started painting. How familiar were you with the other Photorealists at that time?

Up until early 1969 I wasn't aware of them at all. I was looking at the work of the Pop artists and was fascinated with their ideas and choice of subject matter. I had been painting urban subjects for six years but wasn't aware of other artists working in a "photorealist" manner. A friend of mine sent me a copy of *New York Magazine* with Richard Estes' and Malcolm Morley's work in it, and I was knocked out. I couldn't believe that the same thing was going on back East. It turned out that I had done at least four paintings of the same general subjects that Richard had done. Even our titles were identical.

That was in 1969, and Richard's phone booths were on the cover. I've still got that issue. Morley, Kanovitz, Beal—that was one of the first articles on them. Almost from the beginning, you have concentrated on signs and street advertising. You mentioned the connection with Hopper and, of course, Hopper used a lot of signs in his paintings.

In the beginning I was more interested in the architecture, the buildings themselves. I would drive around Los Angeles looking for likely subjects. Trucks and buses were fair game, too. I did a series of oil trucks.

I have always thought of your paintings as being almost cubistic or constructivist in regard to the structural elements. Even though you're usually not composing parallel to the picture plane, you have those forms jutting out—protrusions from the surface of the advertising contraptions. Also, we seldom think about it, but those signs are very surrealistic.

Yes. I've thought of that. I do lean toward a surreal quality as well.

But you are obviously very interested in signage. You have a beautiful collection of English signs and memorabilia. Is there a relationship between the collection and your paintings?

Not a direct relationship. I think that there are several things operating simultaneously. My interest in English signs is strictly a love of lettering and of things English. But I don't consider those signs appropriate subject matter. I'm interested in painting a specific American iconography, and so the signs I choose naturally have to be American. I once photographed signs in Tijuana and Ensenada, Mexico, but because the signs weren't in English they didn't work for me at all. We lived in London for four years, yet I never painted an English sign. The brand names are unfamiliar. Even the letterspacing is different. I didn't relate to them as subject matter, so I would make frequent photography trips to the States and replenish my supply of slides.

Did you show in England?

I had shows in London and in Hamburg during that period.

The Germans were very attracted to Photorealism.

Yes. I'm in a number of German collections.

Regarding the precedent in Pop Art, I think one of the big differences is the irony and mimicry of mechanical processes. That has never been characteristic of your painting.

No. I have a different reason for painting, but I think Pop paved the way for Realism again—brought it back. It was the first step.

Yes. Pop Art, in a funny way, made imagery legitimate again to the art world. But, in fact, Porter, Diebenkorn, Pearlstein, and a lot of other painters were working figuratively before and concurrent with Pop Art.

There has been a continuous thread of realism in American art. But Pop was something new and fresh.

In regard to photography, except for a few of the early paintings, you have worked from slides and transparencies.

I didn't shoot transparencies from the start. I used to take black-and-white photographs and then work out the color myself. I eventually realized that if I shot with color I would at least be closer to where I could begin formulating a color scheme without having to invent the local color of each and every detail in the image. Now I take all color slides and transparencies.

You've said that urban renewal is destroying most of your material.

Urban renewal is the bane of my existence.

As tacky as the things are that are being torn down, they are not really being replaced by anything much better.

Certainly nothing comparable as far as I'm concerned. That magic combination of neon, chrome, brick, and glass will never exist quite the same way again.

Do you feel you are documenting a segment of the American scene?

I'm not primarily interested in documentation, although I think there is a certain documentary aspect to my work. It's unavoidable because of the degree of realistic depiction involved and by the nature of the subject matter. It's a vision exclusive to this century and is fading fast. In the revitalized cities, such as Houston, these signs are virtually gone. It's the end of an era, so you can see where the documentary notion is attractive.

There must be an enormous ratio of the slides and transparencies taken compared with what you wind up being able to use.

I would estimate that one out of one hundred slides yields a paintable image.

Also, you've mentioned that there's a long gestation period. You're continually looking over your material. I assume that some of it is years old.

My newest painting, *Fleishman*, was done from a slide that dates back eight years. *Warren's Bar* was another subject that had been germinating about that long. As my vision changes, older

1

2

3

4

5

6

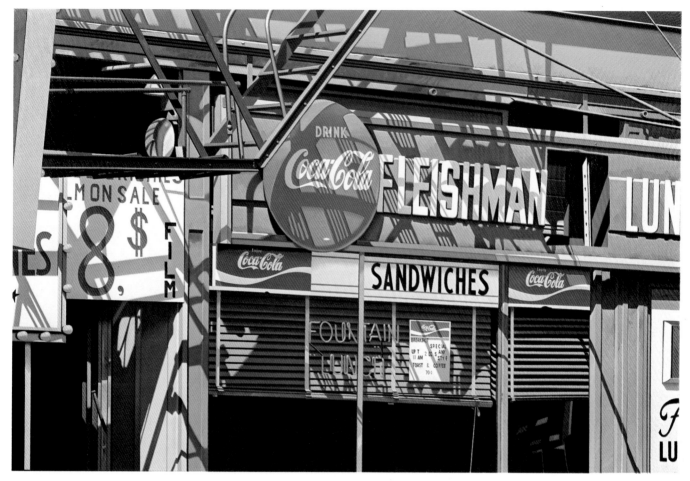

Fleishman (1982) 72″ × 48″ (183 × 122 cm), oil on canvas. Collection Mr. and Mrs. Bernard L. Madoff.

1. After making a preliminary pencil drawing (shown at right), Cottingham projects the slide on the canvas and makes an outline drawing. He begins blocking in with tone.

2. At this point, predominant patterns of darks have been established with an oil wash.

3. The reds are added throughout the canvas with diluted oil.

4. Next, the entire painting is blocked in with oil washes based on the local color in the photograph.

5. The overpainting has begun. Some areas, such as the background of the sign, wall, and shadows above, have been painted with different colors which will show through in parts of the over-painting.

6. With the exception of the window and the neon sign, most of the overpainting is completed. The underpainting can be seen through the overpainting in the sign background and fire escape shadows.

Preliminary pencil drawing for *Fleishman* establishes the patterns and tonal construction.

109 (1978), 31¾″ × 31¾″ (81 × 81 cm), oil on wood. Private collection.

slides I once passed over will surface as distinct possibilities.

You usually cover yourself so that you have more than one shot of each subject?

I will take two or three shots of a sign and occasionally as many as a dozen if it seems especially fertile. But quite often it's the photograph taken on the run, something I just snapped because it was there rather than because I thought I needed it, that becomes a painting. *Candy* and *Bud* are two examples of that. I had only one shot of each of those signs. There's absolutely no way to predict which ones are going to work. Even looking at the slides, I can't be sure.

Unlike the hard-core Photorealists who duplicate all of the information in the source photograph, obviously you edit the information and eliminate a lot of the tactile chatter.

I resist that kind of fidelity to a slide. I prefer the editing and the reorganization that go on in making a painting. The term Photorealism covers a wide range of styles and attitudes. I feel it applies to my work only in the sense that I use the camera as a starting point for my painting. I am certainly not attempting to duplicate the photograph.

You plan and organize your paintings and, in fact, you are stripping the image down to the essentials. The elimination is a conscious thing. With some of the Photorealists, I suspect that the inadequacy in their paintings is a lack of information in their source material.

Except for the fact that the slide is small and I have to put my eye up to this viewer to see it every so often, there is no problem because, as you said, things are simplified and I'm not searching for the minute details that would be hard to see in a thirty-five millimeter slide. Everything I need is usually there.

You have your slide viewer taped to the lamp over your palette, but do you use a viewfinder mat to decide where to crop for a painting?

I never crop from the slide, only from the preliminary drawing, because it clarifies for me the substructure and the value breakdown of the image. There's too much going on in the slide for it to clearly reveal that information.

From what you have in the slide or transparency, how much cropping and adjusting are you doing?

Quite a bit. It starts with a black-and-white drawing of the entire image. Whatever's in the slide becomes part of the drawing. Then it's a matter of cropping, honing in on what I think is the essence of a particular image. In some cases I will use the entire slide, but most often there is a certain amount of editing, especially the cropping of extraneous border areas.

But you do some selecting and editing when you take the slide. I'm thinking in particular about paintings such as Rat *and* Art, *where you wind up with these verbal puns by cropping the letters in the sign.*

Right. In those two cases, that was done with the camera, although with *Rat* I covered myself by shooting the entire sign from several angles. So the composing happens in the camera, then again with the drawing and with the projection on the canvas.

So at times you are looking for those verbal puns?

I don't search them out but they will sometimes emerge and I can't resist. *Rat* was a detail of the famous New York deli Ratner's. *Ode* was extracted from Rhode's, a Los Angeles jeweler.

Art has been widely reproduced. It's on tee shirts and postcards. I find it fascinating because it seems to be such a loaded image. In some ways it's Pop, but it also seems to refer to the commercialization of the arts. How much of that was intended?

A lot of it is intuitive. Part of it is there to begin with and some of it emerges as I work on it.

Of course, we have joked about the little print of the movie marquee, "Black Girl" and "The Butcher"! They sound like very sleazy, exploitive movies, and yet they have a PG rating.

That was there. I didn't make it up.

You said you didn't think about it at the time.

No, I didn't. I overheard someone comment on it at one of my exhibitions.

Your paintings are highly organized in terms of color. How close are you staying to local color, and how much is arbitrary, or formal?

Usually it's the same local color. The red Coke medallion is going to remain red. Most of the elements retain their basic colors, but ultimately they will shift toward my palette, so they are not exactly the red or the green that is in the slide. I'm frequently surprised when I revisit a scene that I've painted to see how different the color is by the time it has made that transition from subject to slide to painting. In some paintings, though, I will change color drastically for formal reasons. *While-U-Wait* has a totally different color scheme than the slide.

What kind of canvas do you paint on?

Linen sized with Liquitex gesso.

You're projecting the image directly onto the canvas?

Right. An outline drawing.

How much adjustment is necessary?

The projection is done freehand. I don't use any straight edges to start with. Once the image is on the canvas, I turn the projector off and it stays off. I don't paint with the projector on. There's a lot of confusion about that. Some artists paint the entire picture with the projector on. I then take a straight edge and begin composing and reworking, sometimes flattening perspective by making some converging lines parallel—eliminating some elements, adding others, or whatever.

Some of the Photorealists wind up with an exact duplicate of their slide or photograph.

For me the projected drawing is only a skeleton, a way of getting things in the right general position on the canvas. I used to grid everything, which would take ten to twelve hours for each painting. By projecting the slide I can do it in a couple of hours. It's a great time-saver.

Do you do anything to separate or seal off the pencil?

No. As soon as the paint hits it, the brush starts shifting the lines to the left or right, so I'm actually doing a new drawing with the brush.

How do you decide what size to make a particular painting? You have certain sizes and shapes that you work with.

I usually project the slide on a blank wall and block off what I think should be the outside edges of the painting with a couple of strips of wood or tape. I can begin to get the feel of an image by the way it accommodates itself to that space. And the sense of scale is constantly changing. The three recent eight-foot-high paintings, *Tiptop, Kresge's,* and *Buffalo Optical,* are all examples of what happens when an artist moves into a studio with a very high ceiling. I had to stretch up and get that height out of my system.

> **"I try to break an image down into a clearcut value scale. There'll be black, white, and maybe five or six intermediate grays."**

Chuck Close, Thiebaud, and you seem to recycle images. I know that Thiebaud and Close—and this is occasionally true of you—might do a drawing, an etching or a lithograph, a pastel, and a large painting of the same image.

There are some images that are so appealing and so rich with possibilities it would be a shame not to explore them in various media.

I think your more recent work is so highly structured and organized that scrapping a painting would be rare.

By the time I begin a canvas, I've gone through the preliminary drawings, an acrylic, and in some cases a watercolor. So I'm very sure of where I stand with the painting. I'll do the drawing, study it, see what's there. If it's got anything worthwhile, then I'll usually take it to an acrylic on paper, a small image.

The pencil drawing is the first indication that your images are also highly structured in patterns of light and dark.

I try to break an image down into a clearcut value scale. There'll be black, white, and maybe five or six intermedi-ate grays. That value breakdown will later apply to the color in the acrylic study. If I'm still interested in the image once I've done the acrylic on paper, I'll carry it on to a large canvas.

After you transfer the line drawing to the canvas and make the adjustments, you start blocking in with tone, as in the pencil drawings, but with paint. How far will you carry the underpainting?

I'll cover the entire canvas with a thin coat of color. There's no blank canvas showing.

Are you using sable brushes primarily?

Yes. I'll use bristle brushes in some cases, but mostly sable. And only sable on the acrylics. There is an excellent brand of sable brush made by a tiny company in England which I've been sending for ever since I discovered it there ten years ago. I've yet to find anything in America that works as well for me. I have never used an airbrush, by the way.

What kind of paint do you use?

Winsor & Newton.

You stick to the one brand?

I've tried other artists' recommendations and always come back. I'm comfortable with it.

Are your paintings varnished?

Yes. I have them done by a conservator.

You've got a large window, so you're getting a mix of natural and artificial light.

It's the artificial light that I rely on. I use a balanced combination of tungsten and fluorescent lights for all painting activities—to view the slide, over the palette, and on the painting itself—so there are no surprises. The light is a consistent temperature throughout.

How many coats of gesso do you put on the canvas?

That depends on the weave of the linen, but it ranges from four to six. These canvases have been sanded, but I don't feel they have to be glass smooth.

The way you work with acrylic is unusual. The paintings have the appearance, especially the edges, of wet-into-wet. There are very soft gradations which are difficult to do with acrylic. It dries too fast.

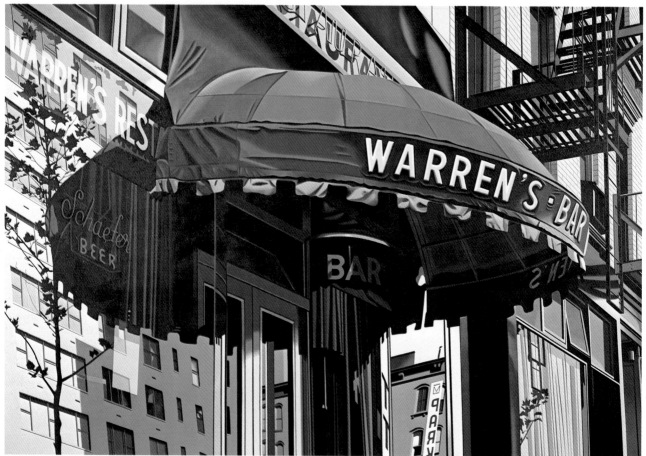

(Page 62, top) *Cafe Bar* (1980), 96″ × 61½″ (244 × 156 cm), oil on canvas. Courtesy Herbert F. Johnson Museum of Art, Cornell University.

(Page 62, bottom) *Warren's Bar* (1979), 84″ × 57″ (213 × 145 cm), oil on canvas. Private collection.

(Left) *Buffalo Optical* (1982), 60″ × 96″ (152 × 244 cm), oil on canvas. Courtesy Coe Kerr Gallery, New York.

Star (1980), 10¼" × 10¼" plate size (26 × 26 cm), etching and aquatint, Landfall Press.

The edges are very important to me because they affect the overall surface quality of the painting. In the oils most of the edges are blended while wet. In the acrylics I use a transitional hairline of color between one area and the next. It's not obvious until viewed closely but it's there. In the earlier paintings the transitional line was simply a color exactly halfway between the two colors I was joining—a mixture of the two. Now the hairline is becoming a third color that helps to intensify the color relationship.

Have you never used masking or stencils to get your edges?

No. No masking at all. I find the buildup of a masked edge very distracting.

We should make a distinction between the acrylics on paper, which are part of the steps toward the large paintings, and the acrylics on canvas, which are a very recent method for you.

I stretched four twenty-one-by-thirty-one-inch canvases as a kind of mini-series to explore the possibilities of acrylic on canvas. On paper it takes two or three coats of acrylic to get a smooth, opaque color. But because of the way the paint slides around on the canvas, it takes about ten or twelve coats of acrylic to get the opacity and the smoothness I want.

Then the acrylics on canvas wind up taking longer to complete?

They take much longer. I can achieve the same results in oil much more easily, so that will probably be the end of the experiment. Putting ten coats of paint on one area is very inefficient.

How much are you diluting the acrylic?

I keep it fairly thin to avoid visible brushstrokes.

You never use transparent paint or do any glazing?

I sometimes alter colors slightly—make a red more orange, for instance, by throwing a wash of yellow over it instead of mixing an entirely new orange.

But basically I use the direct method of painting.

How many layers of opaque paint are required in oil?

The lighter colors may take three or four. Most of the time a coat or two over the underpainting will do it.

How long does it take to finish a picture this size (five by seven feet)?

It will probably take about two months.

And you're very regular in your work habits.

I try to put in a minimum of seven hours a day.

Do you work at night?

Most nights I return to the studio after dinner for another three hours or so. If my day is broken up with other activities, I'll work later into the night to make up that time. It's like dance, music, or any artistic endeavor. The momentum and continuity of a regular schedule are very important.

The paintings I've seen in progress indicate that you work over all of the painting instead of doing a part at a time.

Right. I can't work from the upper left down to the lower right and call it finished. I work the entire surface of the painting simultaneously. It's always a matter of going back over areas. Each color is modified by the one next to it.

In your living room you have the series of small acrylics. Is the Hamburger *the acrylic or the color lithograph?*

That's the original acrylic.

It would be very hard to distinguish between the two if they were side by side.

Yes. I have to be careful about that. I almost let the acrylic out as a lithograph once.

In regard to printmaking, one of the most disappointing aspects of the prints made by many Photorealists stems from their reliance on mechanical and photomechanical processes, which I think is really bogus printmaking. Even if it weren't, the results are very disappointing and anemic compared to the richness of hand-worked prints.

I agree.

Chuck Close, Richard Estes, and you are about the only three Photorealists

Starr (1982), 24½″ × 16⅝″ (62 × 42 cm), acrylic on paper. Private collection.

Joseph's Liquor (1980), 32″ × 32″ (81 × 81 cm), oil on canvas. Private collection.

While-U-Wait (1981), 32″ × 32″ (81 × 81 cm), oil on canvas. Collection Vulcan Materials Co.

who have done quite a few prints and are heavily involved with the technical process. *Your prints are obviously very much the result of your hand.*

Of course. Yes. That's what printmaking is all about. I also find it's a great aid in painting because it continually gives new insights into technique. Every time I make a print I come back to painting in a fresh way. I begin to think in terms of new strategies—layers, sequences of paint applications, et cetera. It improves an artist's conceptual abilities if he makes prints occasionally. I'm working on my first print in about three years and plan to do more very soon.

Some of your lithographs are really elaborate. How many colors were in Hamburger?

I think about twenty-six colors. We had plates all over the shop.

You were drawing on aluminum plates?

In that case, all of them were aluminum. In other prints the key drawing will be on stone.

The registration problems must have been horrendous.

The image was small enough to keep those problems to a minimum.

Larger paper would stretch a lot more.

Yes, and the slightest change in weather can cause havoc.

As in your paintings, the prints are made up of flat areas of color.

In fact, people occasionally mistake my prints for serigraphs because of the flatness of the color areas. But I've never done any silkscreens. The process doesn't interest me. I like the quality of litho inks and I especially enjoy drawing on stone. Each individual stone will have its own personality.

You didn't study printmaking, did you?

No. My first print was done at Shorewood Press, but my real education came from the prints I did at Landfall Press. I left my family in London, where we were living at the time, flew to Chicago and lived on the top floor of the litho shop for six weeks while we worked on *Fox* and *Hot.* I ate, slept and breathed lithography. It was a real eye opener.

Was FW the first etching?

Hamburger (1980) 10½″ × 10½″ plate size (27 × 27 cm), color lithograph. Landfall Press.

Yes. Landfall had just hired the intaglio printer Tim Berry, and we decided to do one. *F.W.* seemed like a likely image because of the rich variety of tones. It ended up being a combination aquatint and etching. Technically, it was very complex.

With etching and aquatint, you've only worked in black and white; you've never taken them into color.

No, not yet, but I did do the one in soft ground, *Ice.*

Ice *is primarily crosshatching.*

It's like a printed pencil drawing.

In your prints and paintings there is rarely a trace of natural elements.

I'm even trying to keep out blue sky.

It's difficult to specify the time of day or season. All such things have been consciously eliminated.

Yes. That aspect doesn't interest me. I'm not painting vistas.

Your work doesn't have anything to do with Monet and his haystacks at different times of day. You've been very consistent in your choice of subject matter. I find it a bit ironic that you have chosen to live in the country and paint urban images. Do you find any inconsistency in this?

Not at all. Let's face it, I'm still a Brooklyn boy who now happens to live in the country. The city is an exciting place to me and I want to paint it.

Your signs aren't just New York. You have made a lot of trips.

All over the country. One year, with an NEA grant, I did twenty-seven cities in the Northeast. On that one bus trip I took about two-thousand slides.

You mentioned that buses go through the parts of town that are missed by the trains.

When I take a Greyhound bus, I get off exactly where I want to be. That's home for me—the subject matter that I

am looking for—right there in the most derelict part of town. I'll get off and shoot for several hours, then catch another bus out. That wouldn't work in the Midwest because the cities are farther apart and the buses run less frequently. I'd have to go by car.

Do you anticipate any change in subject matter?

I haven't found a good reason to move from the subjects that I am doing. Signs hold endless possibilities, and the paintings continue to change because my point of view keeps shifting.

There is never going to be an abundance of work by most of the Realists and Photorealists. What are we talking about with your work, four to six large paintings a year?

That's about it. I had one good year when I think I did ten big paintings, but that was a year of twelve - and fourteen-hour days. With a family, I don't want to spend that kind of time in the studio. It's a juggling act. I want to paint as much as I can, but I also want to spend time with my family.

Another point that I think comes out over and over in these interviews: money isn't the end that these painters are after. Instead, it buys more time to concentrate on painting.

True. But the paintings also take longer. You become more demanding, so you don't get faster. That's the amazing thing. With years of experience, each round is a new challenge and new problems arise, you look for more. You keep pushing and that takes longer.

This has been the case with every painter I've talked to so far.

JANET FISH

From her earliest still lifes, Janet Fish has favored common-place items over *objets de luxe* and has emphasized the abstract effects of light over their plastic properties. She has moved from the densely clustered transparent bottles of spirits and condiments that crowded the space of the canvas to an assortment of objects chosen for their specific visual properties and seemingly arranged with abandon. But, in fact, each still life is a carefully composed tableau.

Janet Fish is a remarkable colorist, although she never strays from the dictates of visual fact, and her work has become increasingly painterly over the past decade. In addition to the large canvases, she has done many pastels, which are stunning demonstrations of her powers of observation and skills as a draftsman.

As is indicated by her work, Janet Fish is frank and unpretentious and eschews esthetic posturing.

"I paint from beginning to end always relating to the objects, always working within a certain way of seeing and being very correct to the actual still life, because I am very interested in finding out what I actually see. I don't really know until I get going."

Orange Lamp and Oranges (1982), 50″ × 66″ (127 × 168 cm), oil on canvas. Courtesy Robert Miller Gallery, New York.

Which comes first, the size of the canvas or the still life setup?

The setup comes first. Then I figure out what size the painting will have to be by working out a scale relative to the proportion of the objects in relation to the canvas. From experience I know that the image will have a certain feeling at a certain size. A highly active still life would have to be big, and a more simple one could be a smaller painting. It depends on the potential activity in a setup. Then I stretch a canvas to fit the scale.

How do you choose the objects that go into a particular still life? We were joking earlier about An Apple *being a painting of all the things that are bad for you, that would rot your teeth, but in planning a still life you've always got the formal problems.*

Well, I always pick things for formal reasons rather than for content. Still life has probably always been the most formal subject for Realist painting. This painting with popcorn and all kinds of "bad stuff" in it I put together basically for formal reasons. There are a lot of puzzle pieces and coins in it and a curtain dotted with butterflies. I picked small things because I wanted lots and lots of tiny bits of shapes and colors. When I was painting bottles, I often picked things like vinegar bottles that had very bland, innocuous shapes because they wouldn't get in the way of the inner activity. Then, as the paintings began to evolve, I looked for more complex shapes.

In those early paintings, when you started doing the glass, your work became more about the light that described the volumetric shapes, but it was much more about the effect of light on the objects rather than the objects as solid, volumetric forms.

Oh, yes. I wasn't interested in the object as a form. At that point the enlarged size of the painted image was a way of almost negating the objects. When the glass was five feet high, you had to look within the glass, which was what I was after in the paintings. I wanted to be able to drown in the activity within the objects and the way the light moved within those forms. I was not interested in the exterior of the object or its edge.

They were always painted directly from the still life, right?

Yes. I have always painted directly. That was part of trying to get outside my head. I also wanted to be surprised by what I found, not to have it all worked out ahead of time, a preconceived idea.

In the paintings done around 1975, such as the Tanqueray *and* Tequila Bottles, *the objects always filled up the canvas completely and were crowded together. There was very little open space.*

I wanted no suggestion of the world outside those objects.

"The still life itself is the drawing."

What about the use of labels?

I was never terribly interested in the labels per se, only in what the labels did visually. I would sometimes leave a part of the label showing to establish a visual theme. Then, when the label was behind the bottle, it set up certain rhythms. The real interest was what happened as the things were seen through glass and liquid.

I remember you joking about Jack Beal and the labels.

Yes. He gave me C-minus for spelling CONTENTS wrong five times in one painting, and I thought I was painting exactly what I saw!

After that your paintings opened up, had more space around the objects, and the view outside the window was specified.

Yes. I did a painting where everything went perfectly. It was all glass, and every mark I made went to the right place and the paint went on exactly right. The shapes and all the visual and formal relationships worked. At that point I became terribly dissatisfied and didn't see how I could go any further with those elements, so I began casting about. Also I moved into this loft. Before, when I looked out the windows, I couldn't see any buildings. In this loft there were all the buildings across the street, so I thought I would bring those buildings into the paintings. They were alien to the glass and offered a different space and different shapes, so I decided

to see what happened. Later, in the country, there were flowers around and I started trying to see how I could integrate them into a painting. A lot of those paintings were very experimental, just to find out where I could go.

You almost always use the window ledge for your still lifes.

That is to get direct light.

"Direct light," but that also means that you are getting backlight coming through the objects instead of light falling onto the objects from a source above and behind you.

Yes.

Also, when reproduced, your recent paintings look fairly tight, but in fact they have become broader and more painterly.

Well, I consider myself to be fairly painterly because I am involved in the paint quality and the marks that can be made with different kinds of brushes.

When I think of your still lifes, I think immediately of the color and light, which sounds like a description of Impressionism, but, of course, it isn't. Your paintings are very much about transparent and translucent light—what happens with light when it is refracted, reflected, or passes through an object—but what holds your paintings together is that the drawing, form, color, and tone are correct and consistent.

I am very concerned that they should be. I paint from beginning to end always relating to the objects, always working within a certain way of seeing and being very correct to the actual still life, because I am very interested in finding out what I actually see. I don't really know until I get going.

You were mentioning Impressionism, and I grew up in Bermuda, with a lot of impressionistic painting around. My grandfather, Clark Voorhees, was one of the American Impressionist painters. The light is very strong in a southern climate; colors are high key. Some people (probably night people or those who live in smog) perceive my light as exaggerated, when in truth it isn't. But I'm not interested in impressionistic light, studies of specific times of day.

You don't seem to draw or make sketches for your paintings at all. You start right on the canvas.

The still life itself is the drawing.

You mean arranging the still life?

Yes. I will spend days pushing the objects around, changing them and putting new things together until I have a setup that seems to be exciting, that has something fresh or interesting.

I know that you are fanatic about stretching the canvas.

Oh, yes. It has got to be exactly square and very tight. Then it doesn't start flopping around on me. I stretch the canvas very, very tight, like three times, wetting and restretching it, and I stretch it absolutely within a thread to the edge. Then I size it with an acrylic gesso. I add pumice powder to it because I was told that acrylic gesso is too slick to let the oil bind properly.

Acrylic gesso is very brittle.

Well, acrylic gets brittle with age. Rabbitskin glue is very brittle, too, and it seems that the acrylic is flexible for a few years, and a painting is more likely to be rolled in its first few years.

Still life setup for *An Apple* (page 72).

So there are no real drawings or sketches for a painting?

No. I usually have the scale worked out. For instance, in this painting, one thirty-second of an inch is going to equal approximately three-quarters of an inch.

During the actual construction of the painting, you use natural light and you

have only natural light on the canvas, but how do you start? What do you draw it in with?

I take a ruler and work out the proportional width and height of each object and where it is in relation to the others. My measurements are often wrong, but I just keep correcting. Then I have kind of a guideline to work with. I wear very thick glasses, so when I am up close to

(Top) *An Apple* (1982), 100" × 50" (254 × 127 cm), oil on canvas. Courtesy Robert Miller Gallery, New York.

(Bottom) *Spring Party* (1981), 131" × 55" (333 × 140 cm), oil on canvas. Collection Graham Gund. Courtesy Robert Miller Gallery, New York.

(Page 73, top) *Tequila Bottles* (1974), 54³/₈" × 66³/₁₆" (138 × 168 cm), oil on canvas. Courtesy Kornblee Gallery, New York

(Page 73, bottom) *Plums* (1972), 30" × 22" (76 × 56 cm), pastel on paper. Collection Chase Manhattan Bank.

the canvas there are distortions as I look up and down the thing, but when I step back they disappear. So I work out the shapes of the objects and I make sure that they are standing straight. If there is a group of glasses and some plates, I draw the ovals of the tops and the bottoms and the heights, and I might draw a couple of lines indicating a certain kind of movement that might be in the painting—a pencil drawing on the canvas with just a few lines around here and there. Then I wash that down with turpentine until it is barely visible so the pencil won't get into the paint.

How complete is that drawing?

It's not a complete drawing at all. It's just a drawing of the parts that need to be absolutely correct—the lip and the base of a glass, the kind of oval that's at the top and the oval at the bottom, and the kind of curve that's on the outside edge. That's all that would be drawn in. It gives me something to hold on to as I begin to work up the painting.

So then you begin applying color?

Then I start painting directly from the still life. I generally start working in one area and establish the color relationships between a couple of the objects.

Are you adding specific details or painting broadly?

Well, some colors have to be put down first because they are so transparent that they would be destroyed by anything underneath them—something like a yellow or white. So I block in a lot of the light areas, and when I start working in just one area, I put in the lighter colors and the transparent colors first, just for technical reasons, to keep the colors clean and pure. Then I work out an area, establishing the various relationships, which gives me a key to the painting. That takes a couple of days.

What is your vehicle at this point?

Turpentine, sometimes with a little oil, depending on how porous the ground is.

And is the paint fairly thin?

Yes. I start fairly thin, but if I'm lucky and things are going well, I use a substantial amount of paint on the brush. It's hard to say, because the way I work is so instinctive. I have an idea of how the paint should feel coming off the brush and how thick it should be. When it gets too thick I wipe it off.

What kind of palette are you using?

Every color! Any color! Every color in the book! Because you can't take just one red and have it do for all reds. They are not made that way. There are orange reds, blue reds, and there are reds that make one kind of pink and reds that make another kind of pink. So I have every red I can find, and the same with blues and browns and black, but I usually add other colors to black.

You say that you have no color theories, but you must have taken the Albers color course at Yale. Have you found any way of translating it for directly observed painting?

Not really. The idea that color is relative was nice to know. I taught the Albers color course once, so it certainly helped me make some money for a year, but his theories didn't mean a lot to me. Then I got a job in an art supply store and had access to different kinds of paints and colors. I got one of every tube made and tried them all out. That broadened my perspective for color far more than the Albers color course. If I had been interested in theories, I would not be painting realistically, which I started doing to get away from theory. So I'm not interested in warm and cool colors or what kind of palette one should be using. I just get all the colors I can find and look at things and use the colors where they make sense.

You use very good paints now?

I've used all kinds of paint, but I've really narrowed them down. I'm using mostly Blockx and Oudt Holland—a little Lefranc. It certainly makes a difference.

You put in the lighter and more transparent colors first. Is it a process of continually working toward more detail and articulation?

I'll work out one area completely and then go on to another because I am interested in actually seeing that part complete. I have an idea of how the painting is going to be constructed—where it is going to be very dark and where it isn't. But I don't ever block in the whole painting because then I would be stuck with it. The underpainting comes through as a ghost, you know, pentimento. I don't want to make a mistake at that point, so I keep working out the relationships. Within a small

area I might work from the general to the specific, but mostly I just do whatever makes the painting work.

In the end it's not thick paint, but it looks like fat paint over pretty much the entire surface.

That's because I just keep doing things. For instance, I trained myself to be able to make the same line over and over again so that painting the lip of a glass would result in one curve. I used to draw it in black and gather up too much white into the black. It would come out gray, so I would paint it again in black. Now at least I have the physical control to follow that line again. Then the black can be wrong and I can do it again in blue. That's one of the things that takes a long time to do, getting each line and mark the right color. I can put the line down again in the same place so it looks like I only did it once.

"If I had been interested in theories, I would not be painting realistically, which I started doing to get away from theory."

So you are painting wet-into-wet?

I may work on one area for a couple of days, so by the next day the paint is a little tacky. It's easier to paint into wet or tacky paint because it can be scraped down if it doesn't work. It's a pain in the ass to sand down the dry paint to correct a mistake.

I remember the first time I was in your studio, around 1974 or 1975, you had a setup of drinking glasses on a mirror, and I was really shocked to see that you were painting from the top straight down to the bottom.

In a sense I still work that way, but I don't always paint from top to bottom. The advantage is that if the paint drips, it doesn't get onto the finished parts. I try to paint every object exactly the way I perceive it. I paint as true to the still life as I can throughout the painting until it is done. At that point I look at the painting and decide whether I have made mistakes. If I have, I go back and try to correct them, but I try to make decisions that won't tone the painting down—like making it all one color or

tone. That's the easiest way to resolve a painting. Anything can work if it's all brown or all gray. You can make it hold together, but you lose the vitality. I want something that has a lot of energy. The problem, if the painting is a real dog, is how to make it work without destroying it.

So you don't scrap a painting?

I hate to scrap a painting. I can't give up. By then I have put a month into the damned thing, so I will worry away at it until it is finally the best I can do.

Janet, you have recently begun to do portraits and figures combined with still life objects. What precipitated this move?

For many years I had seen no point in depicting the figure, but once I started to vary the elements of the still life and change the space, it seemed like a logical step.

Two major differences come immediately to mind. First, unlike a still life, a person is not inert. Does that dictate a change in the way they are painted?

No. My approach has not changed. I've always tried to analyze forms, decide the gesture of a form and the marks that would explain its peculiar character. A still life is not inert. Things decay, the light is always changing, and plants move with the light.

Second, your portraits are very good likenesses. You don't have the kind of leeway you would have with an object, and there is the added problem of expression. Have those aspects presented any difficulties?

I don't take liberties with the way I see an object; so I do want a likeness and I want the figure as well as the objects to have a sense of physical presence.

The real problem created by the introduction of the figure is one of content. One's impression of an individual's appearance is an amorphous composite of many moments colored by one's attitudes. This impression will never be satisfied by any single image or even a reel of film. Every gesture and slight twist of the features changes the expression and thus the meaning of the painting. Any single presentation of a figure is a statement of attitude. Gesture and color alter the content of a still life as well, but it is not so obvious.

I think an idealization or codification of the figure would be the easy way out

of this problem. But I have always been interested in things as they are seen in a particular light and place. Using the figure is making me that much more aware of how these individual elements are changed by their context.

Usually you are working on more than one painting, right?

Yes. I will have a morning painting or a rainy day painting, an afternoon painting maybe. The one I am working on now can be worked on at any time of the day, but sometimes a painting has such a definite light that I have to work on it at a certain time.

How long does it take to do a large painting?

That depends on the size. Usually about a month, but a very big painting takes a few months. I am talking about really working, not working one day and relaxing the next.

So you have very regular hours.

I am very regular, yes. I get up at about six and have some coffee, and I get started around seven or eight. Then I usually work until about six.

So you work eight-hour days five or six days a week.

Yes. Sometimes there is a day when I have appointments or errands, but basically I will work a whole week like that.

You mentioned that years ago you did some small landscapes, but I've never seen a small painting.

I haven't done one for years. I wouldn't be comfortable doing a small painting now. I want more of my arm and more of myself to be in a painting than is possible hunched over a small canvas making tiny brush marks. Just moving my wrist isn't my idea of painting.

What about the pastels? They aren't really studies. How do you separate the pastels from the paintings?

They are smaller, more relaxing, and have fewer elements. A lot of objects would cramp them. I would become simply a recorder of edges. Also, the pastel technique is different, and there are different things you can do with pastel. Draw a yellow line across a blue field and it comes out yellow instead of green. So there is a crispness that's possible with pastel. But the pastels don't relate to the paintings at all.

6 Vinegar Bottles (1972), 36¼″ × 36¼″ (92 × 92 cm), oil on canvas. Courtesy Kornblee Gallery, New York.

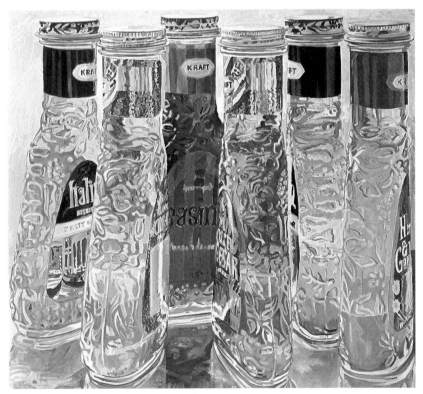

Kraft Salad Dressing (1973), 44″ × 40″ (112 × 102 cm), oil on canvas. Courtesy Kornblee Gallery, New York.

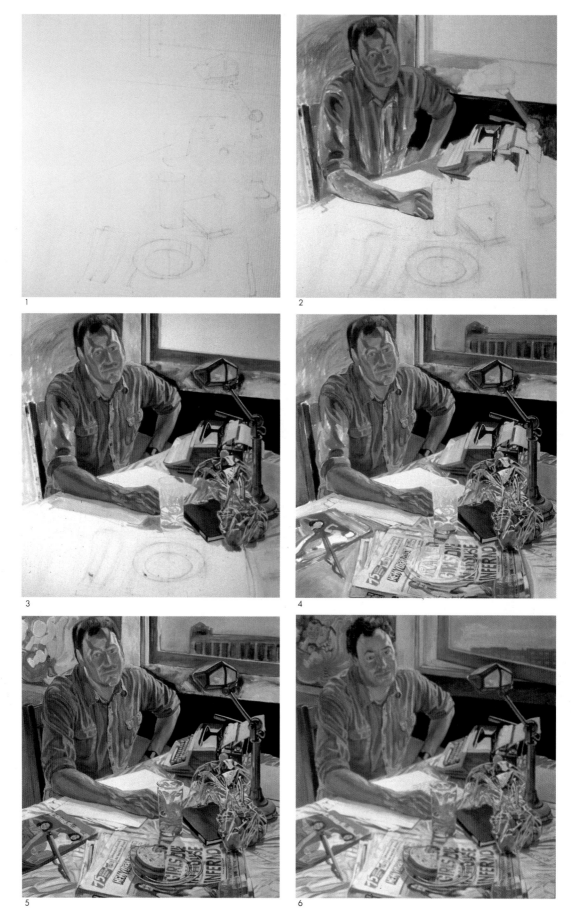

1　　　　　　　　　　　　　　　2

3　　　　　　　　　　　　　　　4

5　　　　　　　　　　　　　　　6

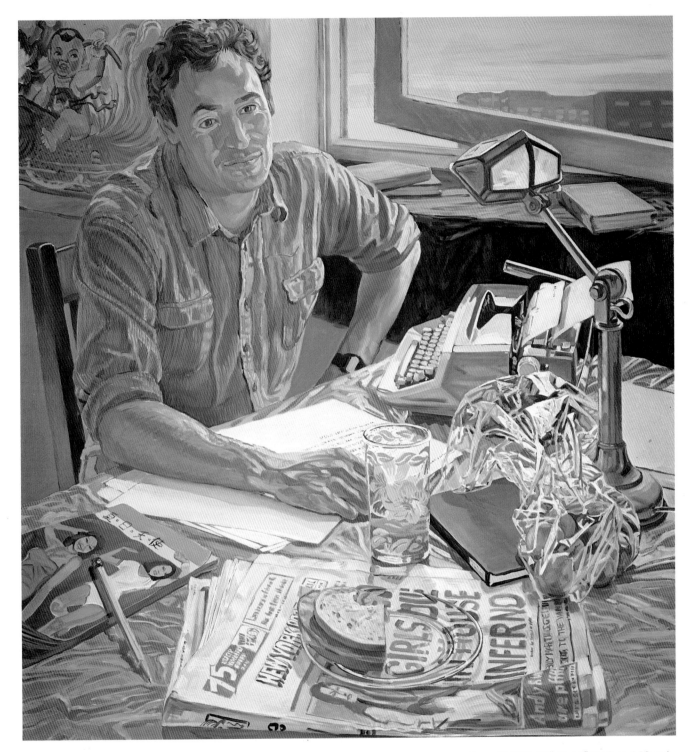

1. Still life objects are drawn in with a water-soluble architect's pencil.

2. Next, the figure is blocked in with oil. Fish is working directly from the model.

3. Some of the still life objects are blocked in, and the figure is developed further.

4. At this stage, the entire painting has been blocked in with color.

5. Further development of the still life elements and figure.

6. The building and window are changed, and other parts of the painting are further finished.

Barry (1982), 56″ × 60″ (142 × 152 cm), oil on canvas. Private Collection. Courtesy Robert Miller Gallery, New York.

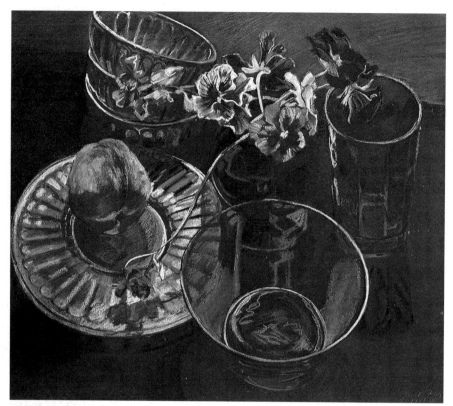

Peaches and Pansies (1981), 28½″ × 25″ (72 × 63.5 cm), pastel on paper. Courtesy Robert Miller Gallery, New York.

Also, I have never seen a monochromatic drawing.

I haven't done one for years. Every time I think about doing black-and-white drawings, I get depressed. Color is too important to me.

You have done a few prints, but you have never gotten too involved with printmaking. Is that because the process is so indirect?

Yes. To get the kind of complexity that I would like to have in a print, it's necessary to have the drawing worked out in advance. Then to get the colors to interlock—and the flatness of prints is deadly, as far as I'm concerned. I've considered doing some etchings, but printmaking is so predetermined, so intellectual, you really have to work things out ahead of time. I like to put a color down and see immediately how it relates to another color.

You have never gotten too involved with teaching.

Earlier I was very interested in teaching. I needed a job, but nobody was interested in hiring me. That was before women's lib. Gradually I began to

sell paintings and was less and less interested in teaching. I would take visiting artist jobs, which would give me some security, but I don't respond well to a regular teaching job. I don't mind the students, but I object to the schedule. It's too depressing and I don't want to live like I am in college all my life, so finally I just said, "To hell with it. I don't want my life to begin in the spring and end in the fall." Also, you begin to believe what you are saying. A lot of teachers make up rules for students, and they seem to believe their rules, and that's crazy, getting locked into some theory. It's much more important to try to bring something out of yourself and put that into painting. All those theories are too small and too thin.

Similarly, I can remember being told in college that the late Vuillards were mediocre and disappointing paintings, and I remember the low regard for Church, Bierstadt, and Moran at that time. In fact, they were quite marvelous painters and they look better every year.

Well, it's sad to think of all the kids coming out of different schools and being taught to dislike certain kinds of

painting. It takes so long to be able to look at paintings and forget what your teachers told you about them. I was taught that Franz Kline was an awful painter by a teacher who was very antagonistic to abstract painting.

Was this at Smith, in Leonard Baskin's class?

Yes. I remember Baskin telling me how bad Abstract Expressionism was, and now I think those are some of the most wonderful paintings. Also, we were taught that the Pre-Raphaelites were absolutely awful painters. I still can't quite get into those vapid teenage English faces with their pouting lips, but I love a lot of things about the paintings.

What was beneficial about studying with Baskin?

Discipline, but I probably already had that. He would make us do pen-and-ink drawings of water for a semester or draw a shell for a month. By the time you have done that, if you are still interested in art, you must be really interested.

What about his criticisms?

He was very opinionated and believed only in himself, I think. I did little "Leonard Baskins" when I studied with him because I didn't know any better.

I've heard that's what everyone did.

That's why Alex Katz was so important to me.

Was this at Yale?

I went from Smith to Yale, and Alex Katz was teaching freshman painting. He was such a breath of fresh air after Baskin. Alex was very hip to everything that was going on in New York, talking about shows and telling us about artists we had never heard about, which was wonderful. He was an important teacher.

Do you remember when George Nick got Yale to bring in Edwin Dickinson?

He came as a visiting artist. What a sweetheart. He carried a mummy's eye in his pocket, and he had one criticism, one piece of praise, and one handy hint for each student. I can't remember the criticism or the praise, but I will always remember the handy hint. He told me how to make my brushes last longer. You hold them under hot water until the

Asters and Goldenrod (1981) 62″ × 40″ (157 × 102 cm), oil on canvas. Courtesy Robert Miller Gallery, New York.

glue is loose and pull the bristles out a bit further. Then hammer them back tight. The brushes will last weeks longer!

There must be at least twenty well-known artists who emerged from the Yale graduate school at that time—Chuck Close, Stephen Posen, Joseph Raffael, Rackstraw Downes, Harriet Shorr—you were all classmates. I assume that most of them were doing abstract painting.

Albers had retired and there was a power struggle. Teachers were coming and going, being fired and rehired. Good people were coming through, but there was no esthetic position. The art students had to figure things out for themselves. The school closed at ten p.m., and we would go to the bars and fight it out. Artists were coming in all the time, but there wasn't a "big daddy" to tell us what was what. Combined with the quality of the students, the situation made for a lot of disturbance and a lot of energy. There was constant

friction—trying to define what painting was for ourselves, arguing about what was good and bad, with no authority figure. As a result, a lot of people came out of there, but they were all working very differently.

At the time, almost all of us were doing abstractions, but I started painting still lifes there. One summer at Skowhegan [summer art school in northern Maine] I started painting landscapes. I was doing abstract paintings and they didn't mean anything to me, so I started to paint landscapes. They were very brushy and close to California painting—Diebenkorn, Park. I was thrilled with David Park.

At Yale no one would talk to me once I started doing those landscapes. When I was thrashing around, pouring paint and doing that sort of thing, I got lots of crits, but when I started painting landscapes and still lifes—I mean you've got to figure, here is this girl painting teeny, tiny flowers. No one was going to talk to me. Sometimes I wonder if I became a

Realist just to keep people from talking to me. Then I painted still lifes that were like landscapes. I began to get more and more specific, which was part of getting outside my head and finding out what was out there, getting away from the theories and trying to find out what the hell painting was going to be for me. I painted pictures of parking lots and cars, figures, still lifes, and a whole pile of landscapes, and they were very brushy.

But landscape was too general and I guess I wanted to be more specific. So I decided as an exercise I would try to make myself be more specific and just paint volumes. From that I tried to eliminate from the painting anything that I wasn't interested in. I started knocking everything out except the form of the object and its volume. Gradually I went from making very small paintings of potatoes and things to enlarging the size of the objects because I wanted the specifics of the form and was interested in the paint quality. Also,

I was concerned about the ideas of image and wanted an image that was impressive and came forward from the painting surface out into space rather than receding. I began to increase the size of the canvas until I found a scale that worked.

I have never decided in advance that "I am going to do this or that." My whole reason for painting realistically was to get away from predetermined theories. The paintings have always taken a long time, and one decision has always led to another. I was painting vegetables, which sat in the window, and I could look at them and look at them. A desire to get rid of certain compositional elements led me to paint them in packages. The packages brought in the play of light on clear plastic, and I became interested in the movement of light on the forms, which led into painting glass.

I have seen only a couple of those vegetable paintings. A major shift occurred when you began painting the shrink-wrapped packages of fruit and vegetables. Previously you were dealing with solid forms and local color, but with the plastic wrapping you had reflections and transparencies over the forms.

Yes. The plastic complicated the image and brought in patterns that swept over the objects. Light united the forms. When I started working with glass, I was able to define my interest as being in the light. The glasses were containers for the light. They caught it and held it. That led to painting bottles. Now I am trying to take the splintered movements and the energy that I found in the light patterns of the glass and carry it through the painting via other objects, forms, and shadows.

Once you have firmed up your ideas, know pretty much what you are doing and who you are, no one can tell you what to paint. That the paintings sell or don't sell won't make you change; you are painting because you want to paint. Only students change. They can be swayed because they don't know who they are. Once you know who you are, you can't be told by a critic or a dealer to change your paintings. Often they are so cuckoo. They tell you so much junk.

Since the early seventies your work has sold very well.

I have been very lucky.

Now you have a Keogh plan and own a loft and a place in Vermont. Unfortunately, the whole business side isn't learned in art school.

I learned about business the hard way. Every time I made a mistake, I figured out some way not to make it again. I wish I had learned something about it in school because, ideally, selling a painting buys you more time to paint.

Someone who really wanted to make money would go into another field. I think I had the brains to be a lawyer or something else. I decided that if I was going to be a painter, I was going to paint what I wanted. I have been very lucky; what I have wanted to paint has been what some other people have wanted to buy.

(Page 80, top) *Bag of Pears* (1982), 70″ × 42″ (178 × 107 cm), oil on canvas. Private collection. Courtesy Robert Miller Gallery, New York.

(Page 80, bottom left) *August and the Red Glass* (1976), 72″ × 60″ (183 × 152 cm), oil on canvas. Courtesy Kornblee Gallery, New York.

(Page 80, bottom right) *Darlene Sleeping* (1982), 30¼″ × 41½″ (77 × 105 cm), pastel on paper. Courtesy Robert Miller Gallery, New York.

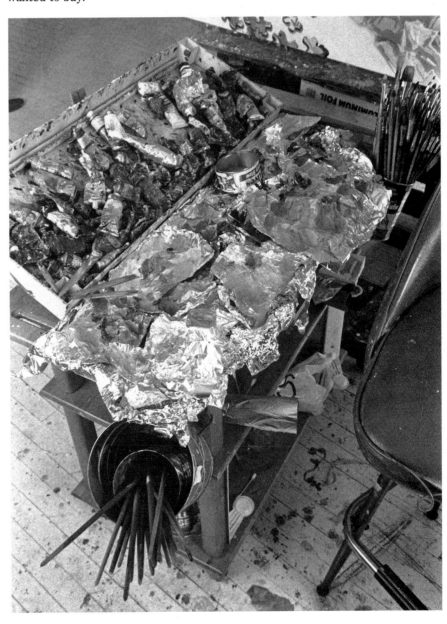

RALPH GOINGS

Ralph Goings gained national prominence in the early seventies through his paintings of pickup trucks and fast food chains. Those pictures contain an air of irony and detachment that is a typical aspect of Photorealism, but after Goings moved from the West Coast to rural New York in 1974, his paintings and watercolors depicted small town diners and their inhabitants and diner still lifes. Goings' paintings adhere closely to the characteristics of the color photograph and are rendered with an almost invisible hand. His recent work is best considered in the context of genre painting, for they accurately reflect the ambience of the rural American town, replete with all its details.

Ralph and Shanna Goings live in a large old farmhouse that sits on a ribbon-straight asphalt road threading through a beautiful valley. A small barn, which is one of several outbuildings, has been converted into a studio, and a watercolor and storage room has been built on. The studio is compact, efficient, and fastidious.

"The 'picturesqueness' of a subject can cancel out any potency that the subject has. I think the subject has to be mundane, so ordinary it's almost boring, before it can have any real significance as a painting."

Diner with Red Door (1979), 60½" × 44¼" (154 × 112 cm), oil on canvas. Collection Mrs. Joyce Bogart.

The first of your paintings I can remember seeing were the women standing on boxes. That was in the 1969 Milwaukee exhibit, Aspects of a New Realism. *But by then I think you'd already started some of the pickup paintings, isn't that right?*

Right.

Also, that was one of the first major exhibits of contemporary Realism. How familiar were you at the time with other Photorealists, such as Richard Estes, Malcolm Morley, and Robert Bechtle?

I didn't know what they were doing. Jack Taylor came out to see me in California when he was putting the Milwaukee show together. He had written to me and explained who he was, but he didn't say anything about the exhibit. When he arrived and we started talking about the Realist show he was putting together, I was really surprised, because I didn't know there were that many people doing Realism. I was aware of Bechtle because he lived in the Bay Area, although, at that time, we didn't see each other at all. I would see his work occasionally in Bay Area group shows, but as for the painters in the East or Midwest who were doing similar things, I wasn't aware of them at all, and I was really surprised that he was able to get enough work to mount a show based on that premise.

Had you seen any of Richard Estes' paintings? His first exhibit was 1968.

No, I had never been to New York until my first show in 1970, so I wasn't aware of what was going on in the galleries.

You were teaching in high school.

Yes, for fifteen years, then about a year and a half at Davis [University of California at Davis].

The pickups and Airstream trailer certainly moved you into the mainstream of Photorealism. How did the change from the paintings of women on boxes to the pickups come about?

This is a story I've told a thousand times.

It actually goes back further than that. Up until 1962, I was trying to be an abstract painter and it wasn't working out. I quit painting for a year. I didn't do anything because I was really at a loss. I couldn't find a direction that fit with abstraction.

Teaching in high school, you use every device and gimmick you can, and I had the kids in some of the beginning classes doing a lot of paste-up things with magazine photographs. So there were always boxes of magazine photographs around which I collected—not with any particular theme, just photographs that interested me for one reason or another. Sometimes I would make collages from them. At any rate, in 1963 I wanted to start painting again but decided I wasn't going to do abstract pictures. It occurred to me that I should go as far to the opposite as I could, which was in part an intellectual process, partly intuitive, and also because of what was at hand.

> **"To copy a photograph literally was considered a bad thing to do. It went against all of my art school training and went against what everybody else was doing—at least that I knew."**

One day I was looking through the boxes of photographs in the studio and I thought, "What would happen if I were to copy one of these on the canvas, just to see if I could do it and just for something to do." It was something to occupy me because I was really at a loss, really at a low place. I picked out a photograph with a couple of figures in it and sketched them on a little canvas with a piece of charcoal and dug out what few little brushes I had (I'd been painting abstract pictures and had all these big brushes). Then I tried literally to copy the photograph on the canvas, and it was a hell of a lot of fun! I spent about a week painting these two figures, then I rummaged around in my box of photographs and found a photo of an object—and painted that on the same canvas with the figures. After two or three weeks of taking things from different photographs, I filled up the canvas. It was like a collage of photographs, all fitted together, but painted with oils. I was having a great time.

That led to a series of paintings in a somewhat more serious vein, based on magazine photographs—juxtaposed images from unrelated sources. There was no particular intent to make a com-ment by the juxtapositions. I was simply painting objects that looked like they would be interesting to paint. Maybe some Ritz crackers with a pretty girl from a fashion ad. There was no relationship other than a visual, tactile one.

As I did more, I got a little better and a little better, and finally the magazine ads didn't provide enough. I began to get a notion of the kind of images I wanted and spent days looking through hundreds of magazines trying to find a particular form or image. Finally it occurred to me that I could take my own photographs and wouldn't have to rely on magazines. Oddly enough, I started out with black and white.

The first part of that series of girl pictures you mentioned were done from black-and-white photographs.

You were drawing those on the canvas; you weren't projecting them?

Right. In the beginning they were just blocked in with charcoal or pencil. There was a lot of sloshing around with very thin paint to develop the drawings, but the finished paintings had a photographic look. I didn't show any of these to anyone. Most of the artists I knew in the Sacramento area were really macho abstract painters, and I didn't want them to ridicule me, so I just told them, no, I'm not working anymore. Finally a couple of them saw what I was doing and they made fun of it. I really kind of enjoyed the fact that they thought that what I was doing was so outrageous, that it was really awful to copy a photograph. So I thought, how can I make it even more awful—just as despicable as possible? It occurred to me that projecting and tracing the photograph instead of copying it freehand would be even more shocking.

First, I projected black-and-white negatives, which was pretty funny—trying to trace a negative with everything reversed. That presented a lot of interesting problems that probably could have led into an entirely different direction if I had pursued it, but I decided that if I was going to project the images, I should shoot slides so I would have a positive image. Color slides are so nice anyway. The last three or four pictures of the women were done from projected slides.

I wasn't terribly single-minded about the image. At the time I was doing the women, I was also doing other things.

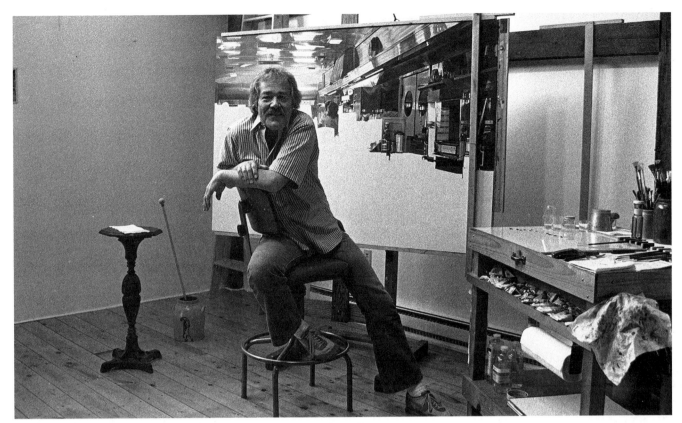

Some were combinations of slides and images from magazine photographs—kind of a mishmash of things. I wasn't so much interested in the image as in the process of painting it. I was learning to make the painting look the way I wanted it to look. I had a notion about how the surface should be and how the colors should look.

The notion that projecting was a despicable thing to do led to expanding on that to being as despicable as possible about the process. To copy a photograph literally was considered a bad thing to do. It went against all of my art school training and went against what everybody else was doing—at least that I knew. Some people were upset by what I was doing and said, "It's not art. It can't possibly be art." That gave me encouragement in a perverse way, because I was delighted to be doing something that was really upsetting people. It irritated their notions of what art was, and I didn't really care if it was art or not. I was having a hell of a lot of fun learning how to paint images.

That working process has, over the years, become legitimate, at least to most people. But originally it flew in the face of the status quo. All through my career, as an art student and in my association with other artists, there

was always this idea that you had to develop a painting in its total—a little bit here, a little bit there. You brought it to completion as a whole, instead of finishing one little part and going on to another. I thought, what the hell, I'll start at the top in the upper left-hand corner, and when I get to the lower right-hand corner I'll be finished. I'll do everything as right as I can get it before I go on to the next little space. It was like reading from the top down and from left to right.

You were painting the pickups at that point?

Yes.

With those paintings of the trucks, Ralph, you were depicting a commonplace subject in a specific locale, which is quite a move from the women on boxes, which were artificial and obviously posed.

Yes. The women were posed.

Those paintings of pickups and trucks really brought you into national prominence as a painter.

Most of the Photorealists have tended to pick a certain subject, and they really don't stray too far from a particular iconography. We identify them more from

the subject than from style of content. I'm thinking of John Salt's wrecked cars, John Kacere's asses, and Richard McLean's horses. It's a bit superficial. How do you feel about that aspect?

I've thought about it a lot. I think it happened because we all came on the scene at about the same time. I was painting trucks, Richard McLean was painting horses, Estes was painting street scenes, and we all got tagged. If you look at our paintings side by side, there are obvious technical and stylistic differences. But the eye of the art community was accustomed to such a different kind of painting up to that point that all Realist painters looked alike. I think most people could distinguish one artist from another only by subject matter.

This has been a thorn in my side and also a stimulus, because it occurred to me that this was another one of those things: an expectancy or attitude developed by the people who look at an artist's work, which becomes a sort of tacit agreement that a painter doesn't violate. So I felt compelled to violate it by finding other subjects. At the same time it brought around a new notion about the subject matter of painting and the fact that the subject matter is important.

But I think that is a major distinction, Ralph.

Yes, it is.

Image as opposed to content. Most of the Photorealists put the emphasis on the image and seldom move their subject beyond its inherent banality. There is no subtlety or nuance. I think the big shift in your work—at least, it was the point where I really warmed up to your paintings— was when the subject and content seemed to become the dominant factors.

It's an ongoing process with me. Every opportunity to find a chink, something that was or is a no-no. If you think about it, subject matter in twentieth-century American painting has not been too important for its own sake. Well, I'm getting into trouble here because you are going to throw the Ash Can group at me, and they had a tag on significant subject matter. But most modernist thinking hasn't allowed for the importance of subject matter. The subject is simply a vehicle, a means to an end.

Clive Bell's significant form, et cetera.

Yes. So we again have realistic painting,

painting that goes out of its way to "copy" reality. This is one of those knee-jerk words that I really like because the camera makes a "copy," a chemical, mechanical copy. I take the photograph and I make a copy, translating the image the camera made into a painted image that is in many ways much like the photographic image. There's an element of style there that nobody has touched on.

Along with all this, we can talk about painters like Morley who were the precursors. Morley was making a literal copy of a picture postcard or whatever, but he went to great pains to point out that the image represented was not particularly important. It was the process that was important. The subject matter depicted was simply what he happened to use. But why couldn't subject matter be meaningful in a new way?

We have scorned subject matter in the past because it got so cloying in the nineteenth century, especially with the Victorians and all of the sticky, ickyness of their subject matter.

I think the impersonal character of the photograph leads to a rather de-

(Page 86, top) *Burger Chef Interior* (1972), 56½" × 49" (144 × 124 cm), oil on canvas. Collection Sydney and Frances Lewis.

(Page 86, bottom) *Safeway Interior* (1974), 68" × 48" (173 × 122 cm), oil on canvas. Courtesy Edmund Pillsbury Family Collection, Fort Worth.

(Above) *Pie Case* (1975), 34" × 24" (86 × 61 cm), oil on canvas. Collection Sheldon Art Museum, Lincoln, Nebraska.

Georgie's (1973), 40″ × 40″ (102 × 102 cm), oil on canvas. Collection M. Mojet.

probably would not have made sense visually.

We grew up on Life, Look, National Geographic, *and the movies. Our generation in particular was tuned in to photography.*

Right. Photographs are as much a part of our environment as air.

I remember reading an account by an anthropologist who showed a primitive tribe with tattooed faces some Polariod photographs of themselves. No one could recognize himself, his wife, or his friends. But when the anthropologist showed them schematic drawings of their tattooes, they could recognize anyone in the village. Interpreting photographic information is an acquired ability that separates us not only from them but from those artists working prior to photography. A painter can move away from or toward its influence, but photography cannot be ignored.

But, to continue, were your paintings, such as the Burger Chefs *and Mc-Donald's, done on the West Coast?*

Yes. They actually grew out of the paintings of pickup trucks, which were sometimes in their parking lots. It was just a matter of pulling back or moving over and there they were.

A major shift in your choice of subject matter seems to have coincided with your move to New York State in 1974. You began to include the people in the truck stops and diners. I think the fast food chains were always empty.

They were, and that was conscious.

I would assume that sometimes you were taking them out. There must have been people in your photographs.

I did. At that point I thought the human figure would be visually and intellectually more important than the environment and all the little details. I didn't want to emphasize any one element. I wanted all things equal, as they were in the photograph. The camera isn't selective. It simply records whatever it's aimed at. I wanted that same quality in my paintings, and it seemed that the camera was neutralizing the figures, but the very fact that they were people seemed to make them more important. I came around to the idea that people could work in the paintings if they were treated with as much or as little atten-

tached kind of painting in most photo-derived work, which gives us a chance to deal with the subject matter in a rather impersonal way, yet, at the same time, depicts subjects that are significant to our time and our society. It has meaning, but not in a literal or anecdotal sense. I think that Photorealist subject matter is important on one hand because it's an aspect of this particular moment.

But that has been one of the most important elements of Realism from Courbet through contemporary Realism.

Except that there's a problem in this. The element of the picturesque has to be avoided, I think. The "picturesqueness" of a subject can cancel out any potency that the subject has. I think the subject has to be mundane, so ordinary it's almost boring, before it can have any real significance as a painting.

A lot of the best Realism and Photorealism is of subjects that people ignore in a first-hand encounter. No one is really attracted to the actual streets Estes has painted.

No, and you can't see the streets the way he sees them. Even with style and emphasis aside, you can't really see one of those particular streets as a visual feast until a piece of it is separated and put on a nice white wall. Then you can focus on it. This is the valuable thing that photography allows a painter to do—take a chunk of reality with all of its random disorder and, by putting a frame around it, isolate a little section. So what if a little piece of something goes out the side of the picture? If you were composing on a sketchpad, you'd tidy everything up, keep the prominent forms from jutting out the edges. That's the way we have been taught—not to have awkward juxtapositions. We have been taught to make them overlap or keep them apart so that it's clear what's happening. But we're able to read photographs, so when photographic information is translated into painting, it has meaning now. Before photography, it

tion as everything else. They could exist compatibly with the ketchup bottles, counters, windows, et cetera. In some instances they seem to be a necessary part of the environment.

This has nothing to do with technique or style. It has to do with the look of the fast food places in California. They seemed better without the people because the dominant aspect seemed to be the inanimate objects and the light. In the West, all of them have large windows with lots of light coming in. Also, when I first started doing the fast food places, I wanted to show part of the inside, but with a view out the window so that you were aware of the environment outside. There were a number of pictures, such as the *Kentucky Fried Chicken* painting, in which the outside was more prominent. And there's another painting of a supermarket interior in a collection in Canada that I like even better. Through the long windows you see the parking lot and, beyond, two or three blocks down the street. That painting was really the epitome of the notion of being on the inside looking out, with the sunshine streaming in making patterns on the floor.

Then I got away from painting the windows to emphasizing an interior view, and the figures seemed to be more compatible with that space.

Another aspect of the fast food chains, such as those you painted on the West Coast, is that the entire building is a trademark. No matter which Kentucky Fried Chicken you stop at, the colors, the lights, booths, and menus are always the same.

Yes. That's why it was important to show something beyond the windows; the environment identified the location.

The big change in the subjects you're now painting is that each diner and truck stop is unique.

Well, that really struck me when I moved here. I was not familiar with the country diner as it exists in the East, especially the stainless steel diner. They aren't on the West Coast at all. The closest thing to the eastern diner in California is the coffee shop or the small cafe. But the small cafe in California aspires to be like a fast food chain. It has to do with the way it deports itself, the kind of counters and stools it has, and so

forth. Whereas the diners here in the East, many of them are old buildings. Most of the stainless steel diners were made in New Jersey in the thirties, some in the twenties, so they have an element of architectural interest. They're a unique kind of enclosed space—long, narrow buildings with long counters and shiny surfaces, not very big windows in most of them. That has to do with the location.

> ## "I think all Photorealism is genre painting. The photograph makes the subject specific and particular, and it's verifiable."

But the new paintings, Ralph, the paintings from the past five years, I think could accurately be described as genre.

Yes, they are. I think all Photorealism is genre painting. The photograph makes the subject specific and particular, and it's verifiable. The painting depicts an everyday scene, a real place. Richard McLean's horses are specific horses, horses that are bred to show, and the owners are very proud of them. You can go to any one of the diners I've painted and say, yes, I recognize this place. You might even see the same people in them.

Maybe what I've described is genre painting of contemporary subjects, but to me one of the most important aspects of Photorealist painting is that specificity—the images are verifiable.

Another thing that struck me about Richard Estes' paintings is that he has made us see aspects of the city that we have previously overlooked, which I think is a very valuable aspect. Once, in a cab in New York, I saw Helene's Florist flash past, and, of course, even with all of the street activity, I recognized it immediately, but what struck me was that the painting is silent.

Yes, and it's also static.

Silent, static, frozen, and isolated.

Well, those things focus the image for you.

When I was doing the pickup trucks, people would see the paintings and immediately start telling me about terrific

pickup trucks they had seen and end up saying they had never paid that much attention to pickup trucks before. I'd always thought of them as just trucks and wasn't interested in the pickup culture. I was just interested in the way they looked.

I'm interested in the look of diners, and I'm sure Richard McLean is interested in the way horses look. That's what Photorealism is all about. Taking these things and saying, "This is the way this looks. Isn't it fantastic?"

Do you shoot a lot of slides?

Yes, lots—hundreds of them.

And very few eventually end up being painted.

Oh, yes. If I can get one slide that has possibilities out of a whole roll of film, I feel very lucky. Sometimes I get only one out of six rolls of film.

Can you describe how you decide which one you think will make a painting? Is it just the formal qualities?

It's a lot of things, I suppose. The selection is mostly intuitive. I go out for a day or take a two- or three-day trip, and I come back with six or eight rolls of film that I've shot. I send them off to be processed, and when I get the slides back, I spend a day or two projecting them in the studio, just looking at one after another. I eliminate the ones that just don't do anything for me and end up with about a half-dozen. I put those away and take them out again in two or three weeks and look at them again. Then I usually eliminate a couple more. A lot of factors are all meshed together.

One thing I've been curious about, which is a rather mundane technical question—when you're shooting interiors, a lot of the view outside the window is shown in great detail. Do you use tungsten or daylight film?

I always use daylight film—Kodachrome, never Ektachrome, which is too blue and does unpleasant things to artificial light. Kodachrome distorts artificial light—it's not naturalistic color or light—but the distortions are interesting. Ektachrome just goes all green or blue in artificial light.

Are the still lifes always photographed exactly the way you find them in the diner?

Still Life with Coffee (1982), 52″ × 38″ (132 × 97 cm), oil on canvas. Collection Mr. and Mrs. Stephen Alpert.

Still Life with Flowers (1978), 8½″ × 12″ (22 × 30 cm), watercolor on paper. Private collection.

Cream Pie (1979), 36″ × 26″ (91 × 66 cm), oil on canvas. Collection Danielle Filippachi.

Schoharie Diner (1979), 64″ × 48″ (163 × 122 cm), oil on canvas. Collection Milwaukee Art Center.

Occasionally I will turn a ketchup bottle so that the label is away from me—I've painted so many Heinz labels. But I don't change the setup because each counter arrangement is an example of the sensibility of the person working behind the counter. Each one is a little bit different. Sometimes all the salt and pepper shakers are in front of the napkin holder, sometimes they are divided with one on each side, and sometimes they are both on the right side and the ketchup bottle is opposite.

You'll notice, however, that in each diner all of the arrangements along the counter are the same. If the ketchup bottle is on the right-hand side of the napkin holder, it's on the right-hand side of all the napkin holders. Should you put it on the left, soon whoever is working behind the counter will come by and put the ketchup bottle back over on the other side. They all have worked out a routine, and they stick with it. It's incredible.

And very amusing. So, once you have selected a slide for use in a painting, you get a color print.

Yes. Often I'll have three or four slides that I think are good, so I send them off and have prints made. Maybe only one of them will be used. I have a lot of prints in the storeroom that will never get made into paintings, and I suppose I could waste a lot of money on prints. But it seems to help. When you see the image projected, it looks incredible because the color in Kodachrome slides is beautiful. If I could find some way to work directly from the slide, that would be the best of all possible worlds. But I can't work it out. I know people get big transparencies made from slides and I've tried that, but it's not the same as a projected image.

Yes. Valerio shoots eight-by-ten transparencies and he has a lightbox rigged up on a little easel, which is right beside the painting. There's a lot of information in a transparency that size. Another thing you mentioned regarding the shape of the canvas—it is similar to the proportion of the slide. Does that mean that you aren't cropping that much?

No. If there is any cropping, it's within the ratio of the slide, because I have the stretcher bars made in the same proportion as a slide. If I pull the projector back, then I can crop off on either end or both ends, top and bottom. It's a matter of moving the projector forward or back. Occasionally I do a square painting, like the little one over there.

Those are mostly still lifes, aren't they?

Yes, but I've done some diner pictures on a square format too. I always keep

Sherwin Williams Chevy (1975), 62" × 44" (157 × 112 cm), oil on canvas. Collection Museum of Modern Art, New York.

square canvases on hand because occasionally a slide seems right with the ends cropped off.

What kind of canvas are you working on? Is it presized?

Yes. This one is. It varies. Sometimes I prime it myself, other times I use commercially primed canvas.

And what do you use as a primer?

Acrylic gesso or rabbitskin glue and white lead. I can't seem to bring myself around to doing things the same way every time. It's too dull.

The different kinds of surfaces don't bother you?

Sometimes, at the beginning of a painting. It will take a little while to see exactly how a particular canvas is going to work. Sometimes it will take me two weeks to figure that out, and that gets to be a little nerve-wracking. I find myself taking risks simply by setting up situations where I'm doing something in a different way than I've done before, simply to see if I can.

Your canvas has a fairly smooth surface.

Sometimes, sometimes very rough. This little canvas over here is very rough.

And it's linen.

Right. I always use linen.

How do you arrive at the scale, the size to make a particular painting?

In the diner interiors, like this one, there is so much stuff, so many objects. The little objects on the counter have to be big enough to deal with in the painting. Generally I have no scheme for determining the scale for the diner interiors. They can be relatively small or large. I don't think it makes that much difference.

But this is about as large as you work, right?

Yes. I have four standard sizes that run from about thirty-four by forty up to fifty-four by sixty-eight inches. They're all the same proportioned rectangle, which is based on the shape of a 35 millimeter slide. Basically, there are four graduated sizes. If I've just done a large painting, then usually I do a middle-size or little one. I did a series of diner still life pictures last year of very similar subjects: a ketchup bottle, a napkin holder, and salt and pepper shakers. All of them were the same size, forty-two by fifty-six inches. In those, my concern with the scale had to do with the size of the ketchup bottle.

When I started the countertop still lifes, I did them only as watercolors. They were never more than about ten

by twelve. The first oil still lifes were small so that the objects would not be much larger than actual size. I was chewing on the idea that, if objects are painted larger than life size, where does that place the work in relation to Pop Art—or the use of commercial images on a gigantic scale, like James Rosenquist, for instance. Over the years I have tried making the objects larger and larger. So far I have not come to any set idea about the ideal size for a ketchup bottle. That's why I'm doing this drawing [a drawing on the studio wall that is 84 inches high].

You've got curtains on all the windows, and you darken the room to draw the image on the canvas with pencil. It looks like that's a very involved and tedious process.

Well, it's sort of a mindless process. The room is pitch dark and I can't see what I'm doing. It's more of a tactile process, simply a matter of tracing around everything. Especially in the dark areas, I can't even tell if I'm making a mark or not. The drawing is just kind of an armature. Actually, I draw in much more than I need to. I find myself not really paying much attention to a lot of the marks I put down. But I get going and it's dark and I can't see what I'm doing. I don't want to miss anything important, so I try to get everything.

Your line drawing is very elaborate, and you've mentioned that in the more recent paintings you really aren't editing out anything.

I'm editing some and I'm putting things together more in the last several years. This painting is not really a "put-together," but I don't like what was outside the window, so I'm changing it. I'm going to paint out-of-focus foliage because there was just more glass and bricks outside, not particularly interesting. Occasionally, if there is nothing outside the window, as in this case, or if I can't see anything outside because it's so overexposed in the slide, I find something from another photograph to put there. But the windows in this diner are so small, the view outside is not going to be that significant.

In the painting *Walt's Diner,* in which an elderly gentleman is sitting at the table by a big window, you see out the window and across the road to another diner. That was put together from two

Twin Springs Diner (1977), 52″ × 38″ (132 × 97 cm), oil on canvas. Collection Mr. and Mrs. Marvin Trachtenberg. Courtesy O. K. Harris Gallery.

different photographs. In the photograph for the interior, the outside was so overexposed that I couldn't tell what was there, and yet the windows were so large that something had to be shown to make it work.

Another thing you mentioned briefly was that things go in and out of focus in your paintings.

Yes, in the still lifes, but in the diner pictures I try to sharpen everything up as much as I can. There isn't a hard-and-fast rule for this, but focus is one of the characteristics of photography that I want to translate into painting. In this one [*Ralph's Diner*] those objects on the counter on the right-hand side are going to be a little out of focus so that, as you move back in the picture, everything sharpens, but I want it to be gradual. I think that focus is one of the visual characteristics of a photograph

that can be utilized in a painting as a spatial element.

There are other things in the photograph that I have tried to translate into stylistic painting devices. A lot of times the way the light affects an object in a photograph is contrary to our knowledge of its form in reality. I find myself drawn into accepting the way the photograph has interpreted that form as light falls on it, even if it's contrary to what I know to be visually logical. The painting ends up being a mix of photographic form and logical form, and I don't find that contradictory. It adds the kind of spiciness I like.

In the photograph, that ketchup bottle in front of the menu is even flatter than I'm making it in the painting because it's a bit out of focus, and the way the light hits it is odd. Intellectually, I can understand what is happening in the photograph, but in this case I want that

bottle to be a little more substantial, whereas in the case of the two waitresses, they become one form in the photograph. Because of the highlight on the hair of the girl closest to us, and the light part of the skin on the girl facing us, it's hard to tell where one ends and the other begins. It's something that happens in photographs that you don't see in reality, and that delights me. I really like that.

You started painting in the upper left-hand corner, and it looks like you're working across.

That's not a hard-and-fast rule. With this painting, I started at the upper left-hand corner and painted the ceiling first. Then I started across just below that, but there's so much dark on the right-hand side, I thought I should establish those darks before going any further, and I underpainted all of the

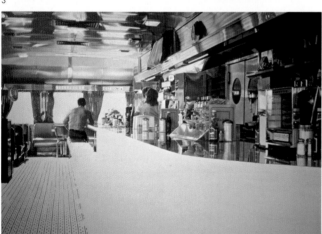

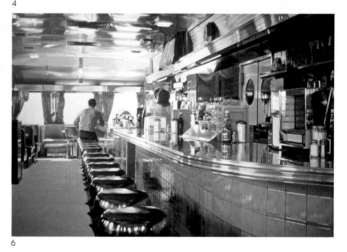

1. The painting is developed from the top of the canvas to the bottom. At this stage the upper half is completed, while the lower half remains unpainted.

2. This detail of the drawing illustrates the type and amount of information taken from the projected slide.

3. Detail of the waitresses indicates the incorporation of the photographic focus and indistinct edges in the background.

4. The pie case and countertop with its maze of reflections are finished.

5. The booths, curtains, and figure at the end of the counter are completed, and the pattern of the floor is indicated.

6. The tile work and stools are painted at this stage, but the view outside the windows will be taken from another slide.

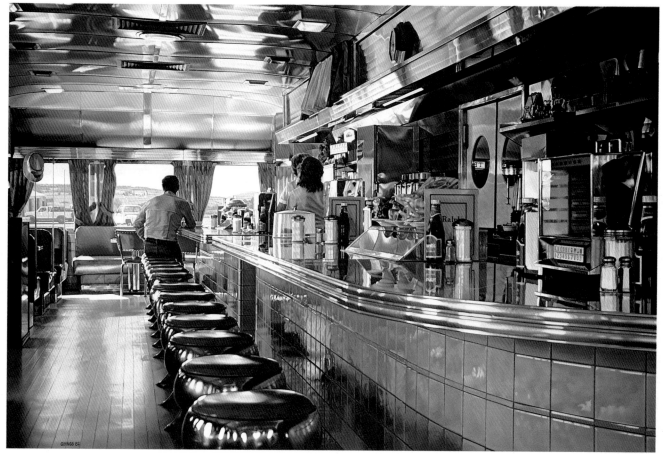

Ralph's Diner (1982), 66½″ × 44¼″ (169 × 112 cm), oil on canvas. Collection Mr. and Mrs. Stephen Alpert.

dark area. I have repainted parts of it, so that some of the dark area is finished and some is still underpainting. It's not completed.

When you say underpainting . . .

Just to establish the darks so that, when I come back and do the actual painting of those areas, the canvas will be substantially covered.

What is your vehicle in the underpainting?

It's just paint thinned with a lot of turpentine.

What about the overpainting?

The medium that I use is very simple—just linseed oil and turpentine and sometimes a little varnish. Nothing fancy.

But the overpainting has linseed oil.

Yes, and the paint is thicker. I use paint about the consistency of mayonnaise.

And you are working wet-into-wet?

Yes. That's my procedure. I try to get it

as right as I can. In a picture as complicated as this one, I'll have to go back and repaint a whole object—make changes and adjust things a little bit.

Are you working only on an area that can be completed in a day, as in fresco painting?

Just what I can do in the day, right.

What kind of paint do you use?

Mostly Winsor & Newton. Some Blockx. One color is Grumbacher. Over the years I have found particular colors by various manufacturers that I like, and I have a tendency to stick with them. I don't use a lot of colors. Maybe I have three reds, two yellows, three greens, and three blues.

You have very few colors out on the palette right now. Is that typical?

Yes, because I use so little paint.

How about black?

I try to avoid using black as a color. I mix black with other colors when I want

certain neutrals, but I try not to use black as black. Maybe that is part of my traditional training showing through.

Well, the black pigments have a tendency to be very dead and flat.

That's the problem. I find myself using the old Georges Braque black—a mixture of burnt umber and ultramarine blue.

How close are you staying to the tonality of the photograph?

That varies from picture to picture. I don't have any set procedure. The colors of the photograph that appeal to me I try to match. If there is an area I think I can make better than the photograph and still have the painting look as though it were derived from a photograph, then I'll change it. I don't go outside the scope of what seems to be derived from a photograph, because I want that element. Photo derivation is an important part of the style.

How do you separate an image you will

do as a watercolor from one you will do as an oil painting? Occasionally you have done watercolors and oils from the same photograph.

Very rarely. I know that McLean and Bechtle do both.

Also Close and Cottingham.

Yes, that's right. I've done it maybe three times. If I've done a watercolor or a painting from a particular photograph, I've dealt with what interested me in it, and so I don't get that excited about redoing it in another medium. The photograph I used for that black-and-white lithograph for the Tulsa exhibit [*Realism/Photorealism,* at the Philbrook Art Center] I had used for a watercolor. Reusing it for the little print put it into a completely different realm.

Yes, but I thought there was also an oil painting of that image. What determines which photographs will become watercolors?

It pretty much depends on the complexity. The watercolors are always small.

But they are not studies for paintings. They are independent works.

Yes. All the study, all the preparation for a painting is done with the slide projector—big paintings, little paintings, watercolors, whatever. I spend a lot of time with the slide in the projector, moving the projector around, cropping, looking at it as many different ways as possible. That takes the place of preliminary sketches or studies. Occasionally I've done a fast little scratchy felt-pen drawing from some element of the slide, but I don't ever show those and I don't consider them as serious works—they are just doodles. They don't solve any of the problems of making a painting.

Do you have any problem with the pencil picking up in the paint?

No. I use a 2B pencil or harder, depending on the canvas. I can use an H pencil and get a line that I can see on some canvases. Other surfaces take a softer lead. But I play with the paint so much, and the lines are not that heavy. The line dissolves, for the most part.

And you never tone the canvas?

No. Sometimes I do a very thin underpainting with a big brush—using oil thinned way down with turpentine so

that it's like watercolor. Or if I have an acrylic primer on the canvas, I'll use acrylic paint diluted with a lot of water, just to kill the white. But I don't do any detail—just a big swash of red for a ketchup bottle, for instance.

About how long does it take to do a large painting like Ralph's Diner?

Two months, maybe two and a half, depending on how steadily I work at it.

And what about a watercolor?

Anywhere from two to five days. That's working all day long.

And you put in regular working hours?

Yes. I work every day, seven days a week, unless something comes along. I take a day off occasionally, and I also go out to take photographs.

> "All the study, all the preparation for a painting is done with the slide projector—big paintings, little paintings, watercolors, whatever."

Except for this large drawing of the ketchup bottle, and a little drawing on the wall of your studio that was done back in 1976, I don't recall seeing any drawings before, just watercolors and paintings.

Well, I mentioned earlier that I don't do drawings. Over the years (I lied to you before) I've occasionally done a little something with a pencil or something, but I don't show them. I feel they are not complete.

You've done very few prints. There was a color lithograph I saw at Bank Street back in 1971 or '72.

Yes. That was a disaster.

And there was a large silkscreen print of a diner interior. Wasn't that reproduced from a transparency?

Oh, yes. I don't know what to call that. It was done by a printer who had developed a silkscreen process in which he could make almost infinite separations from red, yellow, blue, and black. He could make fifty reds or yellows or blues, to infinity. Just to test the process, I gave him a slide that I hadn't

used for a painting. It was just a slide of some men sitting at the counter of a diner. He did his separations and then he printed it, but the end result was a reproduction of the slide. I wasn't particularly excited about it. I never got my hand in at any time. At the very end, I felt that the print needed some—well, it needed a lot—but the only thing that could be done within the limitations of the process was to add some highlights. Even those were done mechanically. It's not a terrific print.

But it was editioned.

Yes, it was.

I believe they're expensive, too.

Yes.

I think a lot of that stuff would be considered specious by knowledgeable print dealers and collectors.

That's why I said I don't know what to call it, because it's actually a reproduction of a slide.

Your dealer, Ivan Karp, has no interest in prints or graphics, but he does sell . . .

Reproductions.

He has reproductions made, which are signed and numbered.

I look at that as a contemporary manifestation of advertising techniques. Ivan looks at it the same way. You know, he won't buy advertising in magazines.

I know, and as a result, the magazines seldom do articles on his artists.

But, seriously, his attitude toward the reproductions he sells is that they are his concession to advertising. He sells them very reasonably, and they get a lot of circulation. I found the still life reproduction in a kitchen in Tulsa.

Speaking of Tulsa, the little still life lithograph for the Realism/Photorealism *gala was a real jewel.*

I liked it a lot.

Have you thought about doing any more offset lithographs?

I want to do some prints, but I need to find my way to do them. Except for the one that I did with you for the Philbrook, all of them have been disasters. They've been too commercial. I've told you about the experience I had

with the traditional master printer at Bank Street, and I just don't like that aspect at all. I'd like to do some more with Joe Petruzzelli at Siena Studio.

Oh, yes, he's terrific. I think the big trick for every artist is to find the printmaking method and medium that work for him or her personally.

I'm probably opening a big can of worms, but you are very successful and no one would dispute that you are a key figure in Photorealism, and yet there has been very little written about your work, a few short reviews and blurbs in books, nor have you ever had a retrospective or a museum exhibit. That's surprising.

I suppose it is, but it doesn't matter. I have work in good collections, people buy my pictures, and I make a good living. Of course, what really matters to me is making pictures, making them as good as I can. Everything else is an interesting side effect.

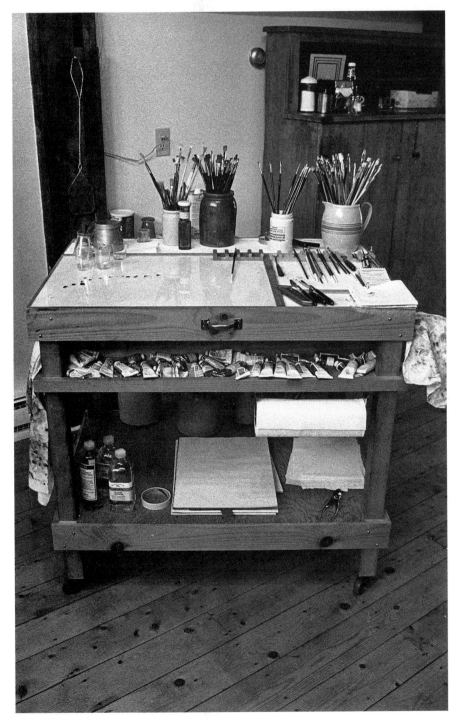

JOSEPH RAFFAEL

Joseph Raffael is the most romantic and expressive of the Photorealists and the first to concentrate on natural rather than man-made subjects. His rich, sumptuous paintings are the most spontaneously direct and abstract of the photo-derived images, and his choice of subjects coupled with his sensuous color has won him a broad audience.

Raffael's watercolors, which most clearly mark his affection for the spontaneity and abandon of gestural painting, are perhaps closest to the Expressionism of Munch and Nolde. His recent activity in lithography has resulted in prints which are surprisingly akin to his paintings and watercolors.

His large, modern studio with its wall of floor-to-ceiling windows nestles on the side of a mountain, surrounded by lush vegetation and towering redwoods. It is highly conducive to his work.

*"Art is not about the mind. It's about the spirit,
and the spirit is very elusive."*

Rose Outside Matisse Museum Garden, Nice, July 1981 (1981), 49½" × 43¾" (126 × 111 cm), watercolor on paper. Courtesy Nancy Hoffman Gallery, New York.

You had a Maxfield Parrish reproduction in your home when you were a child, and you said that you used to look at it a lot. He was a painter that we were taught to dislike in college, but Bruce Goff, the architect, encouraged me to look at him seriously and without prejudice.

Yes. That reproduction was a source of inspiration to me.

When I was in art school in the fifties, we were taught to dislike Picasso, too, because he was not single-minded, and I was in excellent schools. He wasn't Cézanne, who had spent twenty years painting Mont Sainte-Victoire, and he wasn't a Surrealist. He was an independent spirit, describing his many-faceted self. Since then I have come to love Picasso, but not because I like his paintings that much. It's the way he was an artist that inspires me.

My art is about how everything changes, moves from one state to another. People will read this and may quote me for years, but, in fact, this is simply the way I feel right now. I gave a talk in September 1982 in conjunction with the seminars that I've been giving. Afterwards, someone asked me if I were never to paint again, would that be OK? I said, "Absolutely." At that moment it was true. The next day, however, I realized that more than anything else in the world I want to be an artist. What I like about Picasso's work is that it shows the whole spectrum of his being. Some of it was junk, just as part of us is junk. We're not always "tens." Sometimes I'm not even on the scale, and sometimes I'm more than ten.

For me, art is a mercurial, ethereal, ever-changing miracle—and I love it. You mentioned the artists who are going to be in the book. The beautiful thing is that they're all totally different. That's what I appreciate in art, literature, poetry, or music. As you were saying before, if someone is not authentic, it's not worth the trouble. The difficulty is how to get to that authenticity. How do we set up our lives to do that?

I'm not sure you can guide someone into that position.

There are no directions. I would encourage people to be themselves—whatever that looks like to them.

That could wind up being very unpleasant with some people.

And that would be OK, too.

Are you sure?

Yes. For example, take the early paintings of Francis Bacon or van Gogh. They had the courage to be themselves. Van Gogh had no choice in the matter, which is the best way to be yourself. His paintings were scorned and laughed at.

Sure, van Gogh was scorned, but it's clear from the letters that he wrote that he was anxious to get some kind of recognition as a painter. Yet, near the end of his life, Theo showed the paintings to someone who was interested. Van Gogh wrote back immediately and asked him not to show anything else. He wanted recognition and success but was suspicious of it.

"I see art as a glorification of the individual, that sign of a human presence behind the object."

I'm not making a case for anybody to be anything. All I'm saying is that my reason for being is to acknowledge what I am inside. A lot of us keep who we are down deep inside and do not express it. We become gray or neutral. There's a risk of that in art, too, particularly today, when the opportunity for success is relatively accessible. When I was growing up as an artist, it was not so easy. It wasn't even possible, not on the scale that it is today.

I'm not content by any means with what I have done up until now. I want my work to get to a different level, a deeper level. My reason for being an artist is not related to what I was taught in art school nor what I've been encouraged to do by dealers, collectors, critics, the public, friends, or even myself. What I need is to go to some earlier place, like when I was a teenager or a child. We have it all then, when we're seven or eight. Then we become socialized and a lot of it gets pushed way back.

Relatively speaking, I'm not uncomfortable with what I've done in art. I've done the best I could, and I've always tried to show a feeling part of myself.

The earlier paintings were more of a psychological nature. The "nature paintings" from the last ten or so years have been about an appreciation of being alive, being given the experience of

being a human being in relation to nature. That's what I've been painting about. Basically, I see art as a glorification of the individual, that sign of a human presence behind the object. That's what is important to me.

What you're saying is reminiscent of the transcendentalists, Thoreau in a cabin on Walden Pond and his response to nature.

I once heard Ralph Vaughan Williams give a talk at Yale. It was November in New England, an old Yale building. It was very American. It was a transcendental level of experience. He said that, to him, the artist who was most American in the history of the United States was Walt Whitman. That hit the bell for me. I can really get into feeling like I'm an *American* artist, *American* by nature. I'm very optimistic, open, and spontaneous. To me, Whitman, Thoreau, Emerson represent a kind of spiritual place that America has. I love traveling all over the world, but basically it serves by giving me perspective on my life here.

I believe the Oriental artists depicted nature from an essential point of view, as the haiku poets did. For me, that's what great art does; reminds me of who I am and the part of me I've forgotten. It conveys that sense of seeing something for the first time. It is the "beginner's mind"! The Oriental artists had that. Some of Neil Welliver's images are about the same thing, woods, water, certain times of day.

There's a spontaneity in his response that communicates very directly.

Basically, it's like seeing a sunset or feeling the cold. We are all linked up that way. My paintings perhaps might be about a universality. It sounds pompous, but they are universal in the sense that they are an experience for everybody. Part of living is remembering that we know. The more we remember we know, the less we know. So there is a paradox. Painting is an arena for dealing with those mysteries.

I was in somebody's house last night and they had a wooden pelican. It could have been from one of those import stores, yet there was something—it just had a breath to it.

I love primitive art and folk art, but there is a difference. I think folk art is very compulsive, but it is done without an ego.

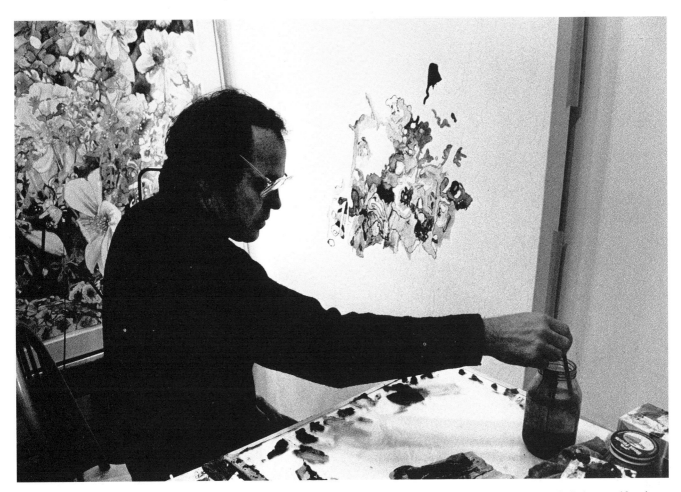

What do you mean by "an ego"?

The artists are never preoccupied with the notion of "making art." In fact, most folk artists will deny that it is art. There's a marvelous fence in Oklahoma that a welder made out of oil-field tools. It's like an early David Smith. But, as far as he is concerned, it's something utilitarian, something to keep the neighbor's dog out. I like that lack of ego and I find it very wholesome and charming.

You've been around a lot of painters, too, and one thing I take for granted is that most of them are inclined toward megalomania, but they must have a fierce self-belief, a strong and directed focus. Ego is an important aspect of making art. Art is something that, if one did not do it, would never be missed.

That's absolutely true, but just the reverse is also true. The beauty of art is what any artist has done that would be missed if it hadn't been done.

No one would notice if Tender Is the Night *had never been written.*

The same is true for Picasso, Cézanne, or anybody. Yet it's very important for

me to be an artist and to do art.

That's true for any painter, but it's also important for you to share your work, to share what you're doing with other people. I don't know of any artist who does the work and puts it in a closet.

That drive is a real mystery. Wanting to be appreciated is a very human aspiration, and I think it's very natural. In art school at Cooper Union I went over to my teacher, Sidney Delavante, with a drawing I had done at home and said, "Tell me what's wrong with this." He said, "You don't want to know what's wrong with it. You want to know what's right about it. You want me to say that I really like it and that you're a wonderful artist." He was absolutely right. I had twisted it all up. That was a real lesson to me.

There are a lot of tests in being an artist and one of them is to do work that is true to one's own center. You hope that it can communicate and touch somebody else. It's very tricky. Ego gets mixed in, fear, and a lot of things that aren't essential to the making of art. My art is best when I'm just doing it

and not thinking of all the ramifications. That's one of the benefits in getting older.

In any art that's really distinguished and authentic we recognize that the artist has found his own center. It has nothing to do with conventions. There's an authenticity we don't find in hundreds of other painters from the same period. For instance, I love Bonnard's passionate interest in his wife, his unabashed voyeurism and the fact that he never saw her age. For me, that's very authentic and deeply personal. I find it much more interesting than the intellectual crossword puzzles of analytical Cubism.

I am more interested in how the world appears to a painter. The most damaging aspect of the way art history is usually taught is that it presents some sort of linear development. We come out not really cognizant of the fact that Munch, Picasso, Matisse, Bonnard, Vuillard, Kandinsky, and Mondrian were painting at the same time and all of them had an accurate and valid view of our very complex and multi-faceted world.

And each one of those artists has been

crucial in the seeding of other artistic sensibilities.

In the early fifties when I was at Yale, there was only Abstract Expressionism and "bad art." "Bad art" was anything figurative.

I was in the art library one day and I came upon a statement by Munch. He said that he wanted to make an art that, when people came in front of it, they would take off their hats as though they were in a church. That really impressed me, because so much of the art I was experiencing was so peripheral to human experience. I mean, hey, that isn't why I'm an artist. I love the Abstract Expressionists, the primary painters such as de Kooning, Pollock, and Kline. They taught me so much.

Abstract Expressionism was very much in touch with that particular period, very expressive of that time—Eisenhower, the McCarthy hearings, jazz, the Beat Generation, and existentialism.

That's right. The confusion of having gone through a war, experiencing the schism between America and the Rus-

sians, the Cold War, living in supposedly a peace time but actually a time of real hostilities.

Speaking of hostility, Josef Albers looked at your work and said, "Ach, boy. Shit!"

That's a great story. I went to Cooper Union when I was eighteen for three years, then I got a scholarship to Yale. Bernie Chaet was my teacher and artist. The next year in the graduate program with Albers, four of us had a studio that was a square room, and each of the student painters had a corner. Every Thursday, Albers would come in and talk to everybody. He spent three-quarters of the year ignoring me. He didn't utter a word to me. There were five chairs, one for each of us and one for Albers. Finally one day he sat down at my painting, looked at it for a long time, and said, "Ach, boy. Shit." Then he got up and left. It was the clearest educational experience I ever had, and I could have stopped painting at that moment. He ignored me the whole time I was there, and I wanted him to love me, love my work. I wanted him to hold up

(Page 102, top) *Landscape* (1972), 132" × 92" (335 × 234 cm), oil on canvas. Collection Mrs. Robert Mayer. Courtesy Nancy Hoffman Gallery, New York.

(Page 102, bottom) *Island Lilies* (1975), 132" × 84" (335 × 213 cm), oil on canvas. Collection Graham Gund. Courtesy Nancy Hoffman Gallery, New York.

(Above) *Wild Iris* (1977), 114" × 78" (290 × 198 cm), oil on canvas. Courtesy Nancy Hoffman Gallery, New York.

Quail (1979), 72″ × 48″ (183 × 122 cm), oil on canvas. Courtesy Nancy Hoffman Gallery, New York.

my pieces the way he held up Neil Welliver's and William Bailey's. I wanted him to hold up a piece by me, too, and say it was great. He never did.

That must have been devastating.

It was. And it was also the clearest lesson I ever got in school. It wasn't the last time I was told my work was shit. In entering the arena of showing our work, we enter a jungle of galleries, museums, of being accepted, being rejected, being bought, not being bought. It can be horrifying. It is also a magnificent challenge to stay committed to doing the art. That experience with Albers was the first experience of what it could be like.

I have found that most painters are so terribly caught up in their own vision that everybody else's work looks out of kilter to them. They have difficulty believing in it since it doesn't correspond with their own way of seeing.

Unlike a lot of painters, you have a very broad audience, and—I don't mean this in any pejorative way—your work is decorative and easy to like. Matisse was one of the few painters who would use that term. We've been led to believe that that's not very good, but I don't see anything wrong with it.

I don't see anything wrong with the word either, but I sometimes feel that it's limiting: "decorative" has a certain meaning. That's something I have to

acknowledge because I do have a large audience, and I love it.

The level of art today is so much higher, so much better than it was twenty-five or thirty years ago. But I do want people to stop and look at my paintings, as Munch said. Munch was one of my greatest inspirations, even though it doesn't show pictorially in my work, but he informed me about the effect and the power that feeling in art can have.

A couple of years ago my daughter, Rachel, came into my studio while I was looking at slides to choose the next painting. Most of them were of waterlilies. She went through them and halfway through she said, "Dad, I'm so sick of these waterlilies. When are you going to do something else?" I knew she was right. I was tired of them too. I gave my slides to Rachel and said, "OK. You pick out something I should paint." She picked out a rose. For years I had taken pictures of roses, but I was damned if I was going to paint a rose because "men" don't paint *roses*. It's one thing to paint waterlilies. They're symbols—transcendental, metaphysical—but how could I paint a rose? Nevertheless, I painted the picture she chose and it's one of my favorites.

The point is that, in order for me to be my whole self as an artist and as a person, I have to open up those parts that are most vulnerable. I love roses and flowers. To plant a seed and out of

that comes a living, green sprout that turns into a plant and produces flowers. Wow! When I lived in Vermont, we had apple trees. I could never get over apple blossoms turning into apples; then you throw away the seeds and they turn into apple trees. I call my workshops seminars because it means "to seed." We're all planting seeds. That's why I'm interested in doing workshops and even being on television. It's time for planting seeds, inspiring people to be themselves.

So, Rachel's encouraging me to do that rose opened up that part of myself, and then I started doing orchids and irises. One of the most cogent things ever written about me was the end of an interview that Jan Butterfield did with me in *Arts* magazine. She said, "Raffael's paintings are for those who are not afraid of beauty." It feels like I've been criticized most my life for making things beautiful. What I now know is that I became an artist because it was a way to describe my love of life and its beauty.

Seurat's painting *La Grande Jatte* is a description of how to spend a summer's afternoon. That's what the subject's about. It's also about color and a way to paint Realism. Another side of that idea is Bonnard, who was essentially a colorist. I remember seeing Bonnard at the Museum of Modern Art when I was a teenager. That was total inspiration about how to paint!

Painting to me is ultimately what takes place at the end of the brush. When a painting is reduced to two-by-five inches or reproduced in black and white, we get to think that's what the image is like. There has been a lot of confusion about recent Realism because most people have seen the paintings only in magazine reproductions. There's something about seeing a work of art in person. It's very different from seeing it in reproduction. I don't just care about Realist art; I care about all art.

I think there has been an effort, for whatever reason, to diminish the individual artist's role in the emanation of the image. Earlier you were talking about a factor that exists in the artist which isn't necessarily explained in the picture. There has been an effort on the part of educators and writers to simplify things rather than tell the whole truth. I had an experience at a university in the Midwest. I was lecturing and this man in

the back of the auditorium started ranting and raving because he was so angered by what I was saying. It turned out that he was the head of the art history department. He spends his life making art simple and serialized so that it will fit into a course, fit into a mind mode. Art is not about the mind. It's about the spirit, and the spirit is very elusive.

There is an emotional overtone in your work which makes it surprising to hear about Rachel's Rose.

There's a lot of conditioning behind that. When I was in art school, Kline, Pollock, and all those people drank in the Cedar Bar, four blocks from Cooper Union. This was before Rauschenberg, Johns, and Andy Warhol. American art was very provincial. It centered in New York. There were the tough guys and there were the artists who didn't matter, it seemed to me. Being an artist at that time meant being really tough, really macho, drinking hard, swearing, driving fast cars. I'm strong, but I'm not tough. I felt isolated. To be at this point now and painting roses is a full 180-degree turn.

I want to go back to Albers. I've heard a lot about him, pro and con.

He was great. He wasn't narrow at all, just the opposite. His style of teaching might have been Germanic and turn-of-the-century, but he was such an authentic person. He taught me that it was essential to be myself in my art.

One of the reasons he didn't talk to me was because I had come from Cooper Union and from New York. He didn't let many people into the graduate school from that background. My paintings were Abstract Expressionist and very facile, and they were me only on a surface level. What I got from Albers for two years was "Be yourself." That was the greatest gift.

I assume that you did all of the Albers color problems. Is there any way you can carry that into what you're doing now?

Oh, yes. This is a very simplistic description, but it's true. I learned from Albers not to mix. As soon as you mix one color with another, it dulls. The other thing I learned was that color is luminous. I loved doing those color theory things, and my color is highly influenced by Albers' teachings. My color is

luminous, phosphorescent. I love color, so he was the perfect teacher. Also, that's why I love French painting.

Your abstract paintings were based on photographs, weren't they?

Yes. I've always worked from photographs. When I was a kid, I spent hours looking at the photograph album. They were all black and white, but they were beautiful. You mentioned Maxfield Parrish earlier. I love his color and also the mystery. The reproduction we had was very romantic—beautiful women lying around and beautiful giant vases. We had a couple of vases like that, which must have been the style then, and the wallpaper in my house was beautiful to look at, too. The black-and-white photographs are like history. Photography is documentation, and imagery is documentation. Documenting experience, the time of day, or specific times in people's lives. Photography has always been important to me.

> "To me, a large watercolor from the Luxembourg Gardens series is an Abstract Expressionist painting. It's some place between the reality of the image and the Abstract Expressionist dissolution of the image."

We grew up at about the same time. For us to go to art school and come up against teachers who insisted on abstraction as the only way of expressing ourselves— there was just no way it would take. Our generation grew up before television, but with the Saturday westerns, the serials . . .

Double-feature movies . . .

And the glut of magazines. Pouring over Life and Look and National Geographic, we were bombarded with visual stimulation and were in love with it.

As you were talking I was thinking about the radio, right in the living room. Sometimes I think my visual life without television, listening to the radio, was much greater. It was very evocative, like literature. The more concrete information becomes, the more limiting it can be.

I must say, though, that my Abstract Expressionist training has informed all of my art. To me, a large watercolor from the Luxembourg Gardens series is an Abstract Expressionist painting. It's some place between the reality of the image and the Abstract Expressionist dissolution of the image. The kind of all-over field I paint is the same. Thank God, I had that background. Kids who are in school now are painting only real things, whereas in Abstract Expressionism it didn't matter. I like that freedom—not having to control—just the medium, the expression, the experience that counted.

That's one of the constants in contemporary Realism, that connection to Abstract Expressionism.

I find it fascinating that you worked as a fabric designer. It seems that some elements of that carry over into your paintings. We were joking earlier about the painting you're working on, that fragment looks like a piece of English chintz.

I love English chintz.

Did working as a fabric designer shape your thinking?

That affected me a lot. By the way, Carolyn Brady and Paul Thek worked with the same firm. It did a number of things for me. It provided training in drawing that I never got in school. The process was extraordinary. I would do a sketch, and if somebody bought the idea, then I would have to put it into an eighteen-inch repeat. So I'd have to get the feel of the original sketch into a mechanical reproduction done by hand, which would repeat eighteen inches down and nine inches across. It had to be exactly the same. You know how it works in textiles and wallpaper. I became so dextrous. I really learned how to draw.

Another thing I learned about was color. If someone bought a sketch that was bluish, I'd have to create a red version or a green one and change the colors relative to the original. It was very informative.

During that time, White Stag had a contract with Picasso, and had the rights to reproduce any of his images for sportswear. Somebody who had a company that was working with White Stag had bought some of my paintings and liked my work, so he chose me to do the project. That was a lot of fun, turning

1

2

3

4

1. Working from a watercolor, Raffael applies the oil in transparent stains, using the white of the canvas for the lights.

2. The wet, abstract shapes of interlocking colors spread across the canvas. Without the identifiable forms of the large flowers, the painting remains highly abstract.

3. The shapes of the flowers emerge as the background is completed. In the upper portion of the painting, the blurred edges correspond to both the focal plane of the photograph and the wetness of the reference watercolor.

4. At this point, the closeup image of the field of flowers begins to emerge, and the abstract patterns and colors read as flora and foliage.

Luxembourg Gardens: Love (1982), 120" × 60" (305 × 152 cm), oil on canvas. Courtesy Nancy Hoffman Gallery, New York.

those Picassos into fabric. Paintings like *Desmoiselles d'Avignon*, crazy things—I turned them into bathing suits, sportswear, and Turkish wrap-around things. I made some money and enjoyed doing it.

And you met Carolyn Brady at that time.

I was working in the textile studio when she arrived in New York and started doing textiles. I met her again in 1974 in St. Louis when I had a show there, and I introduced Carolyn to Nancy Hoffman and she subsequently started showing with Nancy.

In 1963 those collage-like paintings began.

That's when I almost died from hepatitis. I was in the hospital for nine weeks and learned on the day that I got out that I had almost died. That had a tremendous effect on me. Life and living became very important. Simultaneously, the Green Gallery was showing the beginnings of Pop Art and George Segal. Rosenquist and Rauschenberg were at Castelli. The figure began to emerge, so I experienced a combination of almost dying and then being reconnected with life in a new way. It was just the moment—the early sixties and John Kennedy, a whole new spirit, the end of the Cold War period. Things were beginning to lighten up and we were entering a new period. At that time my work began to be more realistic.

There was a national euphoria around the time of Kennedy's inauguration.

Yes, lots of energy, an energy of our time.

Those paintings were based on newspaper and magazine photographs. Were those drawn in?

I didn't draw at all. They were painted in, wherever they happened to go on the canvas. Then I'd see what came up next. I never knew what the next image in the painting was going to be until one was completed.

In 1966 you moved to California when Wayne Thiebaud invited you to teach at Davis. You also met William Wiley and Bill Allan at that time. I would assume that was a turning point for you.

It was. It really shocked me. It was another way of being an artist as well as a person, which had never crossed my

mind. I had spent most of my time in New York and Europe. Coming to the West Coast and experiencing a new way of living—family life, fishing—I wasn't into any of that at the time. Also, it was the time of Haight Ashbury and psychedelics. I got into that and also began to teach. It was a period of maturing.

Around 1967 you changed the spelling of your name because of numerology.

Yes. That was the year I got married. I was having an exhibit, and Grace Glueck interviewed me for *The New York Times*. The headline was "Oh, To Be Born Under Pisces With Sagittarius Rising" or something like that, which for

> ## "The figure began to emerge, so I experienced a combination of almost dying and then being reconnected with life in a new way."

New York in those years was kind of flip. I had gone to an astrologer who was also a numerologist. Changing the spelling of my name turned out to be a symbolic way of changing myself, opening up to a new identity. That's the truth of it. I went from Joe Raffaele with an "e" at the end, to Joseph Raffael. My art was changing, my life was changing, I was changing.

At that time the collage-like paintings ended, and the paintings such as Tut *began.*

That's right. They became isolated images, filling up the canvas.

But those paintings were still from magazine photographs?

That's right.

At that time, 1967 or '68, Malcolm Morley would have been painting the ocean liners.

Morley was with the Kornblee Gallery and I was showing at the Stable Gallery. I might be wrong about this, but I think we were among the very first people to be working in a way that could be called Photorealism. Morley was a pal of mine. He was wonderful.

Those Morley paintings had a tremendous impact. Richard Estes had his first show at the Allan Stone Gallery in 1968.

On the West Coast, Ralph Goings and Robert Bechtle were working from photographs, but no one was really that aware of what anyone else was doing.

I don't know why that happened, but I think Pop Art had a lot to do with it. I think the generation that worked from an Abstract Expressionist mode sensed it was a dead end, and where do you go from there? Some people went to a more quiet, nonobjective form, and some became hard-edge painters. Various things were going on at the same time. One could go further back into the house or go out into the world. I definitely chose to go out into the world.

From the early seventies, the large painting called Release *seems like an important painting to me. Two things occurred in that image. Most of your prior paintings showed evidence of man, either a physical presence such as the Indians or a presence through objects made by man.* Release *is almost prophetic of the work to come. The duck flying . . .*

Released, the hand letting go.

Part of the hand is on the left side of the painting, which seems to be the last evidence of man in your painting.

It was the first painting that I did in California. The release referred to the feeling I had of being released into a new sphere of experience.

Since then all of your subjects have been devoid of human presence.

What could be made of that is that the person who used to be in the painting is now outside the painting looking at it.

The new Luxembourg Gardens paintings are the first ones since Release *to hint at the physical presence of man. We know that the flowers are planted and arranged.*

That's a good point. What was such a surprise to me about the French gardens was all the different kinds of flowers sprinkled all over the place. It is almost haphazard. I was really struck in those very formal gardens by how the flower beds were such a lush array, like a bouquet, as though all the flowers were just thrown together. Very different, and I think of it as a French sensibility. The American way of doing a garden is so different, so organized. The Luxembourg Gardens are planted in the way florists make a French bouquet.

You should see the English gardens designed by Gertrude Jekyll.

Let's move on to your studio procedure. What kind of canvas do you use, and do you prepare it?

Cotton duck, which is sized with Liquitex gesso.

You start out by projecting a slide. By the looks of the painting in progress, your drawing is very loose. You don't put in a lot of information, just the shapes. It's not that specific.

Well, I just put down what I need and I try to do as little as possible.

That's drawn in with a pencil.

Yes.

Your drawing reminds me of the beads of light in a Vermeer painting.

Thank you. That painting, *Blue Pond, Winter Shore*, was done from a photograph and a color print. The drawing was done from projecting a slide and the painting was done from the color print.

The new works are drawn from a slide of a watercolor, and then the paintings are painted directly from the watercolor. So the little beads you were talking about aren't in these paintings because the beads are part of the color photograph.

So the Luxembourg Gardens paintings are always preceded by a watercolor, and the large oils are done from the watercolor. Another thing that is consistent in your work and peculiar to it is that you paint with oil but use it as a transparent paint. The ground of the canvas, the sizing, serves for the white. In those ways it's like watercolor. There's a lot of medium in paint that transparent. What are you using?

Just turpentine and pure color. I rarely mix a color. The white of the canvas shines through. It's like a light beneath the pigment.

In some of the earlier paintings, the paint slipped around on the surface. It looked as though you were painting on a varnish or mixing the paint with varnish.

I was mixing something called Win-Gel in the paint, and sometimes I put it over the gesso before I began painting, so it was more slippery. In recent years I've used the paint more like a stain. It soaks into the canvas somewhat.

I also assume, from looking at the paintings and watching the way you work, that you aren't coming back over an area. It's very direct painting. Do you ever rework an area?

Hardly ever.

Does it matter where you start? It looks like that's an arbitrary decision.

That's right.

The one you're working on now is just a small cluster of flowers floating on an immense white canvas at this stage. Will you keep expanding from there, or will you move to another part of the canvas?

"What keeps me from drawing is that I like the volume of color. Drawing doesn't give me that."

It varies. I just try to keep it interesting for myself. For example, if I'm working on a lot of these little flowers, I might want to go to some green. I will skip to a different color. It's like a jigsaw puzzle. All of those little pieces fit together.

Also, like a jigsaw puzzle, all of the little shapes don't describe the subject matter except when it is seen in total.

Yes. And it's there only when you step back. When I'm painting, it's not flowers or water or fish, it's totally abstract.

Of course, one of the distinctions when you used the gel, you were floating the pigment in that medium, which made the colors transparent. But the pigment was encased in the painting vehicle on the surface of the canvas. The way you're working now is like watercolor. The paint soaks into the ground. So these have a quality quite different from the earlier paintings. What kind of brushes are you using? Are they bristle?

No. They're soft. I'll show you a brush that I'm using for this painting. I know it's absurd, but I'll paint this entire canvas with this brush.

You're kidding.

I'm not. Look at it.

It's a number 6 sable. That's very small. If you don't mix your color much, do you have a large palette?

I have a lot of paint. A lot of different reds, purples, yellows, blues, and greens. For example, that area probably has about four different greens in it. Sometimes I'll mix a couple of colors together, but very rarely.

Do you use the earth colors?

I use burnt sienna. I rarely use umber and I don't use ochre. Ochre's got white in it. I don't use colors that have white in them.

You don't use whites?

Sometimes I'll use a color called *jaune brillant*, which has some white in it. It's a chalky yellow. But I don't mix colors with white to make them light. I'll dilute the color with turpentine instead.

Do you ever put down more than one layer?

Not often, although I've done it a bit in a kind of sketchy way.

So, if it's a lighter color, it has more turpentine, it's thinned more. If it's darker, it's more opaque. You have to be hitting very close to the values that way.

There are a lot of areas where there's so much going on that it doesn't matter if I hit them right or not. Also, I'm willing for the painting to be different from the watercolor. It's a different medium and a different scale. One interesting thing is that the oils are much brighter than the watercolors, which is surprising because the watercolors are really bright. I think part of the reason is the scale.

When your paintings are finished, do you varnish them?

No.

You don't do anything to protect the surface? Have you had any restoration problems?

What kind?

For instance, what would happen if the canvas got marred? Basically, your paintings are stains. The light areas are actually the white canvas sizing. Liquitex gesso tends to be very brittle, easy to fracture.

Yes, that has happened, but of the many, many canvases I've done, it's happened only about three times, usually because of improper handling. So now, when I have anything to say about

Orchid and Shining Spring (1982), 89¾" × 41½" (228 × 105 cm), pastel and watercolor on paper. Courtesy Nancy Hoffman Gallery, New York.

it, the paintings are crated so they never hit anything hard. I have them cradled in a wooden case; they're suspended. Because they are unique pieces of art and relatively expensive, they usually are handled with care.

I haven't seen more than two or three drawings by you.

Uhmm. I have a note on my desk, "Make more drawings." I never get around to it. What keeps me from drawing is that I like the volume of color. Drawing doesn't give me that. I draw with pastel and watercolor. That way I can satisfy my urge to draw. I love drawing. I love the energy in drawings, but I don't get to it very often. I do a lot of watercolors, and I learn from them. My intent is to do some black-and-white drawings.

When did you start doing watercolors? I remember seeing the small animals and bird heads.

You go back a long way! That was in 1969 and '70, hummingbirds and little things.

Were those acrylic on paper?

They were watercolor on a coated paper, so the paint didn't soak in. It stayed on the surface. I did a lot of watercolors with the water paintings, but they were more a matter of exploring the effects of

watercolor than painting. After my trip to Hawaii for the *America 1976*, I started doing some lilies with watercolor. I still don't know how to paint water with watercolor, so when I started the waterlilies I started using it.

You mentioned using pastel, but I've never seen a piece that's all pastel. I've never seen any drawings done with a dry medium, as far as that goes.

I like them wet. I occasionally use pastel with watercolor, just to impart a linear, electric energy. But it's the wet media I like.

You're very comfortable working with a wet medium, but Jack Beal, for instance, can't do a watercolor, no matter how hard he tries; he just can't deal with transparent color.

Really? The pastels he did about five years ago encouraged me to do pastels, those electric colors on dark paper. They were an inspiration to me.

Also, the scale. Some of those pastels are very large. Of course, your watercolors are often very large.

Yes. You know, the idea of doing a whole drawing just with pastel—I wouldn't want to do it. I went to see a Monet retrospective in Paris about three years ago, and I was amazed by how dry he was as a painter. Scumble, all scumble.

Yes. I really love Monet, and this will probably get me in trouble, but I think a lot of the later paintings are just a big mess. They are demonstrations of his poor eyesight. I suspect a lot of people are responding to them via Abstract Expressionism, but if he had had his cataracts removed earlier, he wouldn't have done those paintings. I like the paintings he did when he could see.

I was amazed by the show because there were so few paintings that I liked. But over in the Tuileries, his water paintings are very impressive. It's the scale, the color, the sweep of them, and the gesture I love. You know, I've been compared to him so many times and . . .

It's a very superficial comparison.

It's superficial because we both have been interested in water, but we paint so differently. I think most people who compare us probably haven't seen my paintings in person or haven't seen his paintings. They just can't be compared.

It's like comparing Rachel's Rose *to* Redouté.

People always compare. It gives them some kind of security. I do it, too, but it's terrible.

The Luxembourg Gardens watercolors start from a projected slide, but do you have a color photograph for these images?

No. I draw in on the watercolor paper very lightly. Then I project the slide on the wall and paint looking at that.

Have you run into the problem of your slides fading?

Recently I realized they were fading, so now I have four or five duplicates made, and I work from the duplicates. The color in the duplicates interests me. Sometimes it's much better.

What kind of percentage of workable slides do you get from the ones you take? Is it a relatively small proportion?

It's a tiny proportion. I used to take a lot of slides, but I haven't recently. As a matter of fact, I've been going through my slides and I threw out eighty-five hundred last week. I don't take that many now.

Of course, another important point in your work was when you started taking your own photographs and slides in 1973. It's interesting that, even with a mechanical tool like a camera, the personality behind the lens always dominates.

It's all about vision, what a person sees. It's not how the picture is taken or painted. Don't you think so?

Ultimately. I mentioned before that there is always an interesting parallel between water itself, which is transparent, and your painted images of water, because you handle the paint so that the viscosity and wetness are major factors. There is never that denial of the hand which so often characterizes Photorealism.

You've described doing the watercolors and oils as very direct and very spontaneous. How long does it take you to do a big watercolor?

The Luxembourg Gardens watercolors take a lot more time because they are very complex. One edge of a shape has to be dry before the next edge can be brought up to it, so the more complex the imagery, the more time it takes. Those have taken three to four weeks, which is a long time for me. Usually I can do a watercolor in a week.

You work on the watercolors flat.

That's because the watercolor puddles. I use a lot of water, and it takes about twenty-four hours for the puddles to dry up.

For me, doing the watercolors has

Japanese Iris (1978), 44³⁄₄″ × 33³⁄₄″ (114 × 86 cm), watercolor painted with rain water. Courtesy Nancy Hoffman Gallery, New York.

The Wind on Water, Spring (1982), 28¹⁄₄″ × 37¹⁄₂″ (72 × 95 cm), lithograph. Courtesy Nancy Hoffman Gallery, New York.

Luxembourg Gardens: Summer (1982), 29¾" × 40¾" (75.5 × 103.5 cm), color lithograph. Courtesy Nancy Hoffman Gallery, New York.

physical activity interests me, too. It becomes more gestural. I move in a different way when they are large.

How long do the large oil paintings take?

Right now I'm working on lithographs, watercolors, and oils, all at the same time, because I find they inform one another. Lithography is really informing my watercolors and my oils. The oils probably take a month to five weeks.

You're a prolific painter.

Probably because I am a lot looser than most.

Do you have to scrap many paintings?

I never scrap anything. I figure I'm not the one to judge—let someone else. You see, the way I paint, there is no right and wrong. I think that point can be really misunderstood. I paint seriously and consciously, and I put everything of myself at the moment into the painting, so I rarely leave a painting unfinished.

What kind of work schedule do you keep?

Essentially, nine to five, five days a week. I used to work seven days, but I paid for that dramatically with my health. I used to drink a lot of coffee, smoke dope, and work at nights. That was ten years ago—things to keep me up, keep me stimulated. Now I don't drink much coffee and don't smoke dope at all. I try to drink as little as possible because I need my energy for my work, and if I drink at night, I'm sort of schlocko the next day. My priority is my painting.

Does bouncing around from one thing to another distract you at all?

Sometimes, the less I have on my mind, the better the work goes. Like, when I'm on the phone I'll be painting, and that may be when the most interesting things happen, when I'm not concentrating so hard. It's like worrying about something and then waking up in the middle of the night to say, "Ah! That's it!" It may just come when I let go.

You mentioned that you have done almost thirty prints. Over what time period?

Since 1975, so that's eight years. I have averaged almost four a year since I came back from Hawaii.

One of the earlier prints was based on the painting you did for America 1976.

been a way of letting go. I'll want one to look a certain way, but it will dry the way it wants to, so I've really learned about letting go of preconceived ideas. It's been very freeing. They end up as I could never have imagined.

Did you study watercolor?

No, I didn't. I'll tell you how I got into using watercolor this way. I used to have a white porcelain dish that I used as my palette. I'd squeeze out the watercolors on the dish to mix the colors or dilute them to get them to the right consistency. Then I'd do these very tight, tedious watercolors. But I'd look at the dish with those wonderful washes

and puddles of color and they were incredible, so luminous and natural. That informed my painting. I built up my painting ground to almost a mirror-like surface to get it like the porcelain so the oil would stay on top. Then I started loosening up with the watercolors, too. I didn't learn that in a watercolor class. I learned it from the porcelain plate.

Most of the watercolors are very, very large.

Scale is very important. In the age of film and television, painting for me has to get bigger than life. Part of it also is that the "dance" is different. It moves, becomes more expansive, and the

I did that at Tamarind [printmaking workshop at the University of New Mexico]. It was my first lithograph.

The earlier prints seemed somewhat unresolved, lacking the characteristics that I respond to in your work. The new lithographs with all the reticulation are so close to your watercolors that it would be easy to mistake them. They are very fresh and spontaneous.

Yes. The person responsible for that is a printmaker named David Salgado, at Trillium Press in San Francisco. He's a genius and he epitomizes what you were saying about working on the same frequency and translating my ideas. His involvement is much more than technical; it's a giving of himself to the project, the process, and to the artist. As a result, the prints have a softness and a luminosity usually found only in unique works.

The editions are small, aren't they?

Seventy-five usually. I think that's a lot. I do that many only because there's a real demand for them and the reason I do prints is to be able to have an image that can reach many people.

That's supposed to be the virtue of prints, but because of the phenomenal interest in print collecting, the prices are a bit crazy today. I think the market is somewhat distorted.

Unlike most of the artists I know, you publish your prints yourself, so you have complete control.

Yes, I can control everything.

But your paintings go primarily through the Nancy Hoffman Gallery.

Nancy is my primary dealer and she is like a partner.

You are a professional painter and support yourself and your family from the sale of your work. But there is that chasm between the studio and the art world.

Yes. For example, an art opening is to me one of the most uncivilized and unfeeling events imaginable. Only recently have I been able to distinguish the difference between being an artist and being in the art world. Being an artist is very important to me, but I don't enjoy being in the "art world." It's very far from my reasons for being an artist.

The other day a high school student asked me what I wanted people to get from my art. My answer is simple: "Themselves." I want them to remember themselves. That's what I get from my favorite artists. They help me remember what I've forgotten.

Your works are also reproduced in poster form and on cards, aren't they?

Yes. Also did you know that I have a calendar out for 1983? And the posters and note cards—it's great. People can hang them up and maybe cut out the reproductions afterward and put them up in the bathroom or kitchen. Terrific! It brings back those feelings from the Maxfield Parrish and my living room. I love it!

Do you publish those things yourself?

No. They're published by others. I did some note cards about eight years ago, though.

Do you get a percentage from the calendars and note cards?

Yes. Royalties.

I hope it's more lucrative than writing art books.

It's really not, but it's a great way to get the images out there.

I assume you're incorporated, right?

Yes. I love what you're doing. It's very educational. You're really showing what it can be like as an artist today, and you're demystifying it. But it could be misunderstood, taken out of context.

I'm really sensitive about an issue you brought up a little while ago. Something about how there are more people who can appreciate my work because of the subject matter. I was brought up in the fifties to believe that probably no one would appreciate my work and if an artist was successful, able to sell his paintings, he'd sold out.

Yes, but I think it's important to debunk a lot of those myths. Picasso had it made by the time he was thirty.

I guess it's an American view that I grew up with. Our society has not supported or sympathized with its artists. But success is wonderful.

I gave a talk at the San Francisco Art Institute last April and a man in the front row got very angry and asked, "How do you feel about the prices of your paintings?" I said, "I feel great. How do you feel about them?" He said, "I don't like them because they are out of the reach of the common man." It's true that they're out of reach, but it's also wonderful that today an artist can get these prices; a lot of the artists you're working with do. It's terrific, and why not?

Maybe the more money someone spends on something, the better they will care for it.

That's right.

And, as far as I'm concerned, the collectors are interim caretakers between the studios and the museums, which is where the best work will ultimately end up.

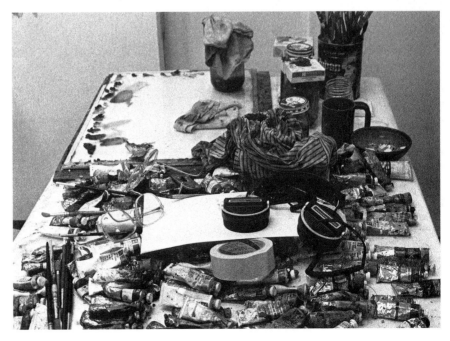

WAYNE THIEBAUD

Wayne Thiebaud's paintings of foods and pastries, often whimsical and double-edged, and always delightful, brought him national recognition in the early sixties. At that time these colorful tableaux of confection and common foodstuffs, rendered in a thick, frosting-like paste of paint, were mistakenly linked with Pop Art. Not only was there abundant evidence of his hand, which was in sharp contrast with Pop imagery, but behind the wit and charm of his still lifes and landscapes lies a strong sense of tradition, obvious links to Abstract Expressionism and Bay Area painting, which is sharpened and tempered by Thiebaud's keen intellect.

Although he is best known for his still life paintings and the more recent San Francisco cityscapes, Wayne Thiebaud has explored a wide range of themes and media, and paints from life, from drawings, and from memory, varying his approach to the dictates of the subject. His San Francisco paintings have evolved from specifically recognizable streets to highly fanciful creations, and he is beginning once again to explore the portrait combined with still life objects. Whatever his choice of subject or medium, Wayne Thiebaud always provides an extraordinary viewpoint of the ordinary.

Thiebaud has adjusted to working in any environment or situation, and he has a studio at the University of California's Davis campus, where he teaches, and one in his home. In addition, he and his wife, Betty Jean, a filmmaker, have a weekend home in San Francisco, where there are two workspaces: a small bedroom on the second floor, and the garage next door. The immediate impression of both was their spareness: a worktable, easel, and clip lights. In the low-ceilinged garage, there were several paintings in progress and a few drawings and thumbnail sketches tacked to the wall. It was as unassuming as a monk's quarters.

"I'm more interested in the duality of the perceptual experience as it is codified by conceptual notions. A painter like Degas, for instance, is crucial to my love of how that is articulated."

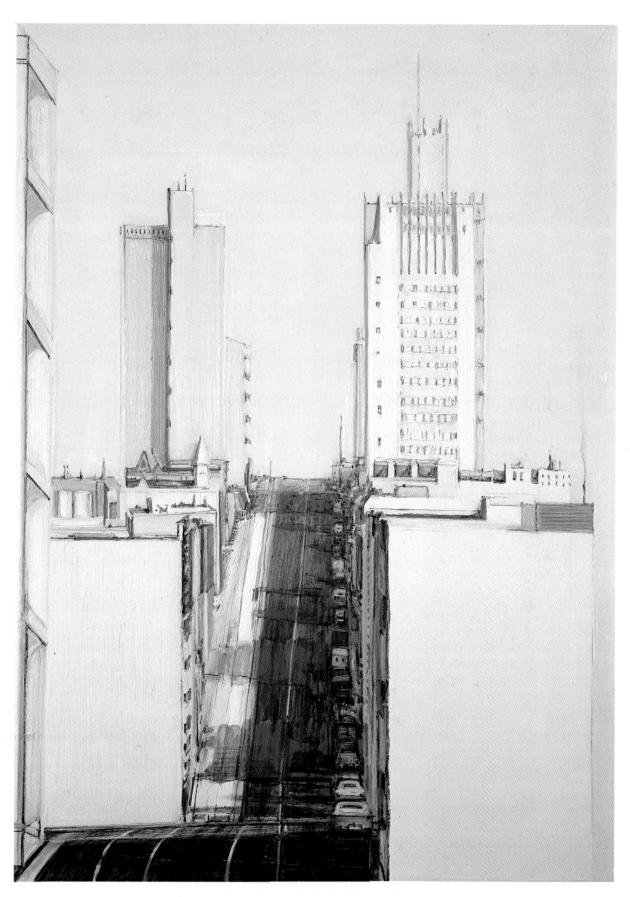

Bright City (1982), 36″ × 47¾″ (91 × 121 cm), oil on canvas. Collection Robert Feldman.

You moved to New York for a year in 1956. I assume you were painting then.

Yes, I was. I had been teaching in a junior college and took a year off without pay to go to New York. I was very fascinated by people like de Kooning and Kline and went to New York expressly to try to meet them and hear what they were up to.

And you did get acquainted with most of the Abstract Expressionists in that year.

Right. Actually, I also met Philip Pearlstein, Lester Johnson, Wolf Kahn, and some of the younger people as well. We'd go to the Eighth Street Club and to the Cedar Bar, and I really just hung around and listened with open ears. It was fascinating, particularly because what I had read about them in the magazines was really quite different from the way they talked and expressed themselves. What they were interested in was heartening because it seemed to me that they were much more authentic in the ways in which I judged painting to be interesting than what the art world had decided they were doing.

When you say the "art world," are you referring to the critics like Clement Greenberg, Harold Rosenberg, and Frank O'Hara?

Not O'Hara so much, because he was more lyrical in his interpretations. I am referring to the kind of language developed by hearsay from brochures, catalog essays—what art dealers and collectors thought as opposed to what someone like de Kooning and John Graham, thought, for example. There was a clear difference and, as a result, a lot of wrong-footed and rhetorical writing.

The painters talked about things which were both philosophical and analytical but also indulged in a healthy kind of "cracker barrel" speculation. I remember one time several painters talking about wall-to-wall carpeting for four hours, what it meant, where it came from, why was it going up the walls all of a sudden, what that implied. Galleries were beginning to put down carpets and carpet the walls. It was fascinating to hear them ruminating about what that meant.

Many people today think of those painters as being financially successful, but at the time most of them didn't really expect to sell much, so they weren't affected by pressures from the art market.

Not at all. As a matter of fact, they were disinclined to work for the market. They didn't trust it, and they were very suspicious of any success that did come. The recognition was mostly trivial or beside the point in the way it embraced their work.

I remember Alfred Leslie telling me that most of them envied Franz Kline because he was on a stipend. It was something like ten thousand dollars a year.

He bought a Thunderbird, a racer. The nice thing about Kline was that he never had one bad word about any other painters. He was not just generous, but very appreciative of painting as a form of communal activity. I could paint very differently, and it made no difference to him.

> "You could almost write the history of stylistic variances based on cartoon notions. Whether it concerns Rubens, Daumier, Degas, German Expressionism, whatever, it's told always in terms of caricature."

He also had interesting, peculiar insights. He told me how much he hated teaching and just couldn't believe that I was a teacher: "That's the worst thing in the world to be." Every once in a while he'd bring that up: "So you're a teacher, eh? You teach at a junior college?" He had a tendency, like so many from that period, toward a sort of affected nonintellectualism. There was a great deal of talk about primal concerns, atavistic preoccupations, and that kind of thing. But Formalism was something I think Kline was trying to get away from, particularly as it relates to the early work.

Finally he got into the spirit of expansion and extrapolation. So I confronted him with his master's degree. He said, "How the hell did you find that out?" He always said, "I just read what comes, what I can find in the Pay Less drugstore bookstand." I suggested he was a wide and careful reader. "I know just from your references, you talk about all that stuff. You've been in the library. I know you've got a master's degree!"

Well, he was very quiet for a while, which gave me courage to ask him what he had against teaching, and he told me. "I'll tell you what it is. It's a basic immorality that teachers have. Teachers expect to be believed. That's a mortal sin."

Do you think that's true?

I think there's an underlying truth. When you get older, you begin to think that, no matter how strong your ideas are, it's possible that you're wrong.

Earlier you worked as a cartoonist and commercial artist and set designer.

An amateur set designer.

And you worked as an animator at Walt Disney.

What they call "in-betweening." The animator draws one here and one there and you draw the ones in between. The low life of animation.

What did you work on?

I worked on Goofy, Pinocchio, and Jiminy Cricket. I only worked there a very short time. I was fired for union agitation. I was sixteen years old and making fourteen dollars a week, working about sixty hours a week and going to school, an impossible situation. It wasn't so bad for me because I was a kid, but there were people with families and they were desperate. The height of absurdity came when the window washers outside pointed out that they were making a lot more money than we were inside. It was a funny time, the change in the animation and motion picture industry. I was there a short time, went out on strike, and got fired.

I've always loved cartoons. I think there are lots of things about cartoons which describe art in terms of style that no one has quite formulated. You could almost write the history of stylistic variances based on cartoon notions. Whether it concerns Rubens, Daumier, Degas, German Expressionism, whatever, it's told always in terms of caricature. The power of the cartoon's graphic energy is something that has always struck me. Now cartoons are finally beginning to be collected. I've collected them for years. I use them a lot in teaching. A methodology of reduction comes out of that experience, I think.

So there are aspects from your commer-

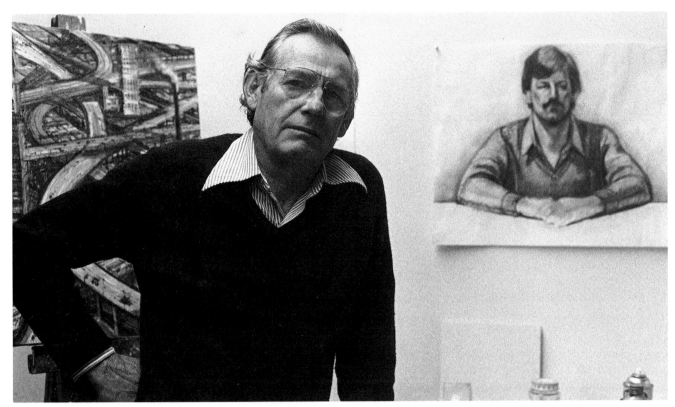

cial art background and work as a cartoonist that carry over. *Every Sunday I look at the fashion drawings in* The New York Times. *Jim Howard, in particular, is a superb draftsman.*

For me it was Dorothy Hood in *The New York Times.* I thought she was better than Matisse. It took me a long time to like Matisse; he was such a smart artist. But Dorothy Hood—she was terrific. She was one of the grand women of fashion illustration in the thirties and forties.

Were you painting at that time?

I was interested in painting, but mostly I was trying to become a commercial artist and art director/illustrator/cartoonist. In 1946, when I got out of the army, I went to New York for the first time to try to sell cartoons. I had been selling cartoons to trade publications and had a couple of strips published. I would go to all the magazines every Wednesday and show my gag things, then go back to the YMCA and draw up roughs for the next week, trying to get some sort of start. It was so difficult that I began also to take whatever I could get in advertising art.

I must say that, in terms of the structural aspects of art, the formulations in commercial art are not really different from what they are in fine art. I

think there's a sort of deception and somewhat pompous categorization that is corrupted by disclarity, at least for me. I'd go further and say that university art departments and art schools like the San Francisco Art Institute lost something they have never been able to replace when they eliminated commercial art courses—design, lettering, and fashion illustration—all of those things which are very necessary for the production of a useful, pragmatic aspect of art. They started sweeping those courses out and calling everything "art courses"—Art 101, Art 105, et cetera.

How are they going to deal with Lautrec posters? That "commercial art" was some of the greatest printmaking ever done—and those Bonnards. There are many illustrators who interest me a great deal. I think their ideas are as solid as those of many painters I know.

Oh, I have no doubt about that.

You've described yourself as being a self-taught painter. Does that mean that you didn't study painting?

No. I started as a sign painter and did fashion illustration, furniture drawing, lettering, and cartooning without going to school. At twenty-eight or twenty-nine, when I went back to college, I got credit for most art courses by special

examination because by that time I had had exhibits, army experience, and so on. I have courses on my record showing I studied painting and drawing, but those were generally by challenge; they just gave me grades. I took art history, courses like the psychology of art, lots of art education courses, but no formal training. In high school I took commercial art at Frank Wiggins Trade School in Los Angeles, which was free, but I had to present a portfolio. There were a couple of teachers; one guy was a shoe illustrator, and there was a woman who did fashion drawings. They had us do projects and plates and that was actually very helpful. Kids would go into merchandising, illustration, or something.

My fine art training came very slowly. I had not thought of myself as part of it until I began going to art directors' meetings and seminars. They would invite painters in to talk, and they were all members of museums and they spent a lot of time in them. At that time, I met Bob Mallary, and he became the one who was really my teacher in any fine art sense. He gave very precise, analytical, formal criticism of my work, which was very helpful. I had a lot of help from people who took time to show me how to lay a wash, refine lettering, what a vignette was, and so on. In that sense I was trained.

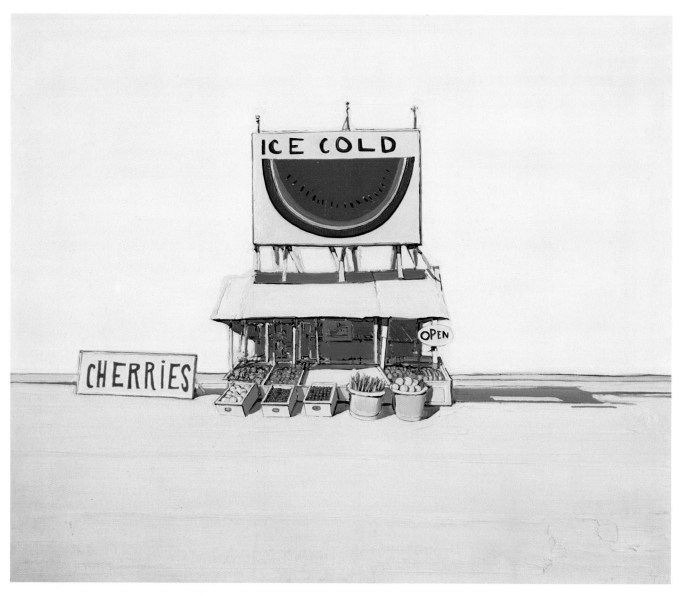

Cherry Stand (1963), 67½″ × 58½″ (171 × 149 cm), oil on canvas. Collection Graham Gund. Courtesy Allan Stone Gallery, New York.

Cherry Stand (1964), 6¹³/₁₆″ × 5¹¹/₁₆″ (15 × 14 cm), etching. Courtesy Crown Point Press, Oakland, California.

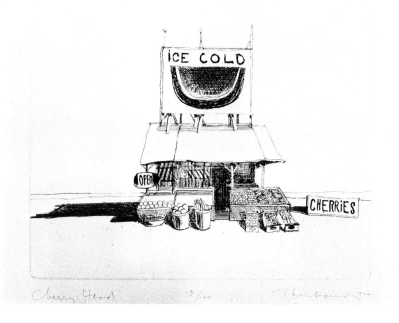

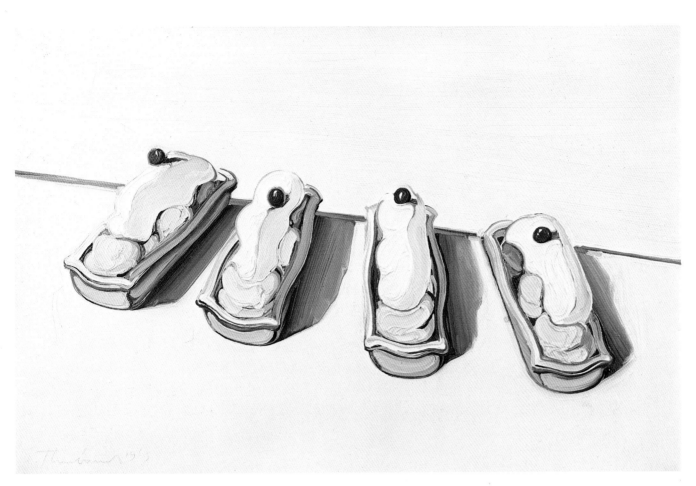

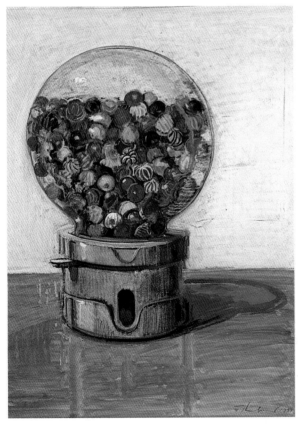

(Top) *Ice Cream Sundaes* (1963) 22″ × 18″ (56 × 46 cm), oil on canvas. Courtesy Allan Stone Gallery, New York.

(Above) *Santa Barbara* (1966), 14″ × 10″ (36 × 25 cm), pastel on paper. Courtesy Allan Stone Gallery, New York

(Left) *Candy Ball Machine* (1977), 18″ × 24″ (46 × 61 cm), gouache, pastel on paper. Courtesy John Berggruen Gallery, San Francisco.

When did you really start concentrating on painting?

In New York I took a job with Fairchild Publications, which publishes *Women's Wear Daily,* and worked in the art department there. After a year I went back to California and worked in various small advertising agencies, then went to work for Universal Studios in Hollywood. I designed ads and publicity for movies. Around 1947 I went to work for Rexall Drug Company and was there for two or three years. It was there that I met Mallary and began to paint. Then I went back to college and finished in two and a half years, and after graduation I started teaching in a junior college, taught for six years, and went back to New York in 1956. I guess I started painting seriously around 1947 or '48, when I was about twenty-seven.

All of your paintings I've seen, including the very early ones, have been very painterly, very much about the paint. I've only seen representational paintings, but you've done abstract paintings also. Is the painterly quality a combination of West Coast roots and your contact with the Abstract Expressionists?

Yes. I was very much influenced by the California figurative school [Richard Diebenkorn, Elmer Bischoff, and David Park] but particularly by de Kooning, for whom paint manipulation was a real issue. There is a long tradition of painting that I happen to admire, in which the paint is obviously manipulated by hand. That kind of coding and descriptive characteristics is very fundamental to my inquiry.

You knew most of the Bay Area painters.

I was in Sacramento and I went to their exhibitions and knew about them. It was only later that I got to know them well. People like Bischoff, Oliveira, and Diebenkorn became acquaintances and friends much later. I never did know David Park. The New York School was also very interesting to me, so there was a kind of dual influence.

I think of your vibrant color as a West Coast characteristic.

That's fairly recent. Actually, it was the mid-sixties when I made any kind of serious color inquiry.

The concept of light as a delineating

force has always fascinated me—what light sources are about, where they come from, whether they're multiple or variable. The color thing, though, came much later. As I look at the paintings from 1960 up to about 1963, the color is coincidental to the value structure of the picture. Then I got very interested in color and tried to find out about it. I had never had a color course, and to this day color is a problem I'm really interested in and still trying to take on.

> ## "I hadn't seen anybody painting pies or gumball machines, so I thought that gave me some options in terms of compositional orchestration and made it possible to do something of my own."

I believe I first saw your rows of pies in Life *magazine in the early sixties. Your work kept getting linked with Pop Art at that time, which I thought was a bit of a distortion. Much of Pop Art relied on the look of mechanical processes and played down the effect of the hand.*

If anything, my interest was the opposite, more out of the tradition of Veláz-quez, Manet, to Eakins, through people like Jasper Johns and Richard Diebenkorn, for whom the signature gesture is central. I'm not interested in rendering, the kind of painting which picks away, modifies, augments, and changes, nor in the resolution or replication of form. I'm more interested in the duality of the perceptual experience as it is codified by conceptual notions. A painter like Degas, for instance, is crucial to my love of how that is articulated.

How did you arrive at subjects such as food and gumball machines?

I'm sure the subjects come out of my experience in commercial art, but also from some sort of stubborn, independent feeling that, in following the tradition of modernism, one should be able to make a picture out of anything. And there was some sort of American chauvinism in saying, "Look, gumball machines really are as beautiful as other things. Why can't they be painted?" I tried to take those subjects and make

them into paintings. The row of cigars, pinball machines, or gumball machine make the painting look like a Jackson Pollock or Willem de Kooning. Slowly, that became less and less interesting and seemed not genuine or authentic. I said, "Well, I'm going to try to paint very clear, sort of modified still lifes. I'll do the same thing I've been painting, but make them much clearer." I hadn't seen anybody painting pies or gumball machines, so I thought that gave me some options in terms of compositional orchestration and made it possible to do something of my own. That selection was essentially formal and referred to those kinds of thinking processes. I wasn't so much aware of it at the time.

When I painted the first row of pies, I can remember sitting and laughing—sort of a silly relief—"Now I have flipped out!" The one thing that allowed me to do that was having been a cartoonist. I did one and thought, "That's really crazy, but no one is going to look at these things anyway, so what the heck."

Those objects were always isolated. There was no indication of their context.

Most of them are fragments of actual experience. For instance, I would really think of the bakery counter, of the way the counter was lit, where the pies were placed, but I wanted just a piece of the experience. From when I worked in restaurants, I can remember seeing rows of pies, or a tin of pie with one piece out of it and one piece sitting beside it. Those little *vedute* in fragmented circumstances were always poetic to me. You take really beautiful objects and bring them together in a sort of stage setting, and they're purposefully represented in terms of metaphor—like Chardin's still life representations of the painter's profession, or the hunt, or good cheer, whatever. The pies and pastries were objects that existed existentially, did not have any self-consciousness. They were isolated, of themselves, by themselves, and just what they were. These aspects fascinated me, but I couldn't see how anyone else could be interested in them.

In a cafeteria you will see sixteen pieces of butterscotch pie which they have tried to get all the same size, but there is always one that looks a little better than the others, and I try to reach around and get

that one. It's characteristic of your paintings that no two slices of pie are alike.

No. They are all calculated to be quite different. They are in my mind like visual notes of music. The orchestration is something that interests me, the shadow, form, substance, et cetera.

Much of your imagery seems to be double edged. A good example is the large painting called Buffet. *While it is like a buffet, it is also like the floats in a parade. They seem to be referring to other things. The rows of lipsticks are like missiles, or candy. They are also very phallic.*

Yes, and like bullets. Those things occur to me. When they occur to me in the middle of the painting, I'm a little dissuaded from continuing, because some people have talked about the irony in my work and the idea terrifies me. That's something I'm not interested in on a conscious level, and the reason I'm not is because that kind of explication of an idea vitiates its power. If I were using what intelligence I have to be ironic, I couldn't be smart enough for myself. I would be disappointed, and I'm generally disappointed in irony for that very reason. It seems self-explanatory and anticipatory in a way that never interests me. The reason I don't like classical Surrealism, if there is such a thing, is that it seems already to have arrived before you've seen it. Even a good painter like Magritte—his ideas put me off.

Once you've seen it, there's not much to go back to.

The ideas may as well be a *Saturday Evening Post* cover, except that Margritte and De Chirico are good in the way that Morandi is good, in knowing just how to give you enough in the substance of the paint. I'm interested in Morandi, that muteness. You can't really understand it, finally. I don't think Morandi understood it either, but you love him for trying and you love him for not revealing—because it wasn't to be revealed. His work is just good enough as it is, a series of reflections, ruminations—that's enough for me. All the metaphor, the double-edged aspect, is certainly admirable, but is not why I like Morandi. It's something which is really quite inexplicable, in addition to the fact that he's such a damn good manipulator of the paint. Slugging that stuff in there, he really built his paintings like a dam.

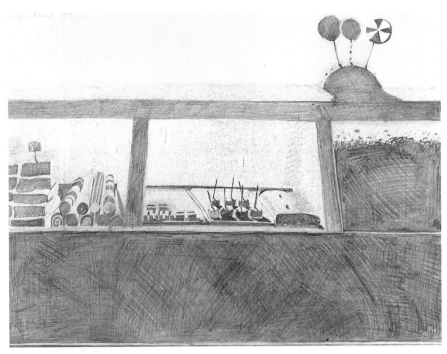

Candy Counter (1970), 26½″ × 20″ (67 × 51 cm), graphite on paper. Courtesy John Berggruen Gallery, San Francisco.

There's that clunkiness in his paintings that's very attractive. You may be opposed to irony, Wayne, but not to wit.

No, I think wit is a very high form of attainment. Any kind of wit is one of the toughest things to do. Also, it's one of the things that's missing in so much of the art world. When you lose the capacity for a sense of humor in an art form, you lose a sense of perspective. That's one of the real problems of the art world, its lack of humor. That's why I liked Guston so much. He and I had a great talk about Bud Fisher, the guy who did *Mutt and Jeff*. That really meant something.

And Philip also loved Krazy Kat. *He talked about it for more than an hour one night.*

A lot of painters feel that way. Elmer Bischoff loves *Krazy Kat*. He thinks Herriman, its creator, is as good as Rembrandt in terms of graphic power.

Of course, the art world turned against Guston. When cartoon elements came into his paintings, they were quite horrified at first. Long term, it's probably the best body of work he did, but underneath the humor in Guston's paintings is a real sense of terror; it's an autobiographical thing.

More like Samuel Beckett in that sense.

You have a repertory of subjects that tend to get recycled. You return again and again to certain things, but they're always different.

I was just talking to Harry Rand, who wrote the book on Gorky, about how, when you get so you can do something, you don't want to do it anymore, and he said, "Yeah, that's very hard, but I think one of the things that painters have to learn is that it's all right once in a while to shoot fish in a barrel." When something begins to be offhand, then changing subject matter sometimes helps. You can go back later with a renewed interest, maybe.

You change subject matter. Chuck Close will change the process but still use the same photograph.

You mentioned that the food and other things you paint are very specifically American. Another characteristic is that they are a bit like Holiday Inns, always the same whether you're in Peoria or Pittsburgh. We seem to have arrived at an Aristotelian archetype of "hamburgerness," for instance.

That does interest me, particularly because most of those still life things were done from memory. They were quite calculated to be that way because I would just try to figure out the way I thought a hamburger bun, in terms of

Cakes (1972), 28″ × 16¾″ (71 × 43 cm), pastel on paper. Courtesy Allan Stone Gallery, New York.

Dark Cake (1983), 20″ × 17½″ (51 × 44 cm), color woodblock. Courtesy Crown Point Press, Oakland and New York.

(Left) *Night City* (1980), 48″ × 60″ (122 × 152 cm), oil on canvas. Collection Donald Bren.

(Below, left) *Hydrangea* (1980), 18¼″ × 17½″ (46 × 44 cm), gouache. Private collection.

(Below, right) *Girl in Yellow Hat* (1982), 25″ × 30″ (63.5 × 76 cm), oil on canvas. Courtesy Allan Stone Gallery, New York.

color and shape, should be, or french fries or a bottle of pop. In that sense I was influenced by someone like De Chirico, who codifies visual attitudes in a remarkable way. Often there's very little there, but what's there is so crucial that it makes a kind of IBM card in your mind. You say De Chirico, and everyone knows right away just what you mean. Maybe not a specific painting, but the visual form comes into view. That aspect of memory is interesting, so prototypes, charaded forms, all are part of it.

A long time ago we were talking about memory and you pointed out that all painting or drawing is from memory; you constantly look from the subject to the paper or canvas and put down what is remembered. To paint without the subject present is a matter of expanding one's memory. But another aspect is that we sift down an experience and remember only its most crucial characteristics.

Yes. Once in a while it seems to me that I have almost a photographic memory, but I can't remember pages of type and other kinds of material. I think that those differences are abrupt and self-revealing, what you know, what you rely on, what you think you know.

Once Sherlock Holmes asked Dr. Watson how many steps there were to his apartment and, of course, Watson had never thought about it. It's a matter of concentrating on such details. A friend of mine asked an advanced class of pianists to draw the shape of a concert piano. None of them could do it, even though they had been playing one for years.

That's right. I do the same thing with my class. I make my students draw their houses from the front. They go crazy; they can't remember very much. Then they come back the next day and, of course, they can draw an entirely different picture. That aspect is fascinating. Another important part is the sort of a perceptive mass of visual vocabulary you develop, the ways of doing a hand or conventions for doing glass. E. H. Gombrich [*Art and Illusion*, Princeton University Press, 1956] makes the point that you see what you're prepared to see. But when you paint a glass of water, you can do one of two things. You can get the painting of the glass of water to match your visual experience or you can interpret—bring

forward from years ago, from other painters—or you might add your own inventive sense in concert with your perception. Even with a painter like Eakins, who seems to be an adroit Realist—anyone who has studied knows right away that the man's got seven or eight kinds of paintings going on in the same picture.

We've been so misled by reproductions. Eakins was pulling every stop and, as you said, there are different kinds of paintings in every picture. Very daring things like that strange pinkish-red wash he used for the woman's dress in An Actress. *That's the focal point of the painting, and you get up to it and there's nothing but a stain.*

"If I wanted a hamburger, I'd paint it hamburger size. Then it became more and more interesting to play with that a little bit."

Almost atmosphere. Yes, it's astounding. To me, that's the most abstract aspect of painting. I don't agree with Sir Herbert Read's idea that abstract codification occurs at its highest level with a kind of symbolic abstraction. I think that's much less rich, less complicated, and less full than the kind of thing we've just described. There are as many levels and conventions and attitudes about the perception of experience as you can imagine.

Someone like Vermeer is often misinterpreted because he seems so singular at first. You think, "Another camera obscura painting, photographic painting." Not on your life! Vermeer is as variable as Eakins and as mysterious as you can possibly get. He gives you all the clues and none of the secrets of an edge. You think, "Well, it should be there someplace," but you can't find the son of a bitch. The bloom of a peach—right next to it is this little slab of metal stuck into the picture. He has sort of woven the tapestry in front of your eyes with the salt and pepper shaker. It's just so nutty. It's not a matter of having a camera; it's painting tertiary or peripheral vision. All you have to do is stare at one thing and suddenly everything else is different in terms of its structural

capacity. Those things are unbelievable in Vermeer. They are the most mysterious paintings in the Western world, as far as I'm concerned.

Another thing about Vermeer, his paintings are small, but scale is very important, as it is in your work. You told me once about making a cardboard cutout of Jimmy Durante for Rexall. You kept changing the scale, trying to figure out how to make it look life size.

Right. He had his hat off and they wanted him to look like he was greeting people when they came into the store. We measured Jimmy and he was five-feet-four or five-six, I can't remember. We made the first photograph exactly his height and it looked like a midget. So we made it larger and larger until it looked right. The difference between size and scale was a real education.

How do you go about determining the scale on a painting?

I'm still trying to figure it out. At first, I had simple-minded notions. If I wanted a hamburger, I'd paint it hamburger size. Then it became more and more interesting to play with that a little bit, see what would happen if I took them way down in size, what would happen when I made an etching out of the same thing. The notion of transposition is fascinating.

Resnick talked very eloquently about the fact that he could not paint a good small Abstract Expressionist picture because it had to expand, have its presence that left you overpowered. Resnick and de Kooning argued about that. De Kooning never felt that way. To him scale was much more important than size. It's very rare that you see huge pictures by de Kooning. Even in the "women" series, de Kooning's paintings are not that big.

Your figure paintings are not done from memory. They are painted directly from the model, aren't they?

Yes. I started out painting the figure from memory, with disastrous results. I just didn't know enough about the figure and still don't. It's very difficult for me. So I have people pose, and I just keep on trying. I think the figure is very tough.

Chuck Close said that you can take a lot of liberties with a tree or a still life object,

but everyone knows what a head looks like.

It's true. We have an astounding amount of information about the figure because we look at it all the time.

In a painting like Girl with Ice Cream Cone, *the figure is painted direct, but the ice cream cone . . .*

The ice cream cone is painted from memory. Betty Jean was holding a screwdriver. I had to get the hand right, then I put an ice cream cone in it. I still have in mind doing figures and objects.

Some of the landscapes seem to be concurrent with the still lifes and figure paintings.

Actually, I'm always doing some still life, some landscape, and some figures. But I'll usually emphasize one of them.

A lot of the landscapes are specific places.

Yes. Some of them are very specific and were painted right on the spot. I simply went out with a French easel and began to paint. The San Francisco ones were done that way. Before, I did the landscapes by making small paintings and coming back and doing larger ones in the studio.

Paintings and drawings?

Mostly paintings, some thumbnail drawings. Any time I get into working very long, I usually go to painting.

What about a painting like Cherry Stand?

Cherry Stand was done from memory, things I'd actually seen on the roadsides in California. Most of these things are very simple. Some still lifes which are quite different would be set up under a light and painted direct.

I remember that you were using a 350-watt photoflood on those ties. And the color . . .

Really bounced up. Or there was a dress hanging on a hanger, which I painted over a really long period of time, and there were some hammers hung on a wall that I painted from observation. In each of those instances, however, there is a lot of manipulation based on former experience and on memory and concept.

How much are you manipulating the color? They seem to be based primarily on local color.

The motivating force came from the perceptual experience of the actual color, but it is heightened or energized sometimes in an attempt at a color system based largely on sort of a focused coloristic spectral tradition.

Do you size your canvas?

Yes. Mostly it is sized with rabbitskin glue and lead white.

Lead white is becoming harder and harder to get, isn't it?

Yeah. I have to go to commercial manufacturers now. I use commercially prepared canvas when I can find some that's well made, but most canvas I prepare. My son was doing it for a while, and now I have a graduate student who helps me out sometimes.

> ## "The cityscapes were not so direct. Another thing happened in those paintings; I tended to make them more graphically endowed."

Do you use linen?

Yes.

I would assume that most of your brushes are bristle.

Yes, although I also use old sign-painting brushes, house-painting brushes, and even sash brushes. I have a lot of brushes.

Your way of drawing in the painting is very interesting. Instead of using charcoal, you often draw with oil, starting with a yellow.

Yes. I sort of draw with the brush rather than start with charcoal, the light color being, in this case, lemon yellow. The next color might be an ochre, a warmer yellow, or an orange. Then I might go to a blue, back to a cadmium red, over to alizarin, each time correcting or rearranging. I found this method to be helpful because it begins that spectral, coloristic potential. All the colors are on the surface and I can manipulate them. I can save an edge that works, put the color back. It's a sort of scattered drawing, two yellows, two blues, two reds—warm and cool in each instance, really.

Are you diluting with turpentine?

Yes.

What are you using for the warm and cool reds?

A cadmium red for the warm, like a red orange, and alizarin or phthalo rose for the cool red. The blues are ultramarine for the cool and phthalo or cerulean for the warm. My yellows are cadmium yellow light and cadmium yellow medium or deep for the warm. It's a simple palette.

And the lemon yellow is a cool color.

Right. It is a greenish yellow.

What are your whites?

I almost always use titanium.

And when you're working on the overpainting, what's your medium?

One-third turpentine, one-third damar or stand oil, and one-third linseed oil.

You're working very direct and the paint goes on fairly thick?

Yes, except in the landscapes. I had to change because some of the San Francisco cityscapes took me as long as eight months or a year, going back and working over. In such a case, I often use an extender, a gel, a transparantizer, or sometimes just thin overpainting and glazing. The cityscapes were not so direct. Another thing happened in those paintings; I tended to make them more graphically endowed. I'd work back into them with charcoal and go back over that with more paint, with milk glazes or transparent glazes. The process was more extended than the direct, alla prima approach, the wet-into-wet painting I had done before with the still lifes.

For the San Francisco street scenes, I did many graphite drawings. I had painted outside a lot, but at a certain point I felt the paintings were too structured, too limited, or just didn't do what I thought they should be doing. So I made a number of drawings over a period of six or eight months. I worked with graphite and an eraser on large sheets of hard-finished Bristol board, erasing, smudging, and fussing around with form. I thought the drawings were quite abstract, although they showed buildings, cars, and streets. For some reason I think they were a kind of breakthrough for me. They showed me possibilities of moving into painting in a

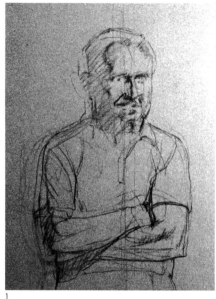

1

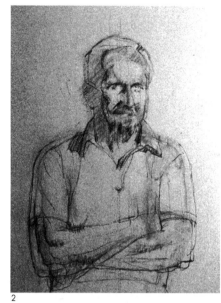

2

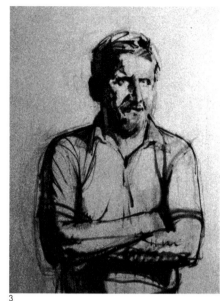

3

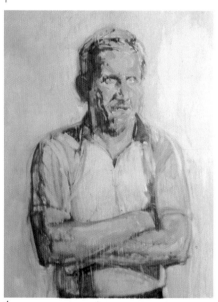

4

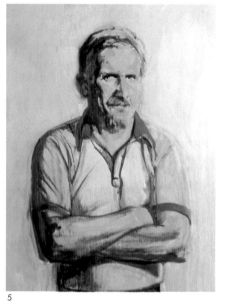

5

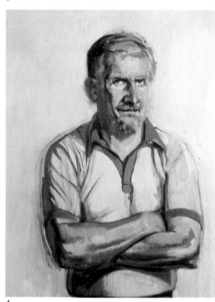

6

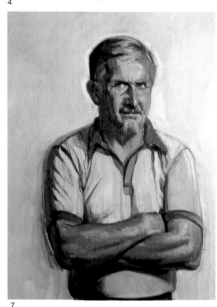

7

1. Thiebaud begins with a charcoal drawing on canvas. Here the figure is being repositioned to the right.

2. The finished drawing contains some indications of light and dark.

3. The darks are established with an oil wash over the charcoal. Parts of the drawing are further refined with the brush.

4. The entire painting is blocked in with diluted color.

5. The forms are developed and the contours redrawn with reds, yellows, and blues.

6. Further refinements are made in the drawing and modeling, and the color is heightened.

7. The creamy impasto and colored edges are now apparent. Working wet-into-wet, Thiebaud will complete the modeling and apply the background color around the contours of the figure, as shown in the finished painting.

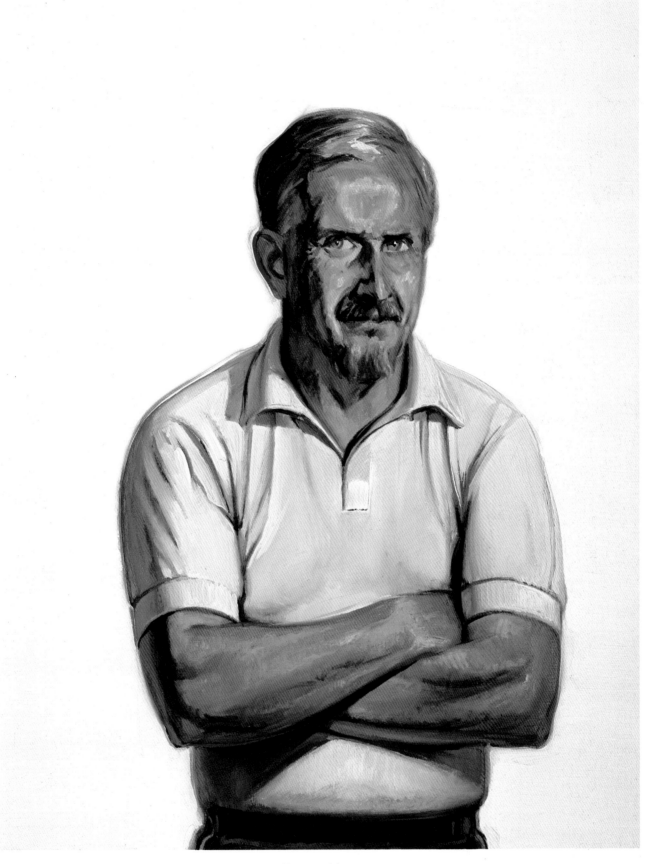

Player (1981-82), 24″ × 30″ (61 × 76 cm), oil on canvas. Collection of the artist.

more lyrical way and being more willing to move things around. All of them were based on actual scenes, but they became much more interpretive.

Such as Night City, *the night painting that was in the exhibit at the Allan Stone Gallery. That one reminded me of Los Angeles in the movie* Blade Runner. *Those cityscapes have gotten pretty strange.*

I think they have gotten to a point where it's probably about time to stop.

You've done quite a few prints. The earliest ones I've seen were the little Delights, *which you did with Kathan Brown at Crown Point Press in Oakland in the sixties.*

They were done in 1964. I think I started working with Kathan in about 1963. Then she was doing all the printing in her basement in Berkeley. I'd go there early in the morning and we'd work all day. I had made an etching in passing but wasn't really interested in it. As a matter of fact, I'm not really interested in printmaking until I have something specific that I want to do. Then I really love it, and she is terrific. I think I made about fifty little etchings from which we picked about seventeen or so for the *Delights*. But we tried everything and it was great.

You hand-colored some of them.

Yes. Those were the mistakes. They were on that nice paper, which you can't waste, so she let me keep them. Later on I had fun watercoloring them. I'm starting to actually print some like that now. The sardine . . .

The color aquatints . . .

Of course, any good print is a collaboration, a matter of the printer tuning into the sensibility of the painter and pulling out the best characteristics of the painter's work. You obviously have a good relationship with Kathan.

Are the prints done from your drawings and paintings?

The earlier ones were done right on plates, sometimes from little thumbnail sketches. For instance, one day Kathan brought down lunch, which was a cheese sandwich, a couple of olives, and a beer, and I said, "Before we eat that, I think I'll draw it." A lot of them were done that way.

The later series were done very

carefully from pre-existing drawings and pastels. I worked right from the painting or a pastel of the bird, just copied it onto a plate in soft ground. It becomes another kind of creative challenge because you're always negotiating color or pattern in different ways. Some of those damn things—I think we must have made eighty proofs of *Palm Ridge*. It was just killing—changing colors, redrawing, redoing the plates. Color etchings are tough because of the oxidizing process. You put a bright yellow on, it turns green, and then the red turns to brown. You can't tell what is going to happen. We had to steel-face some so they would keep. I have no idea how long it took to get some of that color.

Sardines (1982), 15⅞" × 20" (40 × 51 cm), color etching. Courtesy Crown Point Press, Oakland and New York.

In the earlier portfolios you used silk-screen, lithography, linoleum cut, everything.

Yes. I wanted to try it all.

I assume you're happier with the results of etching and aquatint, or is it a matter of working with Crown Point?

A lot of it was Crown Point. Kathan was so great to work with. Also, etching is such a good medium for me. I really love it. I like other processes too. The linocuts were a terrific experience because I worked with Picasso's printer, who has just a tiny place, like an over-the-store print shop. As a matter of fact, there was a stack of abandoned

prints which Picasso had started—you know how he did those things backwards—and had abandoned. I spent hours going through them seeing how he changed his mind and how he abandoned things. It was terrific.

But the etching was mainly a matter of being able to work with Kathan.

You use a lot of different mediums for the drawings. Brush drawings, pen and ink, charcoal, pastel. I've seen some which are a combination of gouache and pastel.

That's right. Any cheap trick I can get. I've always used a lot of different mediums. I'd like to do a series of transparent watercolors. It all fascinates me.

Does the medium dictate how you interpret the subject?

Yes. That transformation process is something that interests me a lot, how one becomes another, transposes the same way that music transposes.

I was struck by the drawing of a little blue flower in a glass. That was in the last show at Allan Stone's. I think it is watercolor and gouache. Was that done direct?

There were two of those, as a matter of fact. One of them is all transparent watercolor. The one at Stone's had gouache in it, right? And drawing. Often there is a specific inspiration and influence. In that case it was Mondrian, obviously. I love the Mondrian flowers, and I had a little book of reproductions of them. I was trying to get as close as I could.

Are you using natural or artificial light in your studios?

At Davis, where I teach, the studio has a skylight. It looks like Giacometti's studio, with a high light from the north. Sometimes I'll be able to paint with that light if it's a good day, but eighty percent of the time, I use artificial lighting. Here it's primarily artificial lighting.

How long does it take you to finish one of the large paintings? Does that vary?

It varies depending on what it is. The street landscapes seem to take an awful long time. They take as long as six to eight months.

You've never worked from photographs?

I have tried to work from photographs once in a while, and I would still use

them if I could. I'll sometimes use a fragment of a photograph, but generally photographs don't give me the kind of information that I want.

Do you have to scrap painting very often?

Yes. Most of the time I do.

Really? More than fifty percent of the time?

Oh, yes. I think I keep one out of twelve. Very low batting average!

Do you ever put them aside and come back to them?

Sometimes. If they have something that's interesting, I keep hoping I can do something with them. But most are doomed to destruction.

Do you varnish the paintings afterwards?

Usually there's enough varnish in the work, but if they're uneven, I'll varnish them with a retouch varnish or a picture varnish. Sometimes, because the varnish is so glaring, I'll wax them afterwards with a regular paste wax.

The kind you buy for floors at the hardware store?

Yes. They use it in museums a lot.

It doesn't discolor?

Oh sure, it discolors, just as it does on the floor. It gets yellowish, but you can take it off with alcohol and put on a new coat. A lot of museum pictures are waxed. I was in the Phillips Collection and saw that van Gogh, the yellow street scene. The surface was so beautiful, it looked like it had been waxed with a thousand coats of wax. I asked Bob Kulicke what was on the surface, and he said wax. Apparently that's often a standard procedure. It protects with-out hurting the paint.

You still draw with a group and with our students. So you do a lot of drawings from the model?

Yes. I try to draw a lot, and I believe very much in the importance of drawing. I've been drawing for six or seven years with the same group: Beth Van Hoessen, Mark Adams, Gordon Cook and William Brown. Every week there's a model and we work for four hours straight on one pose. The drawings for the most part are sort of academic. I think academic inquiries are interesting only to people who really like drawing. Because students like to see how a model may be interpreted differently, we had a show of those drawings at a university.

Speaking of students, you have stayed with teaching, which I'm sure you don't have to do at this point. And you still teach basic courses, don't you?

Yes. I still teach beginning courses and prefer them. Davis has an interesting system in which we all work with the graduates, but I prefer by far to teach beginning drawing, beginning life drawing, or beginning painting. I get a lot out of it. There's something about the freshness of beginning over and always getting those questions which are fundamental and never answerable. Also, I like the independence teaching gives me. If I want to stop painting, become a cartoonist again or a tennis player, I can. I don't like to feel that I am painting for anything other than what I am genuinely interested in. I like that feeling of independence. So the university has been very good to me and for me, and I'll keep teaching there until they kick me out.

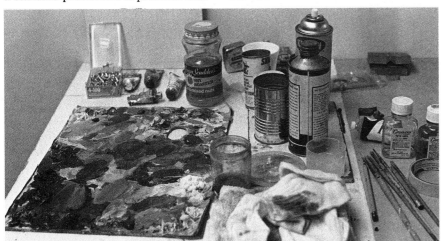

JAMES VALERIO

Since the early sixties, James Valerio has produced paintings with the same extraordinary facility that brought him to prominence in the late seventies. The difference is in his choice of subject matter, which provides an exceptional reminder that in almost every form of Realism the subject will take precedence over its rendering.

Valerio's earlier depictions of nudes and figures involved in somewhat enigmatic or improbable incidents were regarded suspiciously by even the most dedicated collectors. While all were astounded by his proficiency as a painter, they were equally put off by his inexplicable images.

The turning point in Valerio's career came in 1979, primarily through one monumental painting. Allan Frumkin had invited a group of painters to participate in a spring exhibit in his gallery under the title *The Big Still Life.* Valerio's *Still Life #2,* which he produced specifically for the exhibit, stood out in the remarkable company of major works by Alfred Leslie, Jack Beal, Paul Wonner, and other eminent painters. Since then it has become one of the best-known works in contemporary Realism.

Although James Valerio's paintings and drawings are derived from photographic sources and have the high finish and verisimilitude common to Photorealism, his subjects and methods are distinctly different. They are content oriented and are constructed from a montage of transparencies and from life.

In 1979 James Valerio moved from Los Angeles to Ithaca, New York. He lives with his wife and son in a quiet, well-manicured suburb on the edge of the city. A wood-paneled basement game room has been converted into a studio and has served as a background for *The Checker Game* and *Ruth and Cecil Him.*

"I love Ingres and think that his portraits and nudes are marvelously beautiful paintings. . . . But it bothers me that every figure looks alike. I'm more interested in emphasizing the fact that every figure isn't alike."

Self-Portrait (1981), 76″ × 92¼″ (193 × 234 cm), oil on canvas. Collection Richard Zeisler. Courtesy Allan Frumkin Gallery, New York.

Instead of going to college or art school after high school, you went to work, didn't you?

That's a long story. I grew up in a typical neighborhood in Chicago—played football in high school and all that. My father got a job as a janitor and had to move away. I told my parents I wasn't going, and, I don't know why, but they said OK. So I quit playing football, got a job after school, and got an apartment.

After I graduated from high school, I stayed in the neighborhood. The group I hung out with was all Italian and Polish. We were very close, had our own clubhouse and things like that. I stayed in the neighborhood doing odd jobs, but when I was eighteen I got into a bad automobile accident. The father of one of my friends was Duke Nalon, the race car driver, and he had given us pit passes to the time trials for the Indy 500. We were driving up early in the morning and ran off the road going about one hundred miles per hour. I was laid up for about a year in a complete body cast and couldn't work, so I had to move back home. It was a year of reflection, because I thought I was going to die in that accident. I kept thinking, "I'm really lucky to be alive, so what am I going to do with my life?"

I tried to get work, but my back injury restricted my qualifications for most jobs that entailed physical labor, and I couldn't get a job. I took some courses at night school but hated them, and finally got a job in a parts warehouse. When I realized that the men I was working with were at a dead end and I was too, I enrolled at Wright Junior College and told myself, "This time I'm going to make it." The second semester I took a liberal arts course and an art class, which Seymour Rosofsky taught.

Did you know Rosofsky?

No. I had never met him.

Did you know his work?

No. I knew nothing about artists except van Gogh and Rembrandt. The only art I had done was to copy album covers and make the graphics for my neighborhood bar. Chico Hamilton, Miles Davis, Sarah Vaughan—we put them up around the bar. That was my art. I was the "artist" in the group. Anyway, I took Seymour Rosofsky's class. He was very encouraging and called me a

couple of times at home. I loved to draw, and I thought I must have shown some possibilities, so I began leaning toward art with the hope of somehow making it a career.

What kind of drawing class did you take?

It was a figure drawing class, and Rosofsky encouraged me to put my work in shows. I took three semesters with him. I was somewhat familiar with the Art Institute of Chicago because I had been there a few times when I was in some contests. While I was at Wright Junior College, I went up to the Art Institute, and they had some pastels up in the corridor where they hang drawings and graphics. They were beautiful. While I was looking at them, Seymour Rosofsky came up, patted me on the back, and said, "You get an A." I didn't know what he meant until I came to the end of the corridor where there was a sign: "Seymour Rosofsky: Pastel Drawings." I began to realize that he had a big reputation and that he was what it was all about.

"I took fifty dollars out of the bank, bought a lot of paint, and told my friends that I was going to paint the figure."

Finally, I decided to go to the Art Institute of Chicago. Seymour took me there to meet a friend of his who taught art history. I got through the entrance exam and got a scholarship. Now, years later, I am making a living as a painter, and it all started that year I was laid up.

When I was a little kid, my mother used to do some art, and she praised the hell out of me whenever I drew something. But it never occurred to me that I might be able to make a living at art. In fact, one time when I desperately needed a job, one of my uncles, who worked at city hall, asked me what I could do. When I mentioned that I could draw, he said maybe he could get me a job doing those drawings of police suspects. If that had worked out, I would be doing mug shots for a living instead of painting.

How old were you when you graduated from the Art Institute?

I was twenty-eight when I got my mas-

ter's. At that time you had to take your academic courses at night. It gets me when students complain about working now. I used to take classes at the institute all day, at night go to the University of Chicago, and then go home and work on art.

Were there teachers at the Art Institute who really helped shape your ideas about painting?

That's complicated. At the institute you're shaped by many things—Chicago, your peer group, the museum collection, and the various exhibits. John Fabion was very good for drawing. Ray Yoshida I liked because of his attitude. Yoshida was a big influence on a lot of the students and other Chicago artists like the Hairy Who. I did some paintings which were very, very much influenced by Yoshida at that time. It would have been very easy for me to have gotten into that whole Chicago thing, but I moved away from it.

In Chicago there has always been a penchant for Surrealism and fantasy—bizarre forms of art. It's reflected in the private collections, the galleries, and in the holdings of the institutions. When I think of Chicago, H. C. Westermann, Seymour Rosofsky, Robert Barnes, Ellen Lanyon, Joseph Yoakum, Leon Golub, Red Grooms, and the Hairy Who come to mind. Do you think your early work was shaped by those elements?

Most of those artists didn't actually come from Chicago. When I was growing up there, you could see the world by traveling around the bars. Chicago is full of ethnic neighborhoods. There is a certain bizarreness to that, and I have always associated that aspect with the subject matter of the Hairy Who. There is a certain kind of rawness which reminds me of Chicago. Surrealism, that aspect comes from the collectors, not from the city.

By 1968, when you got out of school, there was a lot of Realism around. Pearlstein, Beal, Leslie, and Thiebaud, for example, were very well known.

Not in Chicago.

Pearlstein and Beal were showing at the Allan Frumkin Gallery in Chicago.

When I was in art school, Realism still seemed fairly remote. If you were looking at the human figure, you were really

out of it. But I was looking at Realism, Beal and Pearlstein.

Robert Barnes and Jim McGarrell were also showing at Frumkin.

I loved Barnes' work, especially when he got very opulent. And McGarrell. I was interested in the idea of free flow—James Joyce—and I sensed that in McGarrell's work. But very few people were talking about representational painting in school. My work was more about audience participation. I was interested in lasers and a lot of scientific things. To accomplish my ideas would have been prohibitively expensive. What helped a great deal was when I went to Rockford, Illinois, to teach, after graduate school. I got away from all the art school influences. ·

In the Frumkin Gallery Newsletter, *you said that by the time you got out of school, you knew you wanted to do figurative art.*

The work that I was doing seemed to lead ultimately to that. I took fifty dollars out of the bank, bought a lot of paint, and told my friends that I was going to paint the figure. I had decided that was what I really wanted to do, and

I have been painting figurative works ever since. But I think that all of those things I had been interested in before are still a part of my work. I don't really feel that I've changed so much.

When did you start working from photographs?

I did a painting from an old photograph of Edith Wharton in my first art class. Later I used the photo-silkscreen process when I was at the Art Institute. I remember all kinds of dumb statements about working from photographs. The photo-silkscreen negatives that I was working with sometimes fascinated me more than the prints I did, so I did a group of paintings based on the negatives. Things really came together when I went out to UCLA in 1970 to teach. Richard Joseph, who had been at the Art Institute a year before me, was teaching there. He showed me the paintings he was working on, and he was using a five-by-seven camera. I saw the transparencies and thought, "My God, this is it!" I saw so much more information that could be transposed in so many different ways. I went out and got myself a view camera and

started working from there.

You began taking big transparencies?
Yes.

In the earliest paintings I have seen, such as Four Models and a Chicken *and* Swan Lake and Signorelli's Lament, *the clarity, finesse, and verisimilitude you now employ were fully apparent, but the narrative incident depicted was extremely illogical.*

It didn't seem that way to me at the time, which shows you where my head was. The more I thought about "reality," the more I realized that there was no such thing. I thought that if I had all this photographic information, I could really get down to specifics and have what I needed. But the more information I had, the more questions there were. Ultimately, the information only made the decisions more complicated and difficult. You said that the situation in *Swan Lake and Signorelli's Lament* was unlikely, but I don't think it was. If I had put a little marquee on it saying, "This is a dance class," it would make more sense to you. That was my thinking in that picture.

Paul's Magic (1977), 108" × 94" (274 × 239 cm), oil on canvas. Collection Mr. and Mrs. Marvin Gerstin. Private collection.

Checkers (1980), 96" × 84" (244 × 213 cm), oil on canvas. Collection Stephen Alpert. Courtesy Allan Frumkin Gallery, New York.

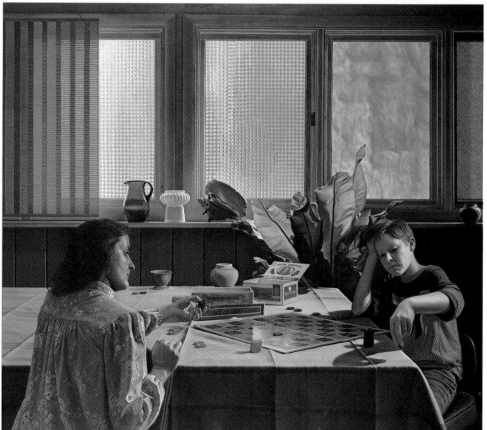

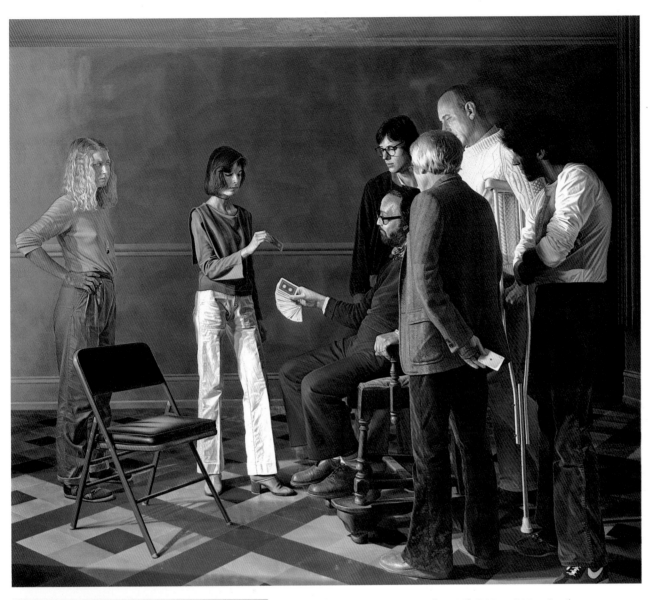

(Above) *Card Trick* (1980), 116″ × 93″ (295 × 236 cm), oil on canvas.
Collection Thomas Segal. Courtesy Allan Frumkin Gallery, New York.

(Left) *Honey Bun* (1974), 72″ × 84″ (183 × 213 cm), oil on canvas.
Collection of the artist.

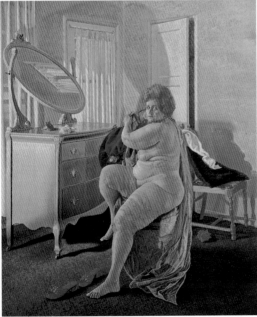

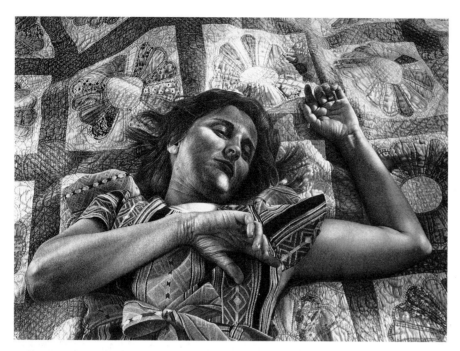

Resting in the Shade (1982), 41½″ × 29¾″ (105 × 76 cm), pencil on paper. Courtesy Allan Frumkin Gallery, New York. Collection Jalane and Richard Davidson.

Explicable but improbable—a very bizarre dance class!

It was forced—like watching TV without the sound.

It reminds me of an incident I encountered years ago. Walking through a quiet neighborhood, I passed a woman in an old tattered bathrobe and fuzzy slippers wearing a halloween mask. She was beating on a shrub with a broom. There may have been a logical explanation, but I assure you, it was disconcerting! If I had a photograph of that little vignette, you would say that it wasn't real, as I said about your paintings.

But such things are going on all over the place. In fact, in New York you learn not to take much notice of such incidents in the street because they happen so often. If you opened up the walls, you would see strange things going on all over the place.

But you agree that those early paintings were a bit forced.

Oh, sure. I wasn't interested in being bizarre at all—just enough so that people would look at the paintings.

Were you working from a group of transparencies as you do now?

I used every possible bit of information I could get, whether it was from direct observation, photographs, transparencies, magazines, imagination—anything and everything. I still do.

With your virtuosity, it's easy to seduce the viewer. It is interesting that many viewers who haven't looked at that much Realism think they want a high degree of verisimilitude, but it really depends on the subject matter. When they see a painting like Honey Bun, *which depicts an older woman, nude at the dressing table, with rolls of sagging flesh, thighs like cauliflowers, and varicose veins, they find it quite repulsive. In a way, you have given them their cake, but they can't eat it. This quality disappears in a painting like* Still Life #2 *or* Gail.

I've always liked obsessive detail and have always loved Ivan Albright. I was absolutely amazed to meet people who couldn't stand to see such things in a painting because of their own cultural prejudices or for whatever reason. But I was never thinking about those things when I was making a painting. I was just obsessive about detail.

Sure, I could have cleaned up that painting, *Honey Bun,* made it more acceptable, but I don't think that would have been right. Many artists believe they should aspire to paint something that makes the world more beautiful, but we have taken that thinking so far that we are airbrushing all the defects away and dealing only in clichés. I love

Ingres and think that his portraits and nudes are marvelously beautiful paintings. I certainly wouldn't deny their validity and I'm tempted to paint that way, too. But it bothers me that every figure looks alike. I'm more interested in emphasizing the fact that every figure isn't alike.

One time I was painting the leaves around a swimming pool. I painted one very meticulously and learned a lot that I could then apply to the second leaf. But it bothered me that I began to imitate myself, so I went to another area and painted one because I wanted to feel that I was in a totally new atmosphere. That's what it's all about for me.

In Paul's Magic *you depict a magician passing a woman through a hoop and your son is letting birds and fish out of a bag. This is taking place in a burned-out forest.*

Paul was six or seven at the time and was very interested in magic. I think the painting is magical also, and I was interested in playing that kind of metaphorical game. The birds and fish are from different continents. The fish are flying with the birds.

We had been in the mountains, where a forest had burned down. When I got back and looked at the transparency I had taken, I decided that the forest could just as easily have been an ocean. I thought I would use that.

When Paul tried to learn magic tricks, he thought the magic was in the words that he said. He would try to do the tricks after I had explained them—go through the procedure and expect the magic to happen because he was so naïve. That's why I wanted him as the focal point of the picture, because the whole thing was really about that.

What about the magician passing the woman through the hoop?

The idea of levitation—in a painting you can make a person float. The tension of watching a levitation would also exist in the painting. In the painting *Gail,* the fish can be seen as floating around the room or as decals on the wall—or whatever. In fact, one of them is actually a plastic fish hanging on a string. Again, I don't think these things are any more bizarre than the possibilities in reality.

But your more recent work, such as Still Life #2, *is rather traditional. The Card*

Trick *and* Differing Views *could be considered genre paintings. This one is a double portrait.*

It is called *Ruth and Cecil Him,* which are their names. In the other two I was more concerned with extracting some kind of dramatic episode.

Did you photograph all those people grouped together for The Card Trick?

I took about twenty different groupings of people, and they were all in a well-lit room with white walls.

The light in the finished painting is very dramatic.

Well, I painted the figures in California, and I played around with them until I could paint the background. When we moved to Ithaca, I built a little room with floor tiles and dark walls and fabricated a light through the open doorway. That painting actually started from a photograph in the newspaper, about the death of a mobster in Encino. The picture was of the coroner at night with the floodlights, and they were carrying the body out.

This really is like a Caravaggio [looking at news photo].

Yes. I wanted to create a situation with that kind of lighting—that type of light has been important to me for the past couple of years.

You always work under artificial light, don't you?

I never had a decent studio, so I am used to artificial light, but if I got a studio with good north light I could adjust very well. I can set artificial lights so they will be constant.

How do you arrive at the scale for a particular painting?

That's one of the nice things about projecting. It enables me to get some idea of the scale and the perspective. Sometimes I do little sketches on plastic and project them to see what the scale should be. I project the figures sometimes to get an idea about the environment I might put them in.

And you stretch the canvas to the size you have arrived at from projecting the image.

Right.

For this double portrait of the Hims, you

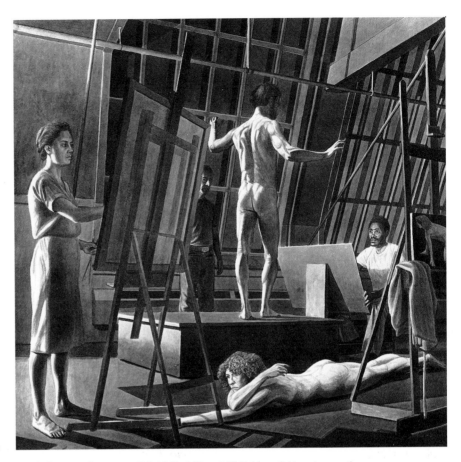

Study for "Studio Figures" (1982), 96" × 96" (244 × 244 cm), pencil on paper. Courtesy Allan Frumkin Gallery, New York.

started with two tiny sketches which contained the germ and the composition.

Yes. I work out the composition with little stick figures—sort of like some film makers do.

Working from a group of transparencies must get very complicated. For this painting you have a transparency of the couple with the quilt and another one of only the curtain. The tile floor isn't in the transparency of the Hims. How do you unify the light and the shadows? It seems like a lot of juggling.

It's those difficulties that excite me— the idea that I don't know where I'm going to end up. I can't follow a strict formula. It just depends on how I feel about the light and color, the mood I'm after. I try to pull it off. Sometimes I do and sometimes I don't, but that's why I can't have something else going on when I'm working on a painting. I'm concentrating on putting something together that's not there in front of me.

Do you use linen or cotton canvas?

I use cotton, but I have used linen and

want to use it again. I put about six coats of gesso on the cotton duck, thinning each coat a little more. If I don't thin it, I end up getting brushstrokes instead of the weave of the canvas. I want the gesso to soak into the canvas, and I sand a little between each coat. I want a finish that has a little bit of tooth; I don't want the paint to slide around on it. Linen is better. The kind of painting surface I would like to get is like Pearlstein's.

And you stain the canvas. Is that done with watercolor?

No, it's hard to get a stable and fairly opaque stain with just watercolor. I take the acrylic emulsion, thin it down with water, and add watercolor to that. The tint I choose depends on the subject matter. Usually it's one of the browns. It's kind of atmospheric.

And you project the 8-by-10 transparencies?

Sometimes 8 by 10, 4 by 5, 2¼, or 35 millimeter—or sometimes a combination.

1. The pencil drawing on paper is the same size as the painting. The figures are modeled with tone, while all architectural elements are line only.

2. The unpainted figures and easels are silhouetted against the finished background. Parts of the easels are masked out with tape while the floor and reclining figure are painted. Beyond the nude male figure on the platform is Valerio.

1

2

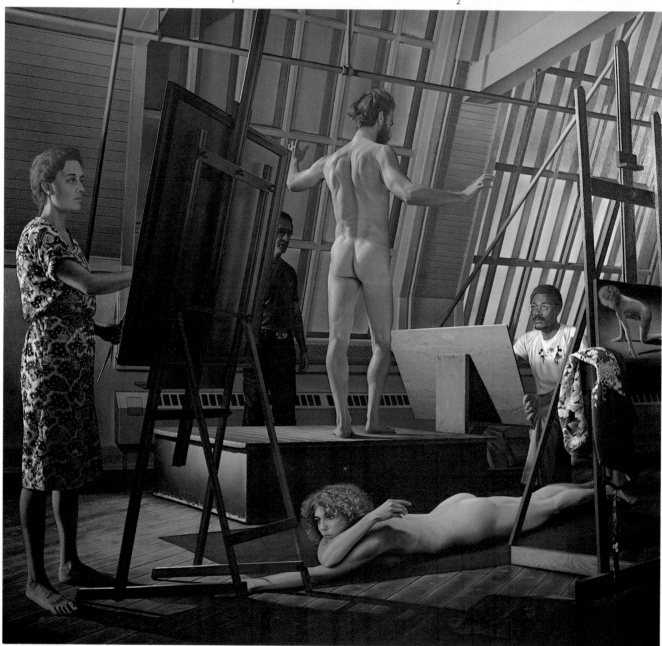

Studio Figures (1982), 100″ × 92″ (254 × 234 cm), oil on canvas. Collection Mr. and Mrs. Edward E. Elson.

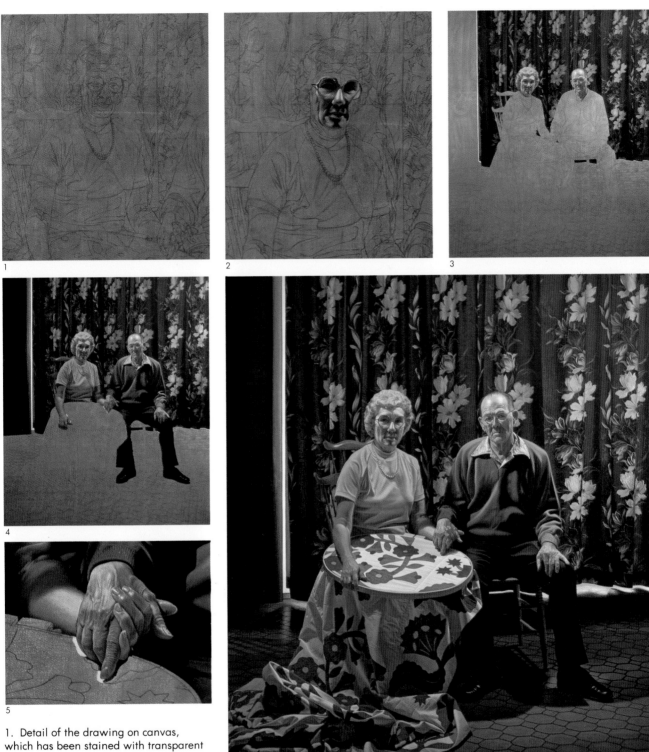

1. Detail of the drawing on canvas, which has been stained with transparent acrylic.

2. The eyes and face of Ruth Him are completed first.

3. After both heads are completed, the curtain in the background is painted.

4. Both figures are finished before Valerio begins painting the quilt and the floor.

5. Detail of the clasped hands, with the unfinished quilt.

Ruth and Cecil Him (1982), 80¼″ × 92¼″ (204 × 234 cm), oil on canvas. The Robert Harshorn Shimshak Collection.

Pat Combing Her Hair (1981), 41½″ × 29½″ (105 × 75 cm), pencil on paper. Courtesy Allan Frumkin Gallery, New York.

You use an overhead projector to lay in the drawing?

Yes, for the transparencies. But going so large with an overhead projector, the image is not that distinct. I like it that way, and just put down what I want. Enough to get a sense of it. The drawing is very awkward when you trace from a projected image. I get the forms down with the projector, but then I actually redraw them.

So there is a lot of fine tuning. All of this is done with a pencil?

Yes.

You once said that you always paint in the eyes first.

I feel that I have to get them first. I guess there is the psychology of having an eye staring back at me. It's the human aspect that interests me. I'm not approaching the figure from an anatomical point of view, so I have to get that eye—the human contact—from the beginning.

You completely finished the eyes and everything inside Ruth Him's glasses first, before you moved on to the rest of the face.

I go to the eyes first and finish them.

From the progressive slides it looks as though you're working wet-into-wet, one part of the painting at a time. What is

your painting vehicle?

I use stand oil, turpentine, and a touch of varnish. Also some oil of clove to keep the paint from drying too rapidly.

After you finished the heads in this one, you painted the curtain in the background.

Normally I would finish the body next. If the background is very complex, I put in more of a tone or paint part of the background in order to get the edges around the head. But in this painting I was very worried about making those figures separate from the drapery and making the flowered pattern on the drapery stay in the background with the light coming through it. There is a point where contrast defines light, and I was thinking about the chroma. I knew if I could get the color just right, it would look like the light was coming through from behind.

Usually I paint with Winsor & Newton oils, but Bill Beckman told me about Blockx. Some of their paints are more brilliant, which is what I wanted. The idea that light is not just contrast, but also color, is very important. The luminist painters—Church, Bierstadt, and the others—their paintings really have that quality. I enjoy that aspect.

Your color is always very rich and clean, but in this painting the flesh tones are very yellow.

Well, take a look at the curtain. The flowers are yellow, and the knotty pine walls have a yellowish cast. That color unifies the painting.

What kind of palette do you use? Do you have a broad range of colors?

I experiment with different brands because certain pigments—like cadmium red—will vary a great deal. I'll show you. I have all of these charts with little dabs of color from different brands which I refer to. I almost know them all by heart.

You don't do any glazing, do you?

No. I read a long time ago that you can't help but glaze because of the transparency of the oil, but I don't intentionally glaze. I go for the wet-into-wet alla prima.

When you aren't teaching, what kind of painting session do you put in? Do you work an eight-hour day?

On a normal day I start at about eight and work until five, with coffee breaks and lunch.

And this painting took about two months?

Yes, but I was teaching too. I used to work a lot at night, but with teaching it was just too much. Now I might work on a drawing at night.

In your paintings, almost everything is brought up to the same finish. The emphasis is fairly consistent throughout.

I think I understand what you are saying. I could paint a rug by doing each strand or I could generalize on the overall pattern, color, and texture, or I could focus on isolated parts that would accentuate them. Those are the choices. I'm reminded of Vermeer's paintings, especially *The Love Letter*, where you look through the doorway to the woman with the letter, her mistress behind her. Everything in the foreground is just slabs and patterns; the middle and background are more detailed. Sometimes Vermeer would emphasize a few strands of fabric and then leave the hands or a head undefined. Those are choices he made. You make decisions on how to edit the information. Once you have an idea about what you are seeing, the surer the image will be.

Do you consciously use any symbolism?

Sometimes I do. For my self-portrait, I carefully chose the objects to put on the table. You'll notice that the hand against my face looks rather awkward, as if my face were a mask that could be pulled away. The clock is at five minutes to twelve, which used to show how close we are to using the atomic bomb. But often people read things into my work that I certainly haven't consciously implied. For instance, Jean Frumkin noticed that *Still Life #2* was like a Last Supper, with thirteen groupings. I had never thought about that.

You do think about juxtapositions and associations?

Well, I guess what I'm trying to say is that I don't have a painting that well thought out, but those things interest me. In *Still Life on a Bedspread,* which is all fruits and vegetables on a bedspread, the melons are like two lovers on a bed, and that crossed my mind. That was part of my reasoning for using those voluptuous forms and luscious colors. But then a graduate student at the University of Iowa sent me a paper that went into all kinds of metaphorical stuff about the objects. I can only tell you that some of those things occasionally cross my mind, but I don't set them up that way—not the way Leslie and Beal do.

But even in a still life, the most innocuous object can be changed by its relationship to the other objects, its context. In Still Life #2, *the Cornish hen is disconcerting because it seems to be too small in relation to the other objects in the painting. Also it is more "naked" than "plucked."*

Everything is larger than life size in that painting. I projected them life size, but a little larger they seemed more interesting. I like the idea that people look at that Cornish hen and expect it to be the size of a chicken. That's the unexpected I was talking about. A lot of painting is an acceptance of clichés, but Realism enables the artist to break from them. All apples are red, and all apples are round, but try to paint one accurately and you have to break such preconceptions. One of the reasons I did this painting of the Hims is to say, "These people are older than I am. They are very conservative, which is part of the distinction between old people and young people, but is that really true? I

may not agree with everything they believe, but I like them." I wanted to explore those things.

Let's talk about Differing Views, *which is certainly one of your best paintings. There are drawings that show the inside of the room reflected in the windows, but in the final painting there are buildings outside. In one of the drawings the dog wasn't included. So you keep adding, subtracting, and changing things.*

It's like the decisions that Richard Estes makes, according to your book, regarding the information he wants to include in a painting. You never know what he has chosen from, only what he has decided to put in. In *Differing Views* I depicted a particular moment. I was talking to my wife one night and was looking out the window while she was watching TV. We were looking at each other's reflection in the window. I thought about my wife and myself having different viewpoints, which was also literally true in visual terms at that moment.

The buildings outside the windows are really downtown Ithaca.

But in reverse. I liked them better that way.

And the interior is actually your suburban living room, so Differing Views *is really pieced together.*

Yes. That chair is the chair I sit in every day, and the view of Ithaca is one that I have seen many times. That particular

window I have looked at and through many times. I could do many paintings of it, and each one would be different.

One thing I want to touch on—you didn't really do any finished drawings until the past few years, and you haven't done any prints for a long time.

I enjoy drawing and have always done some drawings, but I really felt that painting was the thing for me. I'm giving more time to drawing now.

You're now working on a lithograph.

The last time I did one was in art school.

So you aren't really too interested in prints at present?

There are so many good printers out there. If I were going to do prints, I would like to go to someone who really has the technical skills and work with him or her.

The large drawing, Still Life with Tomatoes #1, *must have taken almost as long as a painting.*

It took more than a month.

And the one of Pat at the dressing table?

That took about two weeks. I really fell in love with the surface of the paper. Some materials I have abandoned because I had no feeling for the medium. In a lot of drawings you can see that the artist fell in love with the materials. I like to see that. I like working on the stone with litho crayons, but I feel that oil paint is really magical.

(Above) *Differing Views* (1980-81), 102¾" × 92¼" (261 × 234 cm), oil on canvas. Courtesy Allan Frumkin Gallery, New York.

(Right) *Study for ''Differing Views'': Interior* (1981), 27" × 22⅜" (69 × 57 cm), sepia on paper. Courtesy Allan Frumkin Gallery, New York.

(Page 143, top) *Still Life on a Bedspread* (1980), 82" × 72" (208 × 183 cm), oil on canvas. Collection University of Iowa Museum of Art.

(Page 143, bottom) *Fractured Still Life with Decoy* (1983), 100" × 84" (254 × 213 cm), oil on canvas. Private collection. Courtesy Allan Frumkin Gallery, New York.

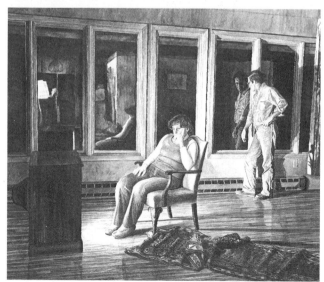

NEIL
WELLIVER

While Neil Welliver's monumental landscapes have become more specific in their recollection of ambience and physical topography, they have remained surprisingly physical and spontaneous paintings. These signature paintings descend directly from Abstract Expressionism by gesture, scale, and composition.

If we have a contemporary dean of landscape painting, it is Welliver, and in addition, he is also one of the finest watercolorists and printmakers. He is a thoughtful and committed environmentalist and lives in a farmhouse constructed in the eighteenth century, which was disassembled and moved to its present location on a wooded back road in northern Maine. Electricity is generated by a windmill, and the long, rambling house and connecting barn are heated by woodstoves. A large organic garden is the plentiful source of produce.

The barn provides an enormous studio space, and a large assortment of the small paintings, which serve as source material for the large canvases, sit in rows along the beams. In the corner a stack of large cartoons from previous paintings are spindled to the wall. A skylight over the painting wall has been glazed from a sheet of glass salvaged from the ill-fated windows of Boston's John Hancock skyscraper.

"For me the energy in a representational painting flows on two levels. . . . One level is the material and the canvas. Sometimes whole sets of relationships and 'energy flows' take place on that level. . . . Then there's another level of observation of objects and space—natural associations. The simultaneous presence of those two aspects of the painting is what I'm interested in."

Late Light (1978), 96″ × 96″ (244 × 244 cm), oil on canvas. Extended loan to the Rose Art Museum, Brandeis University, from the Herbert W. Plimpton Foundation.

One of the things I'm curious about, you studied with Albers at Yale. I assume you were doing abstractions then.

I can tell you exactly what I was doing. I had been painting on my own and had been badly educated as a painter, frankly. I was painting farm machinery, great reapers and tractors sitting in fields, when I arrived at Yale. They were, in fact, landscape paintings—kind of spidery—hard to relate to anyone. That's what I came to Yale with, and Albers called them insects. Then I began to do abstract painting at Yale, what was later called color field painting.

I've always heard that Albers was adamantly opposed to representational painting and very rigid and dogmatic.

That's not true. Albers certainly was a convinced abstract painter. He saw Western painting as a kind of continuum moving toward abstract painting, and thought it was the right course.

Linear thinking.

Linear, right. But some people at Yale were doing figurative painting, and Albers wasn't opposed to it. He was inclined to be harsher with people who were doing figurative painting because I think he found it more difficult to discuss, but it's untrue that he was opposed to it.

I have also heard that Yale didn't have life drawing.

There wasn't a lot of drawing, but Bernard Chaet taught a life drawing class.

So a lot of this is just myth.

Yes, myth. Albers is terribly maligned, terribly maligned.

Are you able to adapt his color theory to Realism? Does it have any bearing on your landscapes?

I learned an enormous amount from him about the perception of color—how we see colors, why they appear the way they do. Fundamentally, the basis of the Albers doctrine was that all colors have the particular characteristics they have because of the context in which they occur. If you take them out of one context and put them into another, they'll appear to be entirely different. You can make red look blue and blue look red. That relates to all painting. So, in that regard, his color theory is appli-

cable. But if you're saying to me, "Is Albers' idea applicable to my painting now, the way it would have been applied by Anuskiewicz," no.

It's so hard to transpose those concepts if you're working directly from nature.

What I got from Albers was a broad, substantial base in the perception of color and the way color changes in different contexts. That relates to landscape painting and to abstract painting. But making it directly applicable to the imagery? No. I would give you again the example of Anuskiewicz. He comes directly out of Albers' theories.

> ## "What I got from Albers was a broad, substantial base in the perception of color and the way color changes in different contexts."

How did metamorphosis from abstract painting to Realism occur in your work?

I'll tell you an interesting story. When I left Yale in 1957, the hottest gallery in New York was the Stable. I was making some sensational abstract pictures at the time. Marca-Relli saw them and said, "I want to bring somebody to see them." He brought Eleanor Ward, who ran the Stable Gallery, to New Haven to see my work. She was excited by them and said, "I'm very interested in these and I'll give you a show." I said, "I want to think about it." I thought about it overnight and said, "No, I don't want to do it." I knew then that I was ready to change.

After that, I had two absolutely horrendous years. I was on the floor with pumice and paint, scratching, digging, pouring, drawing, and smearing, and nothing was coming out of it. I was really trying all of the obvious aspects of modern painting that I had never been introduced to. I just wanted to go through it, to try everything: materials, images, the whole thing. I made a series of quasi-expressionistic paintings that were influenced to a certain extent by de Kooning. Observation was involved. I was starting to look at things, use people, and so on. Out of that came a series of pictures that I first showed at the Stable: *The Burial of Count Orgone* and all those take-offs on historical

paintings.

That show was around 1959.

I was still at Yale. Then I took off and went to Asia. I kicked around there the better part of a year and came back in 1960.

How did the move from those allegorical paintings and homages to the portraits and figure occur?

In the allegorical paintings there were a series of nudes, and foliage and trees, sometimes used rather decoratively. I wasn't painting in Asia, just kicking around, looking at Chinese landscape paintings. But while I was on that trip I figured out that I wanted to come back and focus on nudes. When I returned to New Haven, I started doing very direct, very crude, rough paintings of nudes in landscapes.

Then I came to Maine in 1961, found this place, and started painting here.

What was your reason for coming to Maine?

I first went to French Canada. I wanted to paint in the country, and I was sure by then that I was going to paint from nature. I had some friends around La Malbaie, on the St. Lawrence. I liked it and thought I could paint there, but my French was so appalling I finally gave up and started moving down. I came to Maine and knew that Alex Katz was near here. He had a place here because he had been to the Skowhegan summer school a short time before and had bought a cottage. He was summering here. I came and stayed with him and thought this area was great. People spoke English and I liked the landscape, so I just hit the back roads, found this farm, and bought it. It was that simple. Immediately I began painting my children and the landscape.

Such as the canoe paintings.

Those and some others that precede them.

Were the nudes in streams painted up here?

Yes.

Did you bring the models up?

Yes, as a matter of fact. If there was a model posing at the school—there was a model agency at the Pennsylvania Academy—I would just ask if she would

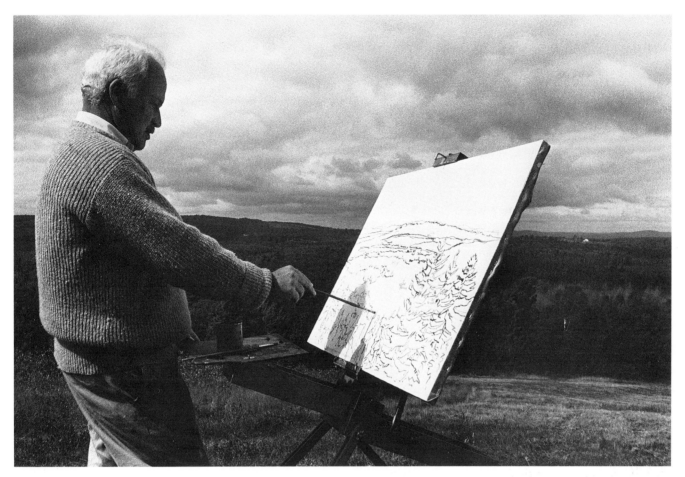

like to work in Maine.

So you would bring a model up for the summer?

Yes.

Knowing New England and this part of Maine, to pose in those mountain streams . . .

Froze their pants off.

Yeah. That must have been very, very cold.

But I never forced a model to sit out during black fly season. Rudy Burckhardt made a movie of me painting a model in the water from a drawing. The black flies were so bad, I painted in the barn. But, sure, they posed in the water—cold as hell.

Very hard on the models.

Oh, yes. Very. Sometimes I would make drawings, which I took back to the city, then posed a model there, based on rough drawings I had made. But a lot of them were done here, directly from the model.

You never did get involved with painting from photographs.

No, for a very simple reason. I sure as hell don't object to that, you know. I see some work that's done from photographs that interests me greatly, but photographs are monocular. They exclude by the nature of the machine the psychology of the picture, which I'm interested in—the binocularity of things—so I've never used photos. Polly [Welliver's deceased wife] and now Shelia [his present wife] have both gone along with me and taken photos of me painting or the place I'm painting. I can hardly read the photographs, so to speak.

Over the past ten years, the figures have disappeared from your paintings.

Right.

Also, the earlier paintings were much broader, more generalized. Now they have the appearance of being very specific. Did that just gradually evolve?

Part of it is that one's vision changes. The other part is that one becomes able to handle more.

It's a matter of developing the skill and facility.

Of course.

More than ten years ago, I was talking with Philip Pearlstein about his early paintings, which were very broad and very generalized also. Philip said that at the time they were painted they seemed fairly tight, in the context of the abstract painting of the time.

I remember Philip's first show at Frumkin. Philip and Alex and I were in New Haven. I had an old sports car, and we drove down for his opening. Philip had worked that day, teaching drawing or something, and Alex drove and it could have been the end of the whole Realist movement. It was wild. We were damn near frozen to death when we got there. Philip was painting those very broad pictures at that time.

The moutains, the Italian ruins?

No, it was the first figure paintings. They were rough pictures. Not rough in the technical sense but in a psychological sense They were hard to look at. I remember looking for quite a while be-

fore I could get a handle on them—and I
liked Philip and liked his mind.

*What about your friendship with Fair-
field Porter?*

By the time I got to know Fairfield or
was very much aware of his work, my
painting was beginning to take the form
it has now but was less developed. I
met Fairfield through Alex, I think
about 1958. I liked him well enough but
was not very interested in his work. I
thought it French and soft. In short, I
missed it. I later told Fairfield I had
missed his painting and thought it just
French painting. Fairfield said when he
had first seen my work he thought it
"just good-natured Expressionism." I
talked with him a lot, and there seemed
to be some real fundamental agreement
between us about a lot of things, mostly
social and political. But we rarely talked
about painting. Fairfield made a great
issue of the Nabis. He was enamored of
those painters, but they were not paint-
ers that interested me greatly. I wanted
something very different. Once Fair-
field said to me that our work was really
antithetical. He came out of the Nabis
and French painting, and I really came
out of American abstract painting. So
we approached painting in a very differ-
ent way.

*You said that he was always bothered by
the way you painted.*

He came here once, I told you, and saw
a painting half-finished. The canvas was
totally finished above but there was
nothing below, and he just said, "That
can't be done. You simply can't do this."
Then he said, "We're antithetical. You
use your mind one way; I use mine
another. I recognize what you're doing,
but I can't imagine it." It was a semi-
passionate discussion.

*When Porter did a really top-notch paint-
ing, he was as good as one can get, but he
did a lot of really awkward, clunky paint-
ings, too. Which do you think will ulti-
mately be more important, his writing or
his painting?*

I think that the Fairfield Porter paint-
ings that are good are very, very good
American paintings. God knows that
they can never be dismissed. I can't
imagine that. But whether Fairfield's a
major painter or a minor painter is a
judgment to be taken care of by time, as
it will be for all of us. I don't think it's

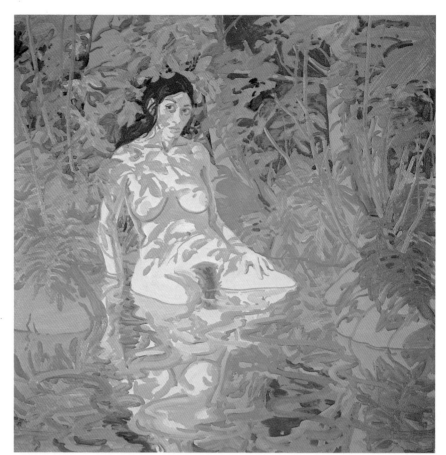

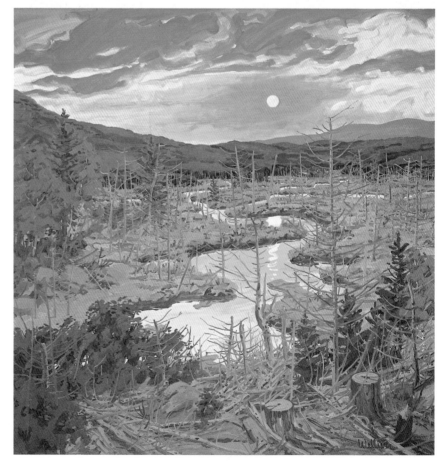

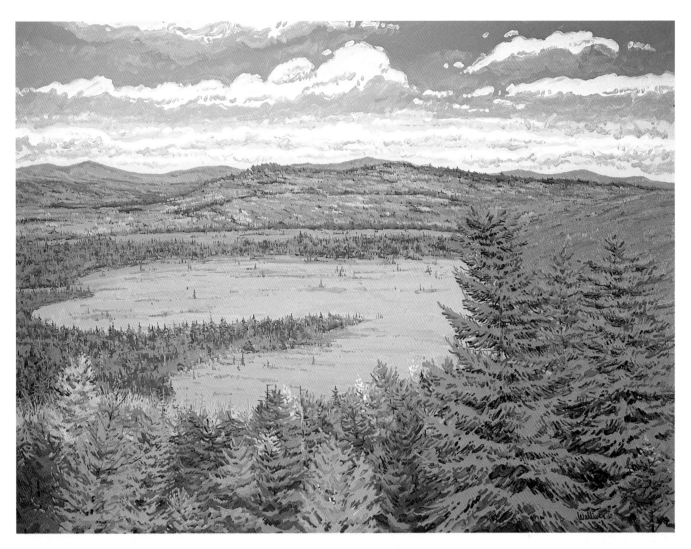

(Page 148, top) *Reflections* (1973), 41" × 44" (104 × 112 cm), oil on canvas. Courtesy Marlborough Gallery, New York.

(Page 148, bottom) *Sun Over Briggs Meadow I* (1972), 72" × 72" (183 × 183 cm), oil on canvas. Courtesy Marlborough Gallery, New York.

(Above) *Peat Bog* (1982), 72" × 96" (183 × 244 cm), oil on canvas. Courtesy Marlborough Gallery, New York.

(Left) *Study for Trout and Reflection* (1979), 22¼" × 30" (57 × 76 cm), watercolor. Courtesy Brooke Alexander, Inc., New York.

subject to discussion. Fairfield's writing is very unusual. He was an interesting and exciting critic, but I certainly think that his paintings are in another league. I'm thinking specifically about paintings of the caliber of the *Columbus Day* painting, which is as good as painting gets. By the way, much of the attraction of his pictures is that awkwardness you refer to.

Another important point that you made about Fairfield, which I had misunderstood, is that his influence as a painter was really on the younger Realists, not on the Realists of your generation.

I could say that, in terms of the way I developed my imagery and what interested me, Fairfield had little effect on me. But his conversations had a great effect on me. He was extremely articulate and had one of those minds that didn't follow the line of thought one would anticipate. There was always something new about what he said and what he saw. I spent hours and hours—days—talking to Fairfield. Those conversations were very exciting, but I think his statement that we were antithetical as painters is accurate. I think we were very, very different. But he had a tremendous effect on people like Marjorie Portnow, Janet Fish, Rackstraw Downes, and Susan Shatter.

My generation of painters, which are people who come out of abstract painting or were affected greatly by Expressionism—Alex, I think, would agree with that, and Philip Pearlstein, obviously—I think we come from very different stuff and Fairfield had virtually no effect on us. I would say, in fact, that Alex probably had an effect on Fairfield. Anyone who spent any time with Fairfield was certainly affected by his character. He was unbending and one of the most inordinately decent people I've ever met.

Your move to landscape painting started in Maine, is that right?

No. I think, and this was very important to my painting then and is now, the nudes and the landscapes were the same thing. A Chinese painter, Jay Yang, said to me once, "Oh, it was so exciting to see the fish, the nudes, and the trees; everything was painted with the same touch and the same intensity."

Your scale and way of using paint seems to stem more from Abstract Expression-

ism than from the landscape tradition.
Yes. I think that's accurate.

But the paintings are based on direct observation.
Very strongly. You've seen the drawings and small paintings. You see the wedding of those two things.

For me the energy in a representational painting flows on two levels, and for many painters I think it doesn't. One level is the material and the canvas. Sometimes whole sets of relationships and "energy flows" take place on that level, and whether you see the image or not is immaterial. Then there's another level of observation of objects and space—natural associations. The simultaneous presence of those two aspects of the painting is what I'm interested in.

> "I was looking at something extremely obscure, not light in the normal sense, light bathing objects, but light in the air, flashing and moving like a flow of energy through space."

With the best Realist paintings, one can literally have one's cake and eat it too. Everything that one responds to in an abstract painting is present, and yet there are all of the connotations of the image.

But one thing about a lot of good Realist painting which does not interest me is the delineation of volume. For me the volume is volume that moves from the surface of the canvas into the space—total volume. But the description of the volume of forms—that kind of tightness stops the energy flow I'm talking about. That aspect of Realist painting is of very little interest to me.

I think there are two ways of describing form in a painting. The one most of us learned had to do with the volumetric description of form and stems from Cézanne and Cubism. But volumetric form can also be defined by light and dark, à la Rembrandt, Velázquez, and Eakins. Both ways are accurate and valid.

I remember one time Paul Resika was here and I showed him a brook that is a sea of boulders. He walked in and said, "A feast of planes." A feast of planes. For me there were no planes at all.

Instead, I was seeing a great energy flow of light, fragments of light whistling along the brook and back through the total volume we were looking into. The idea of immediately focusing on the object and its planes—I wasn't seeing that at all. I was looking at something extremely obscure, not light in the normal sense, light bathing objects, but light in the air, flashing and moving like a flow of energy through space. That interests me greatly. That's what my paintings are about. Does that make sense to you?

I understand what you're getting at, but do you find that kind of light in paintings from the past?

To be honest with you, almost none. I said in an interview with Mark Strand that I look at a Courbet or Corot—both are painters I like to look at—and I find their paintings empty. I'm not derogating them as painters. They're great painters. But, in regard to my interests and what I'm trying to describe to you, I find their paintings empty.

In what ways? Neil? I think there are some obvious comparisons between your landscapes and the nineteenth-century American landscapes, for example.

No. They don't relate at all. Nineteenth-century landscape painting was basically object oriented. For instance, look at the Luminist painters, the great and miraculous skies of Church, Kensett, Bierstadt, and those people. Basically they were volumetric painters and very procedural painters also. It's very clear when you look at a Cole that he had a method for putting in all the trees, a signature, a scumbling—laying in the scumbling. For me, those painters had very abstracted ideas about space—the great Arcadian space. They were totally involved with the specific characteristics of a situation, and I'm much more interested in the general energy flow through space. They're not favorite painters of mine. Of all of them, the one who occasionally transcends that is Kensett—his best paintings. In a way they become metaphysical. Cole's and Church's paintings to me always seem like a child's fantasy and have very little to do with a substantive vision of the world. But occasionally Kensett really makes me stop. I'm much more interested in Ryder.

What do you think are some of the basic

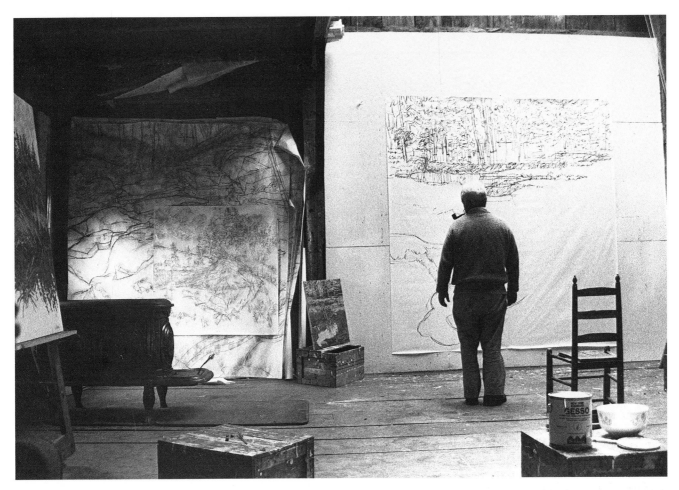

differences of attitude which separate the contemporary landscape painter from the nineteenth-century painters?

I can describe my own attitude, but I can't speak for other painters.

The great Arcadian view of the nineteenth-century doesn't exist now. The sociology of late nineteenth-century and early twentieth-century France doesn't exist anymore. Thanks to modern physics, our view of the world is totally different. But I think a great many landscape painters just go out and paint the landscape as it's always been done. I'm interested in something else.

What about your attitude toward the land, divorced from esthetics?

You mean in a social sense? I'm an ecology freak. I'm passionate in my belief that if this species doesn't support, and prevail upon one another to support, other species on this planet, we're a meager lot and don't deserve the dominance we certainly have on this earth.

Our generation is extremely conscious of the fact that the environment really is

endangered. That is a major difference.

I just read a very interesting figure in one of the nature magazines. Right now a species a month is gravely threatened. In another ten years there will be a species a day. We're talking about insects and everything. Everything is going to go if we don't change.

When you say you're an ecology freak, your lifestyle certainly supports your position. You are living in the Maine woods, generating power with a windmill; your only heat comes from woodstoves, and you maintain a large vegetable garden. In a way, all of this loops back to the nineteenth-century, but it's actually very progressive.

I hope so. In the nineteenth-century the prevailing attitude was that our resources were endless. God knows our resources are not going to go on forever, maybe only for a very short time. Yes, that is a central interest of mine, but I don't paint for that reason.

But you do paint landscapes, and your reasons as described earlier sound more

like the concerns of an Abstract Expressionist in some ways, but your attitudes are reminiscent of van Gogh and Munch.

I'll tell you a very interesting thing that's happened to me as a result of painting. I accept myself, in a real sense and not in an intellectual sense, as just an animal part of nature. The old Judeo-Christian separation of myself from other things has no substance for me anymore. That may sound very incidental, but it's a very exciting state of mind for me—to go over the ass's bridge and recognize that.

When I curated America 1976 for the Bicentennial, we sent the painters anywhere and everywhere in America to do works specifically for the show. Most of the painters picked places where they had never been before. You chose to stay in Maine, with the subject matter that you were deeply familiar with.

My familiarity with the subject matter is a totally different issue. But I certainly didn't go very far up the road to paint— had no desire to. It never crossed my mind to go somewhere else.

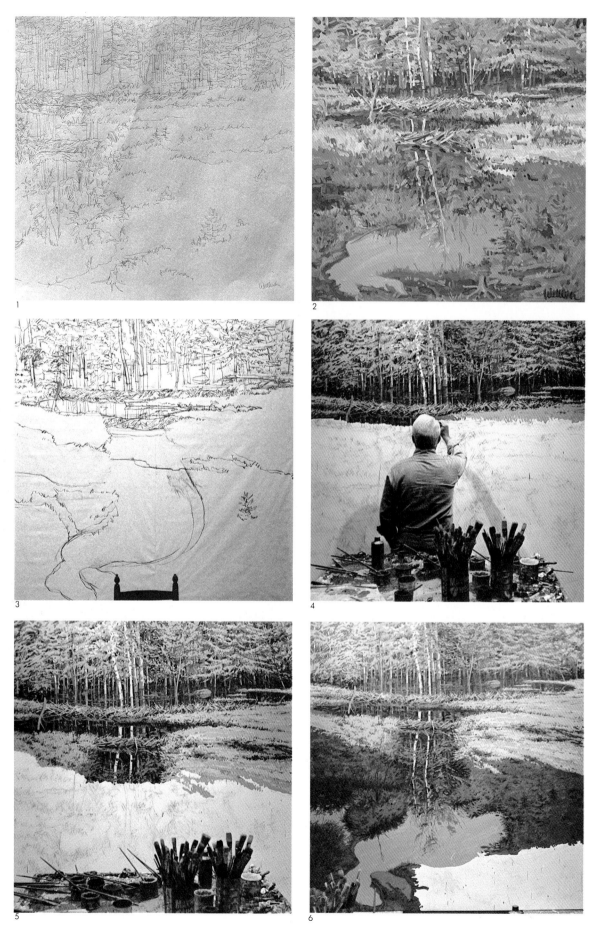

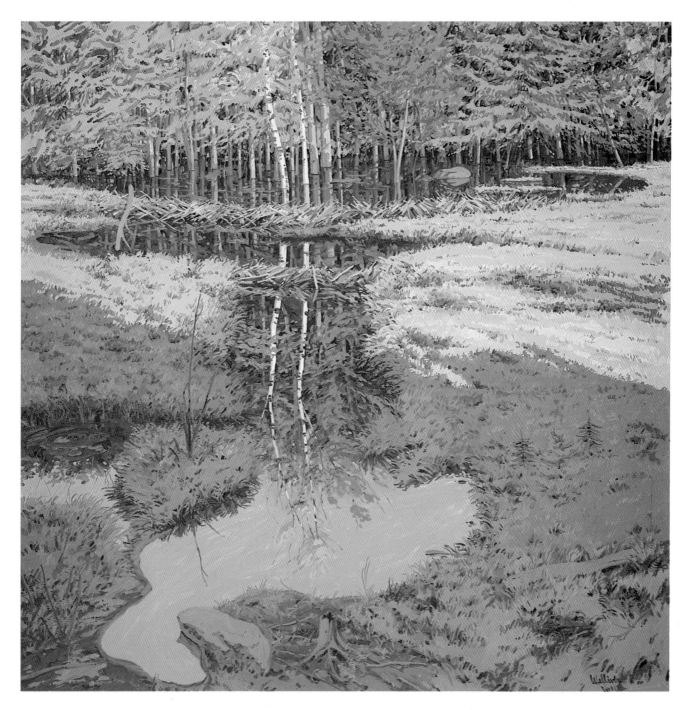

1. A pencil drawing was the first study for *New Dams in Meadow*.

2. This small oil was painted on location. The large painting is done in the studio from this painting. Note that the shape of the pool has been changed from the earlier drawing.

3. Incomplete charcoal drawing is done from the small painting on sign painter's paper. This drawing will be transferred to the canvas by using a perforating wheel and ponce bag.

4. The painting is completed from top to bottom. The transferred drawing can be seen in the lower half of the canvas.

5. Development of the painting is very direct, with little or no reworking.

6. At this point, only the lower corner remains unpainted.

New Dams in Meadow (1982), 96″ × 96″ (244 × 244 cm), oil on canvas. Collection Laurance Rockefeller. Courtesy Marlborough Gallery, New York.

I think your sense of deep familiarity with the specifics and the nuance of the landscape is important in your paintings. They're not the work of a tourist who has set up a French easel on a hillside.

Good, because I spend a lot of time on that. Otherwise, you could never see what I'm after.

In fact, the closest parallel that I can think of is Bonnard painting his wife over and over, and the way she never aged, never changed in his paintings.

Right. He painted her endlessly.

You don't show the drawings, but you do line drawings and small paintings directly from nature. In those small paintings, you seem to be dealing very specifically with the topography, flora, the nuances of light, the weather, and the season.

Right.

But I read in Edwin Denby's interview [for the Currier Gallery of Art Catalog on Welliver] that you're not really interested in attempting to duplicate nature or its local color. Are you only after ambience?

No. In fact, to paint what's out there, you would have to have a tube of air because of the air and light which surround everything. What I'm interested in finding are the colors that are equivalent to those objects in air. I find that trying to use local color is almost a guaranteed way of missing it.

You're a very good watercolorist. Why is it that you do your small studies in oil instead of watercolor?

Because oil is such an infinitely flexible medium, and watercolor is not. Fairfield Porter said to me one time, "You know, watercolor isn't like oil. Oil you must put down and leave, but watercolor can be worked over and over."

It's just the opposite.

Right. But it is typical of Fairfield's view that he would say that.

Yes. So when you do watercolors, they are not studies, but finished works.

I rarely do watercolor studies. I often make color notes, like the little duck heads I showed you, which were done directly from the ducks. But I feel totally comfortable with oil painting. For me it's the most infinitely flexible me-

dium for painting. I absolutely love it.

You have a very limited palette.

Eight colors. I use Permalba white because I like its consistency, ivory black, cadmium red scarlet, manganese blue, ultramarine blue, lemon yellow, cadmium yellow, and Talens green light.

So you've completely eliminated the earth colors. For the neutral grays or any of the browns I would assume you're using a mixture of opposites, such as red, green, and white.

Yes. Red, green, and white. Of course, I'm rarely after a neutral gray, but those grays which are charged with blue or green or something.

> "What I'm interested in finding are the colors that are equivalent to those objects in air. I find that trying to use local color is almost a guaranteed way of missing it."

And there is that multitude of colors described as brown, when, in fact, there is no brown in the spectrum.

Right. I make all those colors, and by doing that, I can make them enormously luminous. I find that the earth colors in fact have an opacity and density that I'm not much interested in.

You always use the oil opaque. There's no transparent paint and no glazing.

No glazing, no scumbling.

How much gear do you carry when you go out?

Well, I carry a backpack with about seventy pounds in it. I've just reorganized my frame and gotten a smaller French easel, so I've reduced the load a bit. But I carry things that a lot of painters don't take. I carry binoculars and a spy glass to pick out things I want to see more clearly that are far away, and I like to watch animals and that sort of thing. I carry a French easel, all the colors in triplicate, water, and turpentine cans. In the small paintings there's no overpainting. I use no medium at all, just straight turpentine. I find the paints very fat anyway. Also, rags and brushes, and with the pack,

the weight is about seventy pounds.

How far do you go?

A mile, sometimes five miles. It depends on what I'm after.

Are all of the paintings on your property?

Not all, but a lot of them are. This property is greatly varied. It has ravines, hills, and flatland, ponds and a river.

How long can you work on the small paintings before the light changes? About how many trips does it take to complete one of the small studies?

I work about three hours at each session on the small paintings, and they take about three sessions each, or nine hours. On occasion twelve or fifteen hours.

You paint outside year round. It must get very difficult in the winter, physically and in terms of problems with the paint.

Painting outside in winter exhausts my discipline. It is cold, very cold. The paint is stiff. I can only do it by concentrating absolutely on the painting.

What are the factors in deciding which of the small oils will be done as large paintings? How do you decide on the size and scale for a large painting?

I don't know. As I said to Edwin Denby, when they look too small, I make them larger.

You draw with charcoal on sign painter's paper from the little paintings, instead of drawing directly on the canvas. What is the advantage of the extra step?

Also, there are no compositional markers or guidelines. The charcoal drawing is surprisingly direct—and accurate.

When trying to arrive at a proper scale and place things where I want them, a kind of tedium takes place, which is present in the drawing. I prefer not to begin a painting on a bed of tedium, so I draw on paper, puncture it, and transfer a generalized image onto the canvas.

You transfer the drawing to the canvas using a perforating wheel and ponce bag. Do you use anything to seal or stabilize the image?

Yes, I spray the drawing with crystal clear Krylon.

What is the difference between working in the studio from the small painting and working directly from nature?

Working in the studio is physically more comfortable!

You start painting at the top and work across and down until you get to the bottom. It looks as though you never go back, never rework anything. Is that true?

Yes.

I'm amazed at your palette. These porcelain pans you use. With the paint all piled up, it looks like a strange, horrible sore. How do you keep your colors clear, and how can you mix color in that mess?

It is not, for me, a mess. It is extremely clear and orderly. I've never seen, or had, a sore which looked like that, thank God! Beginning to mix paint over existing but dry paint makes more sense to me than mixing on white. The color being mixed on a palette with color is immediately seen in relationship to the other colors.

Do you paint with a mix of artificial light and natural light?

In the studio, yes.

What do you try to maintain in the large painting that is carried over from the small painting?

The energy.

What kind of hours do you keep? How long does it take to finish a large painting like this one?

I work from ten till five, with a five- or ten-minute break every two hours. Sometimes I paint longer, but usually put in a seven-hour day. The painting takes from a month to five weeks.

When you get the canvas covered, is it finished?

Yes.

Back in 1972 I saw your little hand-colored etching of the trout in your studio and told Brooke Alexander about it. At the time he was working toward an exhibit of hand-colored prints. You didn't know Brooke and didn't know about the exhibit he was planning. I'm curious about how you arrived at the idea of doing a hand-colored print.

I had made a black-and-white etching, and it was crying for color, so I colored it. It was really that simple.

You've done quite a few hand-colored etchings since then.

I really have come to love hand-colored prints and have made quite a number.

Was Moose *your only color aquatint?*

No. I have since made another of a deer and am planning a third. I am working with Arlene Gostin, the printer. She has a kind of genius and extreme sensitivity to the person she is working with. She is so orderly, she makes me feel undisciplined.

Recently you've been doing color woodcuts with a Japanese printer. Are those done using the traditional Japanese method?

Exactly. I make a master drawing, a cartoon really, in full color. I never make prints from watercolors; rather, the master drawings are conceived as prints from the beginning. They are separated onto rice paper, which is glued onto the block. Shige then cuts the negatives away. They are, of course, printed by hand.

The little woodcut is a jewel. Brooke described it as "Kyoto meets Lincolnville," which is very accurate. That print and a couple of small paintings indicate an interest in night and/or twilight landscapes. Is that right?

I don't know whether I'm influencing Shige or he's influencing me, but I promise you, that view is near my farm in Lincolnville. I have been working on and off on night things for five years. That little print is to date the only product of that venture. I am still working on night pictures, but to make a transcendental one evades me.

Maine is well known for its fall colors. That brings in a lot of tourists and sells a lot of postcards. Ironically, it is a season you seem to have skipped until now. Why is that?

My present show at Marlborough has numerous fall pictures, another of those slippery ideas that I have been playing around with for sometime. The fall, you know, is beautiful, but it is also bizarre and ugly. It is the latter which interests me.

These recent additions to your ouevre reminds me that a painter stays in a state of flux. To deal with contemporaries, one is facing a situation that is not static.

Yes. I agree.

Do you still find surprises in the landscape, areas that you haven't seen?

Every day. It's interesting to go out to a place I've been through fifty times. Sometimes I'll walk through an area and the light will hit it a certain way, and I'll have no idea where I am. I do literally, but visually I have no idea. It's a totally new thing, and that's very exciting, very exciting!

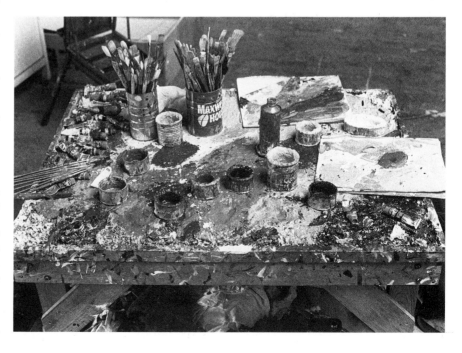

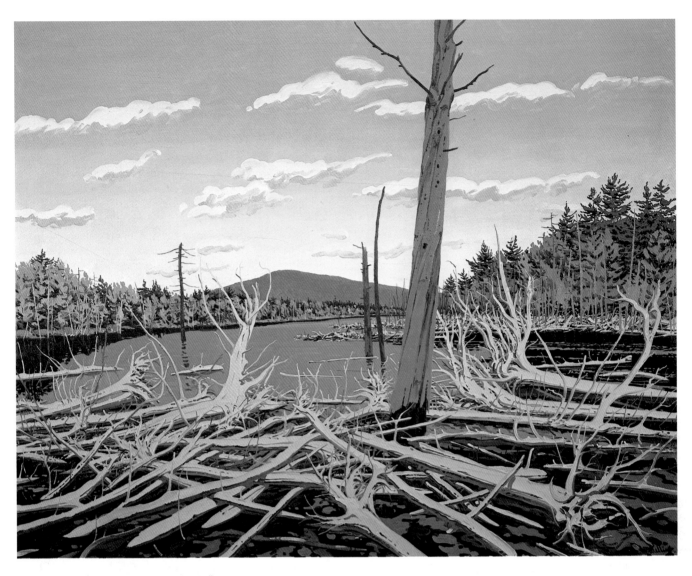

Drowned Cedars, Moosehorn (1980), 96"
× 120" (244 × 305 cm), oil on canvas.
Courtesy Marlborough Gallery, New York.

Night Scene (1982), 16" × 14" (41 × 36
cm), color woodcut. Courtesy Brooke
Alexander, Inc., New York.

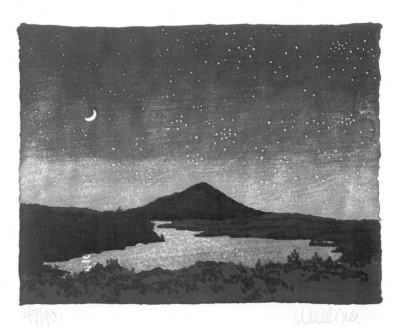

47/90 Welliver

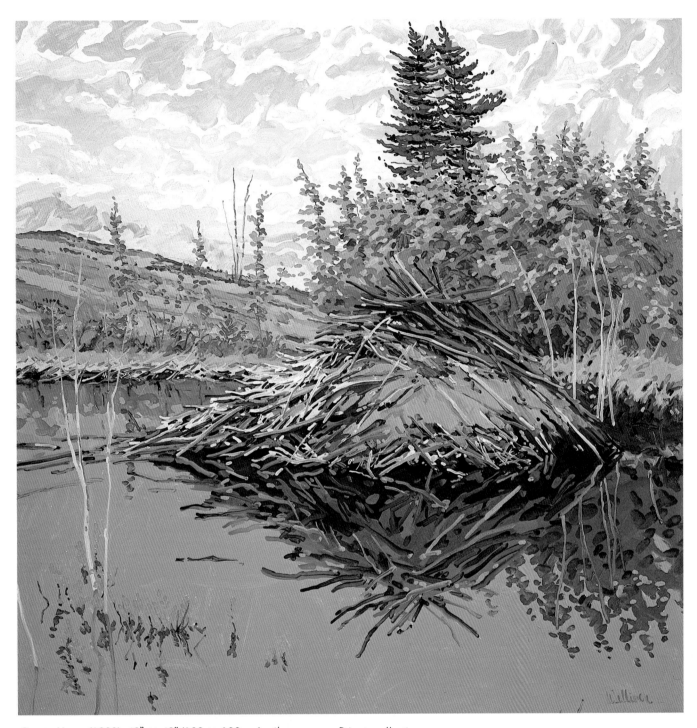

Beaver House (1982), 48″ × 48″ (122 × 122 cm), oil on canvas. Private collection.
Courtesy Marlborough Gallery, New York.

INDEX